Eight Days in Yemen

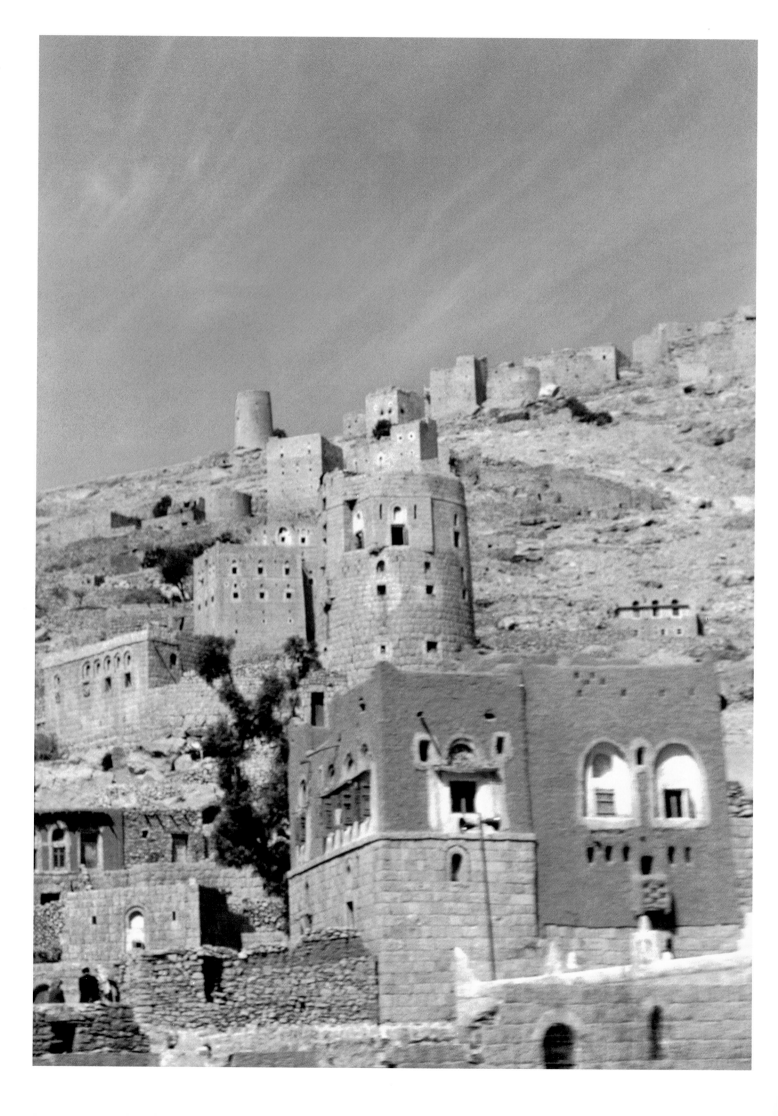

Eight Days in Yemen

Peter Schlesinger

Introduction by Bernard Haykel

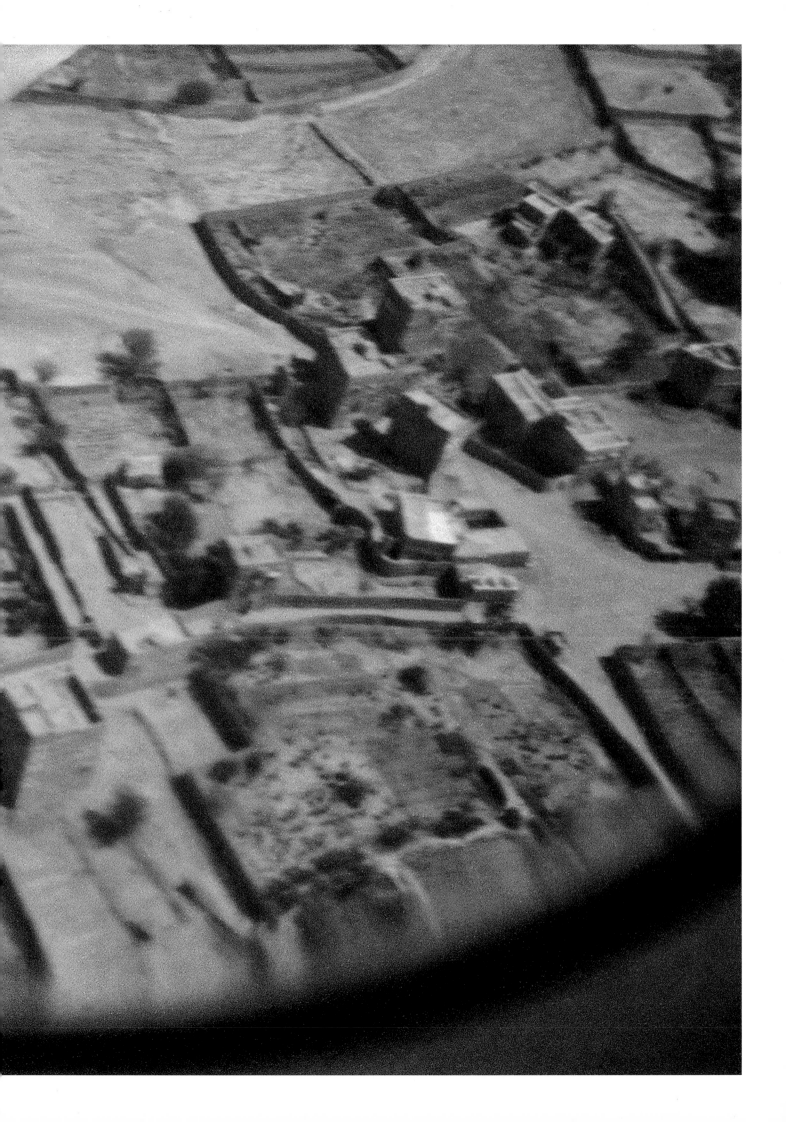

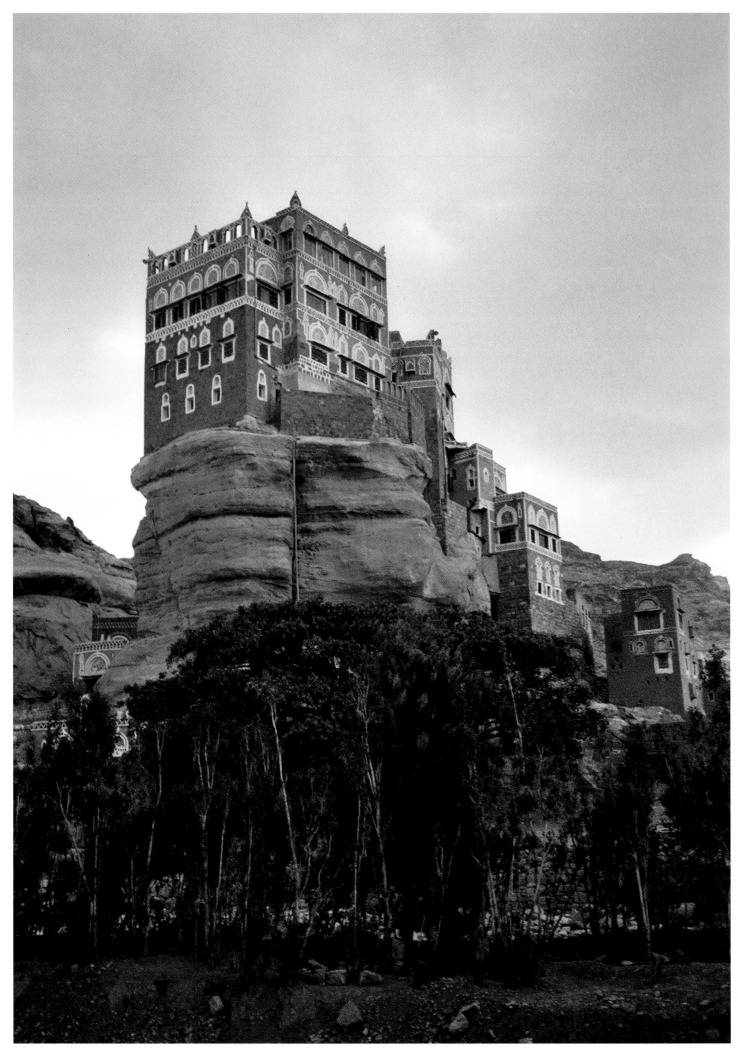

DAR AL-HAJAR

Introduction

This book of photographs represents a remarkable archive of daily life in Yemen in the 1970s. Unlike the few published photographic books from this period, this one does not offer the viewer a glossy and airbrushed version of this stunning country and its people. Rather, it captures a truthful and uncontrived representation of what Yemen was then like. In 1976, when these photos were taken, Yemen had only recently emerged from a bloody civil war (1962-1970) and was finally opening up to the world and welcoming outside visitors. Few foreigners ventured into the country and fewer still made a record of their visit. Unfortunately, Yemen is again experiencing a devastating civil war, and much has been destroyed lately, making these photographs all the more important as a record of what once was.

Peter Schlesinger visited for eight days and, by his own admission, knew little about this land and its people. Perhaps because of this unfamiliarity, his camera captures scenes and details without premeditation or prejudice, producing photos that are quite revealing of a social and economic reality during a period of change. Yemen in the mid-1970s was in transition from the older ways of living to newer patterns of consumption, social interaction and organization. Politics were still in flux and traveling in safety could not to be taken for granted; one needed government authorization, and the traces of the civil war were still strewn across the landscape. The people also bore the scars of a brutal war that had cost tens of thousands of lives, and many more injured and maimed, including from the use of chemical warfare by the occupying Egyptian military.

But by the mid-1970s, life was finally improving, and the foreign troops were gone. Now, imported products were becoming available, especially industrially manufactured ones such as shoes, pipes, metal vessels and rope. Healthcare was slowly improving, and public utilities such as electricity and piped water were also gradually being provided, as one can see in some of these photographs.

Old social hierarchies were in flux and traditional professions, which were often backbreaking, were dying out. And while armed tribes remained important, a new politics of republicanism and citizenship was spreading. The economic effects of the oil-price boom of 1973, which were to transform in radical ways all the countries of the Arabian Peninsula, had not yet affected the country, and Yemen was then, as it unfortunately still remains today, a desperately poor and underdeveloped country. However, as you will see in the photographs, some of the uglier sides of development, namely plastic bags, had not yet reached the country and because of this the landscapes and streets were still clean and not strewn with this unattractive feature of modernity. Today, unfortunately, Yemen is awash with plastic, in both urban and rural areas. Virtually everything being used back then was still biodegradable such as baskets made of palm fronds.

The photos in the book were taken in Sanaa and its surrounding villages, on the road north to the northern city of Sa'da, which is today the center of the Huthi militant movement. This is the group that controls much of the northern half of the country and is a party in the devastating civil war that still rages in Yemen. Some of the photos were taken in the villages of Hajja province and also on the road from Sanaa down to the Tihama, the coastal plain along the Red Sea.

In these images you have a sample of some of the country's different architectural styles, including such jewels as Dar al-Hajar in Wadi Dahr on page 6. This palatial rest house belonged to the ruler of the ancien régime that was toppled in 1962. Another set of photographs is of the stone-built homes in the mountainous regions around Sa'da, Hajja and Manakha. These are very different from the more ornate and gingerbread-style tower houses of Sanaa, which we see on page 94 for example. There are also wonderful examples of the architectural style of the town of Sa'da, with its mud-brick homes and their slightly elevated and buttressed corners, as on page 62. And in two photos, the first in Sa'da (page 56) and the second in 'Amran (page 34), we see the main fort and government administrative buildings from which each town was respectively ruled.

Another photo displays the very ground itself: an unpaved street in which metal juice cans and bottle tops of brands like Sinalco (a local soft drink) and 7-Up are crushed into the earth (page 132). Doing this was apparently quite common at the time and created a pockmarked and cratered effect that is very evocative for contemporary Yemenis because as children they would play with these bottle tops and cans, making toys out of them.

These photos are also an archive of various dress styles, representing a sample of clothing across gender, regional origin and age group. Reflecting the country's poverty, one sees that most of the people do not wear shoes, especially the children. Also, women back then dressed differently from today. On page 19, for instance, we see a woman in a cloak called a sharshaf which drops to just below the knees and not to the ground as has since the 1980s become de rigueur with the modern Islamic revival that has swept across Yemen from such places as Saudi Arabia. The same woman is wearing a yellow face cover called a litham or lithma which is no longer worn at all. The girls in the photo are wearing pointy hats called gargush, which signifies unmarried status, and these are still worn today.

Other photographs depict the magnificent homes of the wealthy and illustrate the styles and motifs that typify Yemen's architecture, especially in Sanaa and in the garden retreats on its outskirts such as al-Rawda. One such photo, on page 26, appears to be of the former ruler's (imam) home in al-Rawda. This is one of the tower houses that are quite unique to Yemen, and which have led UNESCO to designate Sanaa a World Heritage Centre. Here we can see the upper four stories, the bottom two being built of stone and the top two of brick. The masonry is of extremely high quality and we can see two types of stone are in use: a hard, volcanic black rock called hajar al-habash ("Ethiopian stone") and a beige stone that is called hajar al-bayda ("white stone"). Worth noting here are the

pierced and gypsum-traced arched windows with colored glass (called qamariyya = moon window) as well as the decorated gypsum bands that form the markers of the different stories. In the same photograph, we see two star of David motifs at the top of the building. This is a symbol that is common to both Jews and Muslims in Yemen and is often found on buildings, including mosques. Islamic and Yemeni architectural motifs are captured throughout the book. See, for instance, the crenellations and merlons on pages 34 and 144, and the attempt to ward off the evil eye with such objects as the horn on page 107 and the trident on page 82. Other windows, which are round and often in superposed doubles, appear to have translucent alabaster panes, another feature of traditional Yemeni architecture.

From the lofty and the beautiful to the basest, these photos also offer a rare view onto the way human waste was dealt with, both before the availability of pipes and drains and after. See, for example, the photo on page 48, which is a house in Sa'da. Here the raw sewage is coming out of the back of the house, and the old system of separating the liquid from the solid waste, appears to have broken down. A water pipe is also evident in the foreground. In other homes, one can see drains have replaced the lime-based cement (qadad) that used to run down the side of the houses to allow liquid waste to flow and dry on the exterior wall on its way to the ground.

On page 30 we see a photograph that represents a scene from the market in the town of 'Amran. What is on display illustrates the transitions Yemen was undergoing then. We see a woman carrying dried cow dung, which was used as a fuel (waqad) for heating and this is no longer in use. She is carrying this substance in a palm-frond basket and is wearing a blue face cover (lithma) and a black cloak. These features, too, are no longer to be seen in Yemen. The two men in the fore-ground are wearing skirts called a mi'waz or futa, and you will notice that this is made of the same cloth as their shirts and jackets, underscoring the limited range

of choice in cloth and style that people then had. The shoes they are wearing were called Chiki because they are made in Czechoslovakia and were considered at the time to be the best quality available. Both men are carrying curved daggers, the famous Yemeni janbiyya, still a marker of a tribesman's social status and identity. And in this case, we can tell the men are from the confederation of Bakil because their sheaths are made of leather, a feature typical of this tribal group. In addition, the man on the left is carrying a shawl and wearing headgear (sumata) that is probably imported from India because of the embroidered design. The flow of textiles from India to Yemen goes on still, and there is a particular colored cloak (sitara) which women use today that is made specifically for the Yemeni market. Finally, it is also worth noting from the photos of the market in 'Amran that both men and women are wearing relatively short skirts that come down to slightly below the knee. This was a population that was still engaged in arduous manual labor and people had to dress practically in order to perform work. At the time, wearing clothes that covered the ankles was considered shameful for social, practical and religious reasons.

Markets are well represented in this book. For instance, page 102 has a photo of the rope market (suq al-salab). In the past, ropes were made locally from palm fronds. Now, however, you can see that the ropes on display are imported and made of multi-colored plastic. On page 150 the items for sale include tobacco in the background and henna and coffee husks (qishr) in the foreground. You can also notice on the next page a money changer's shop and in earlier pages several barber shops. And on page 148 we see a trader offering items in different containers: on the woven platter is a sweet made of sugar cane and sesame seeds; in the metal vessel are sesame seeds, and in the sack a dried fruit called dawm (otherwise known as Hyphaene Thebaica which is native to Egypt).

Some of the most wonderful and arresting photos in this collection are portraits of individuals. These include the photo of two young boys in a barber shop (page 92), and worth noting here is the wonderfully embroidered cap (kufiyya) on the head of one of the boys. In this society, head-dress is an important marker of identity and social status. Another photo is of a boy who proudly sits astride his oversized Japanese bicycle, on page 140; he is wearing sneakers called booty. His prized possession is also covered with colored tape, the fashion among young cyclists then. Yet another wonderful photo is on page 134, which shows two young men and a small boy. The two men wear distinctive clothing, identifying one as being from Sanaa and the other, the one in the colorful skirt, is from Ta'izz, a city in the southern highlands.

The last photographs in the set, of the driver Mahmud and his family, are rare because they bring us inside a Yemeni home, a space that is not usually open to outsiders. These show several generations of a family, including the young wives of what appear to be two brothers. Also, on display is the meal they offered their guests, which includes the traditional dishes of shafut, an appetizer which is made of bread and yoghurt, and bint al-sahn, a sweet desert made of layered dough and served with clarified butter and honey and sprinkled with black seed.

There are many other photographs in this book that are worth discussing, but for reasons of space and time, I have been unable to describe them in detail. Briefly however, some of these photos stand out, such as the village's public water cistern on page 46 with the women on the steps coming to collect this for their households. Another set are the photos of the gardens in Sanaa, Wadi Dahr and al-Rawda, with their qat trees and various other plants and vegetables. On pages 24 and 88, we see stone stanchions in an orchard in al-Rawda, and these were used to create the trellises for the grapevines that grew in these gardens. These stanchions have disappeared since all trellises are now made of metal or wood. On page 22, we have a photo of a lime plasterer (mujassis) in a bosun's chair, and his job was to put a lime coating around windows to waterproof these, a feature that gives Yemeni architecture a very distinctive and aesthetically pleasing look.

This book of photographs is truly wonderful, especially for someone like me who is passionate about Yemen's history and people. It captures the spectacular landscapes, the fortified hilltop villages and towns, the diversity of architecture and, most touchingly, offers a real feeling for the Yemenis, of different ages, genders and professions. At a time when this beautiful country is experiencing war and a major humanitarian catastrophe, and with so much suffering and destruction, the book in your hands is a valuable contribution as well as a testament to Yemen's rich culture and breathtaking beauty.

Bernard Haykel, Princeton University

[1] For an example of the glossy representation of Yemen at this time see Simon Jargy and Alain Saint Hilaire, Yémen avec les Montagnards de La Mer Rouge, Lausanne: Editions Mondo S.A. and Paris: Hachette Réalités, 1978.

[2] See the destroyed armored vehicles on p. 57.

[3] Cf. https://whc.unesco.org/en/list/385/

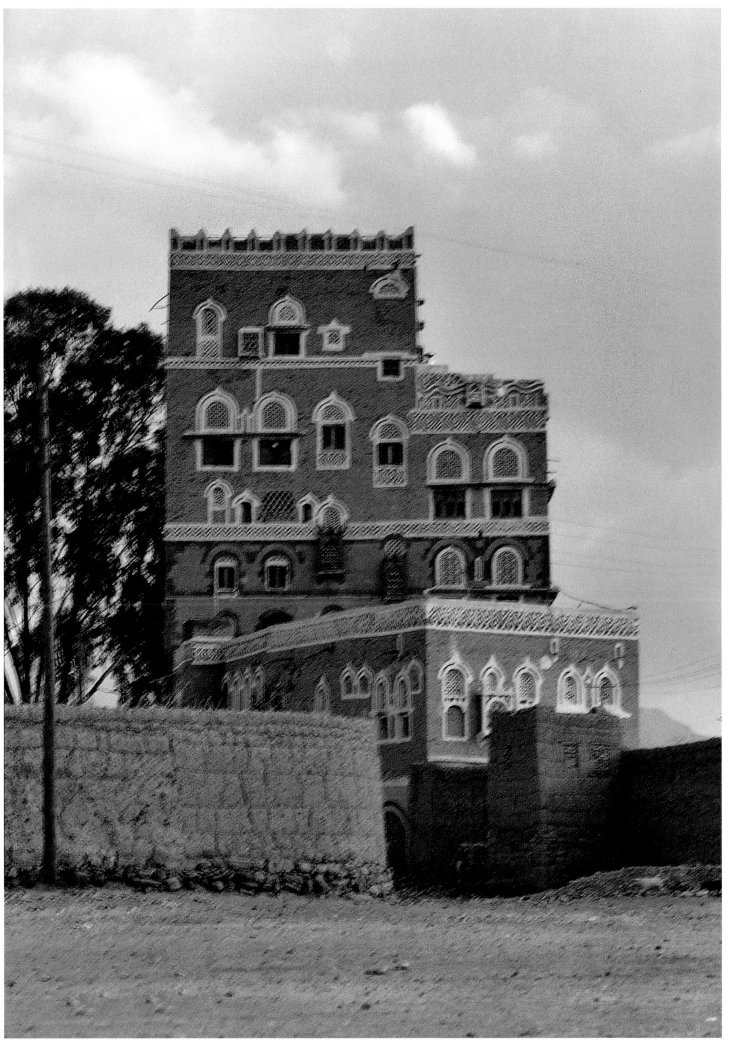

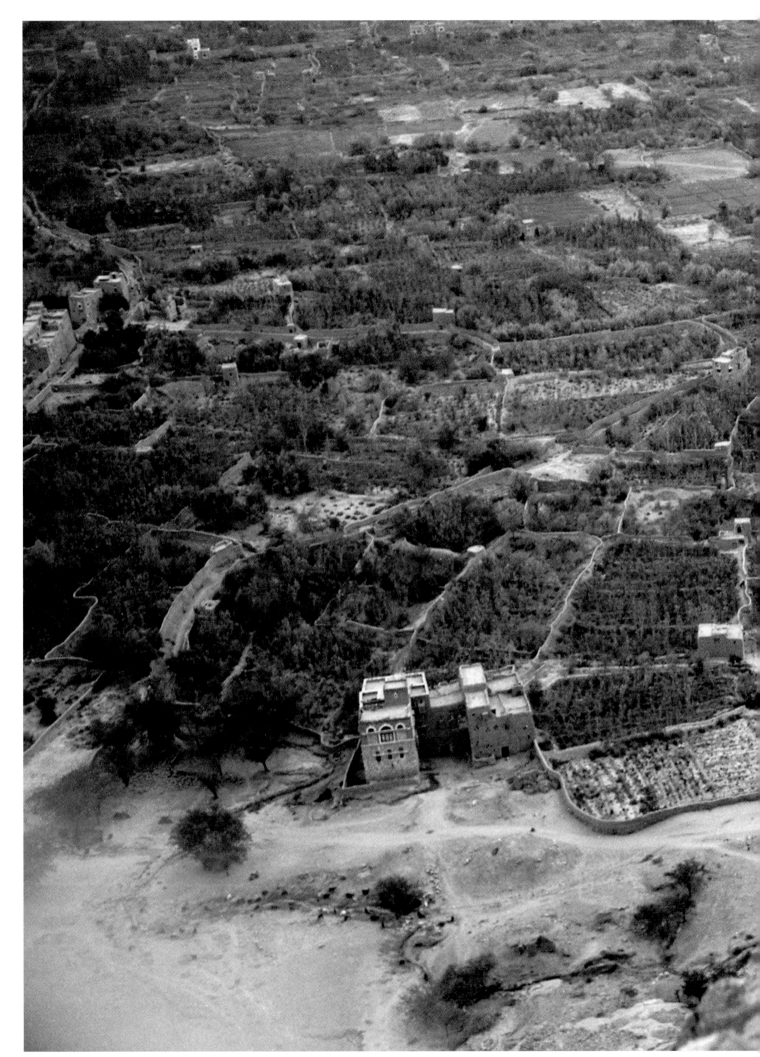

WADI DAHR

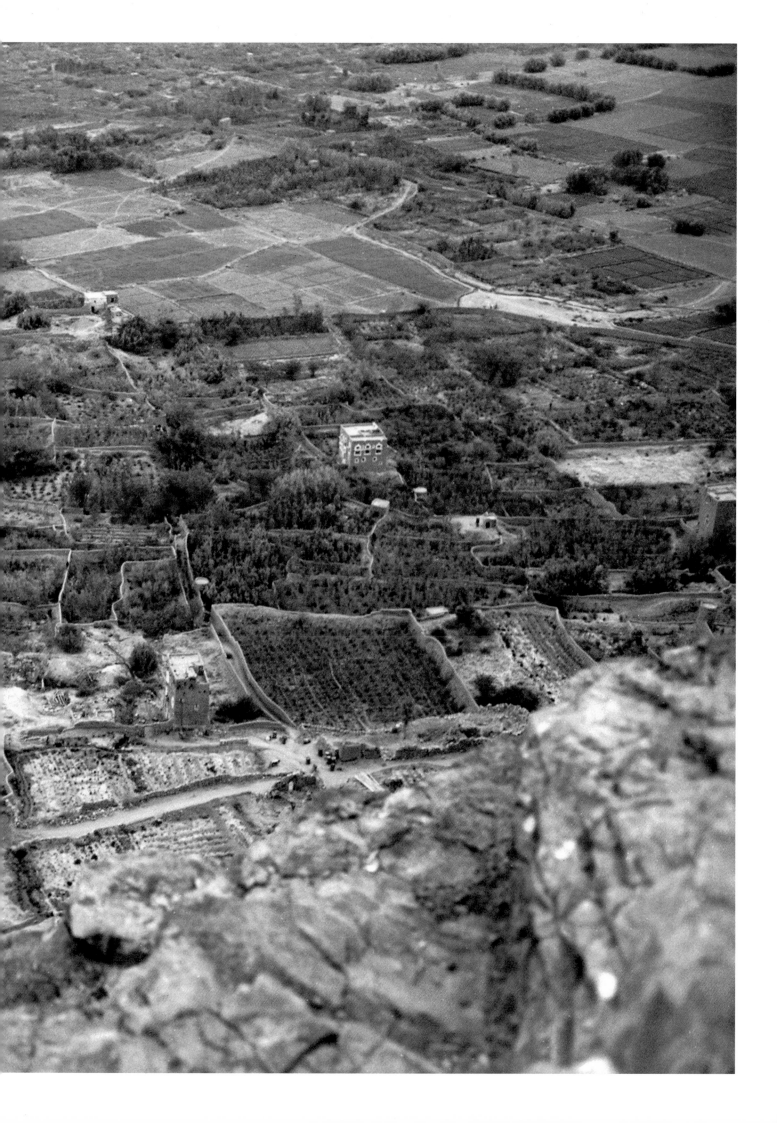

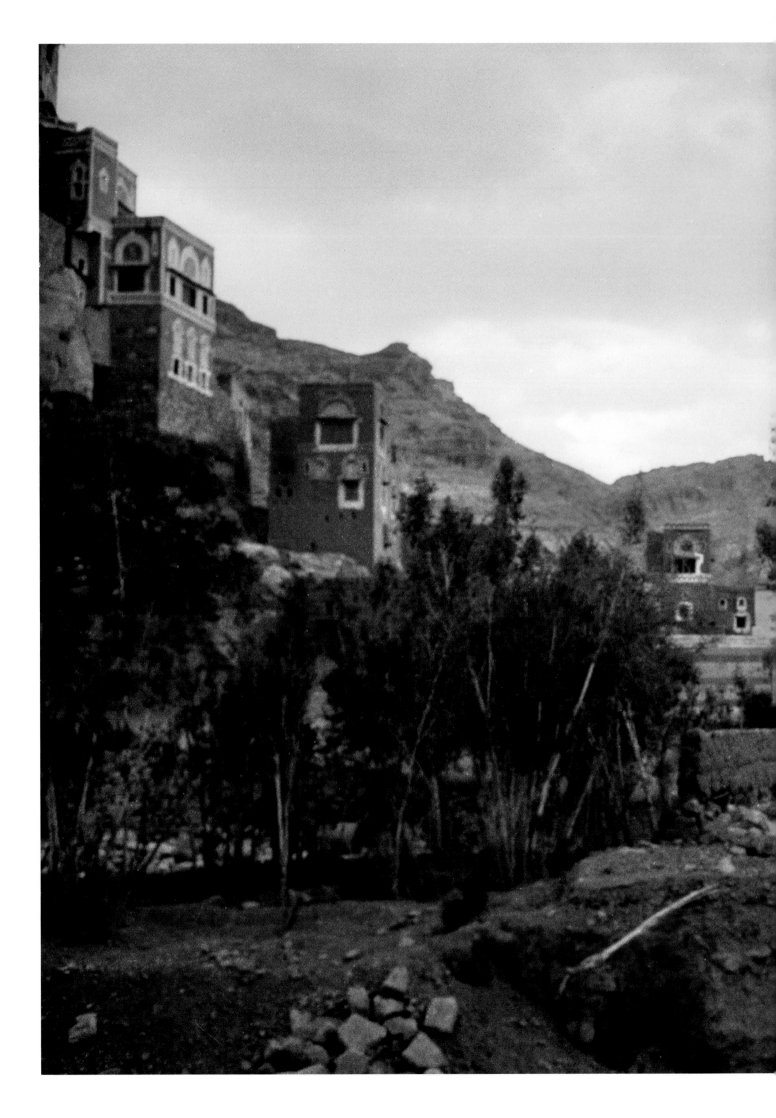

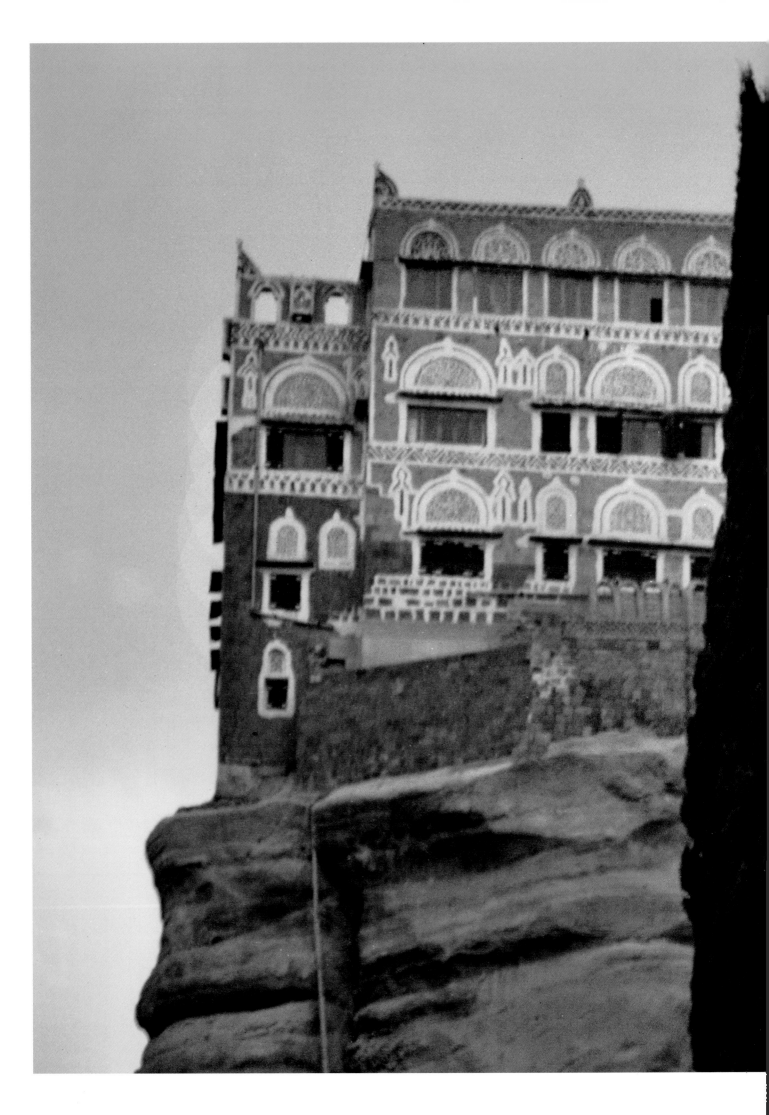

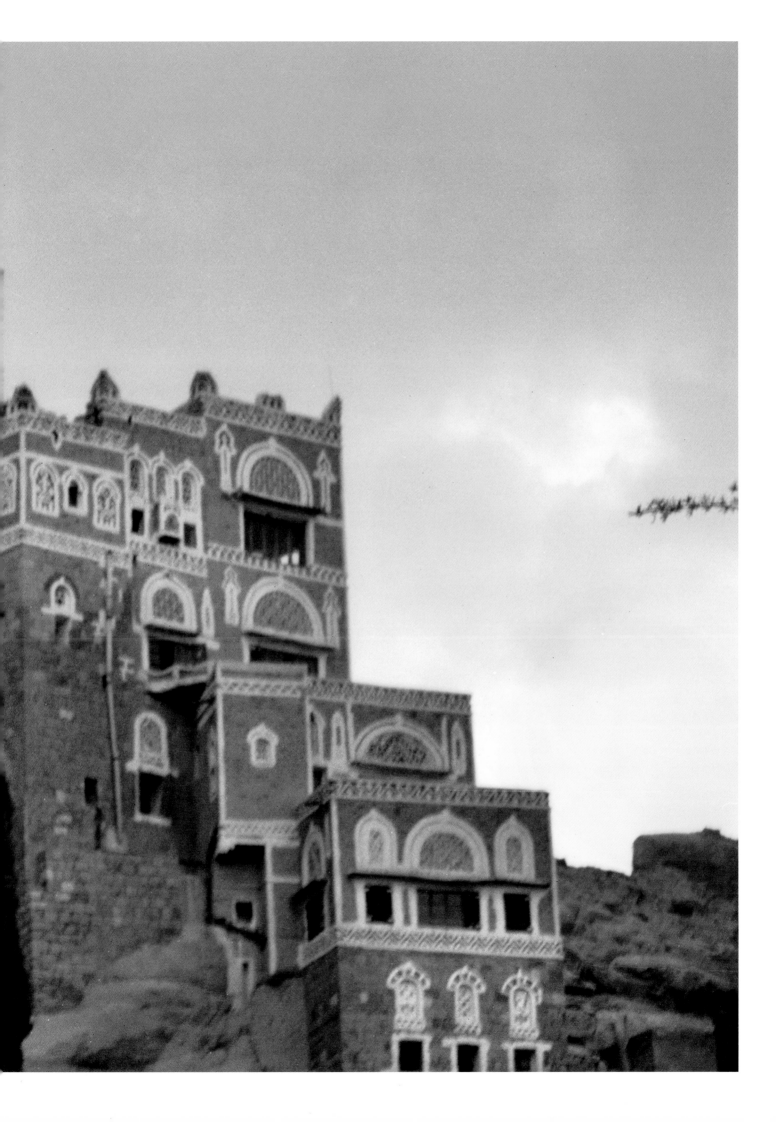

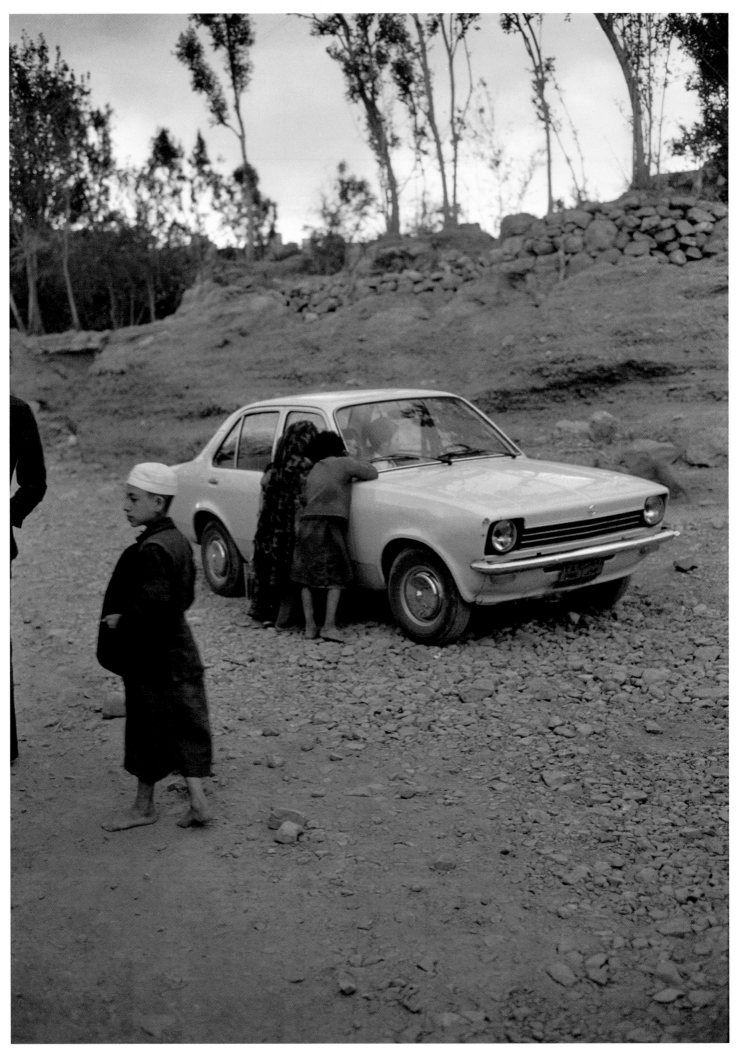

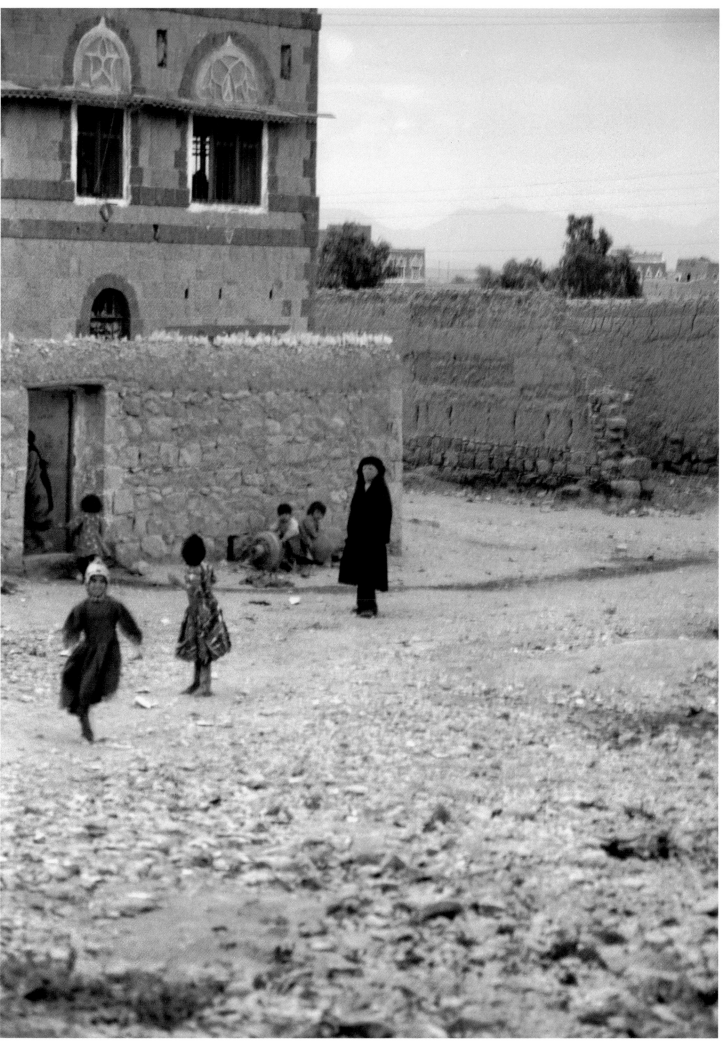

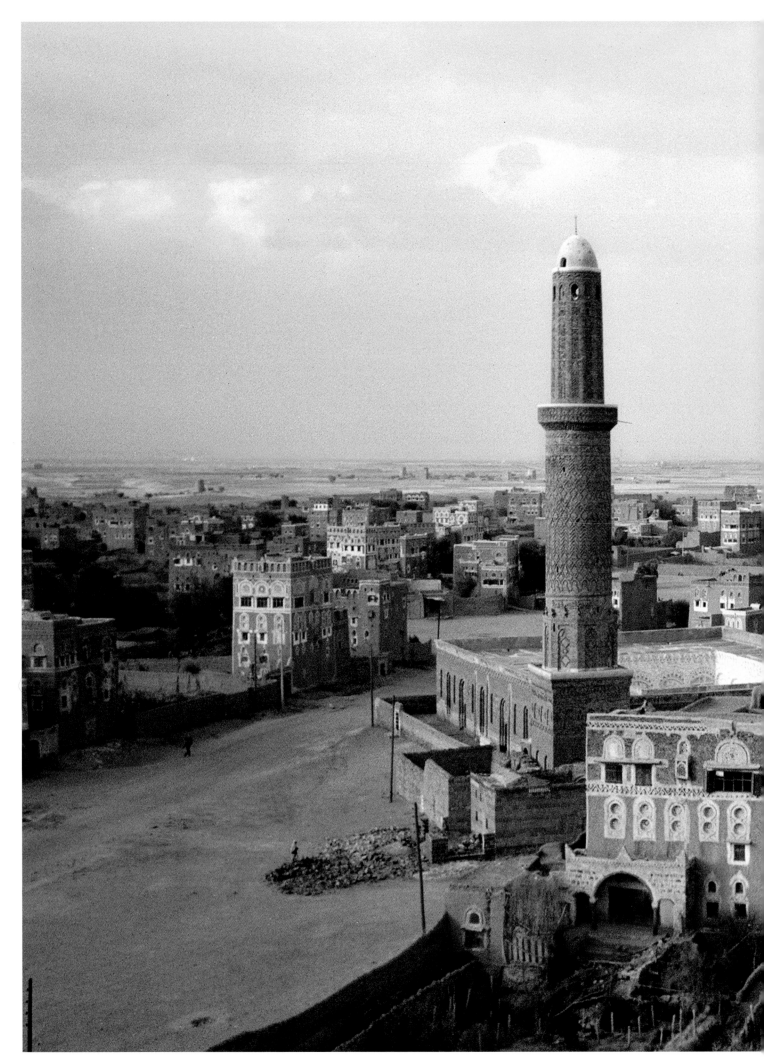

AL-RAWDA

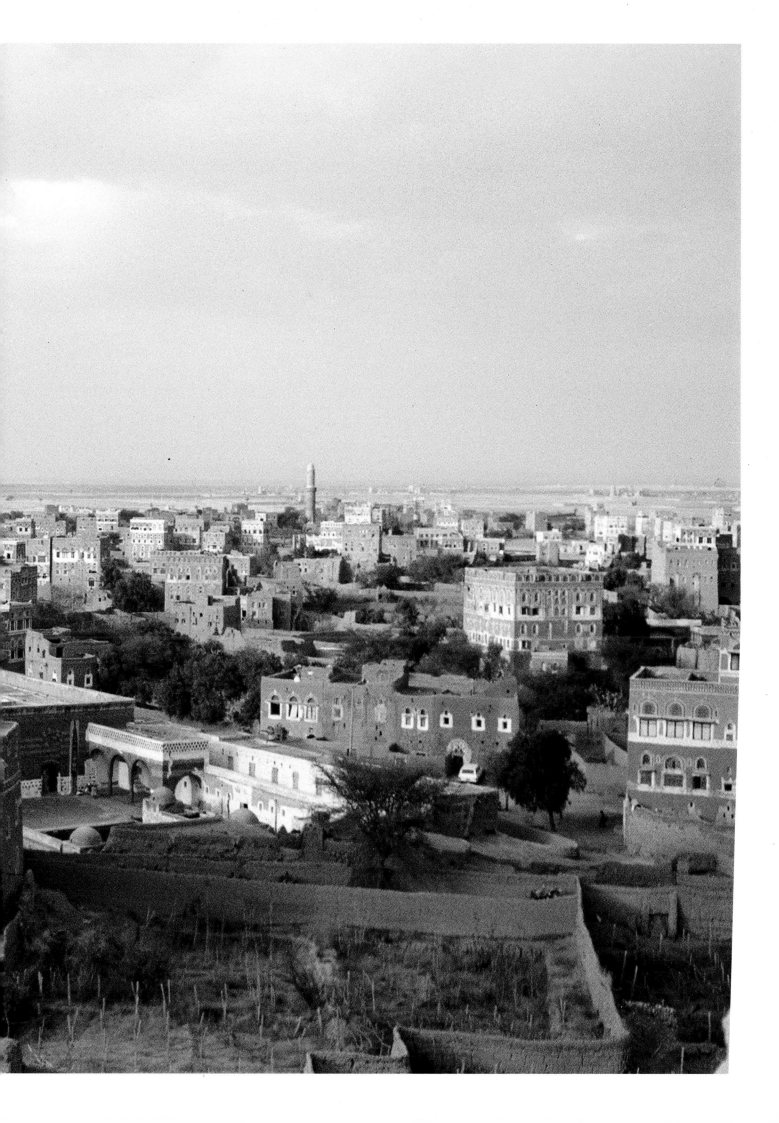

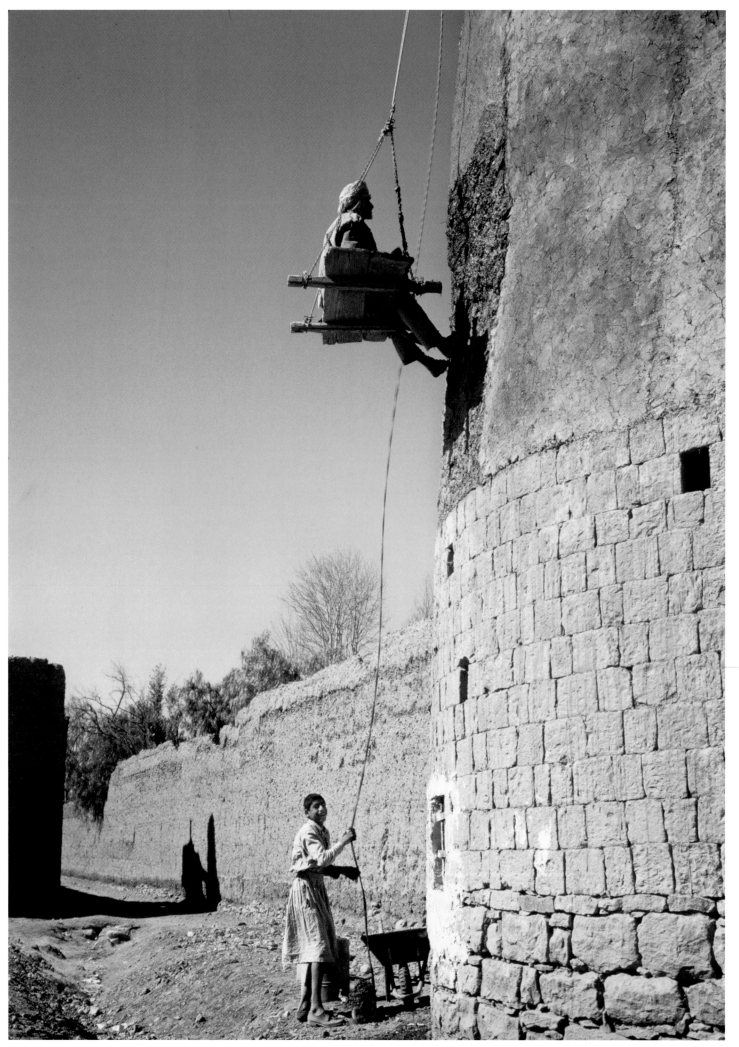

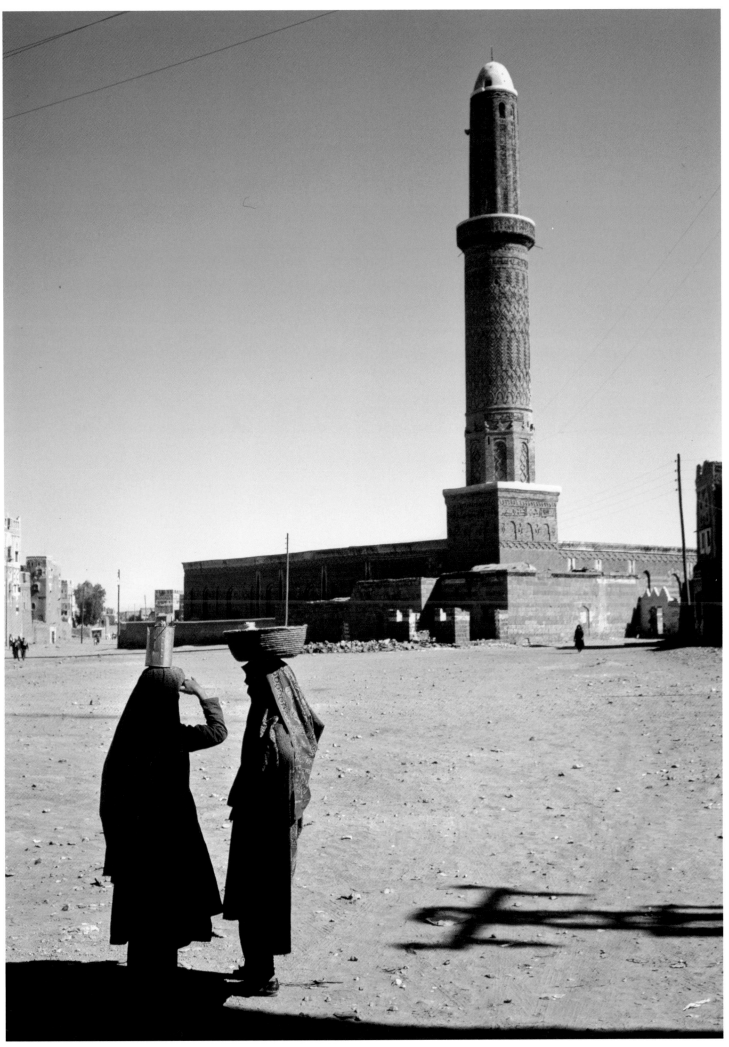

24

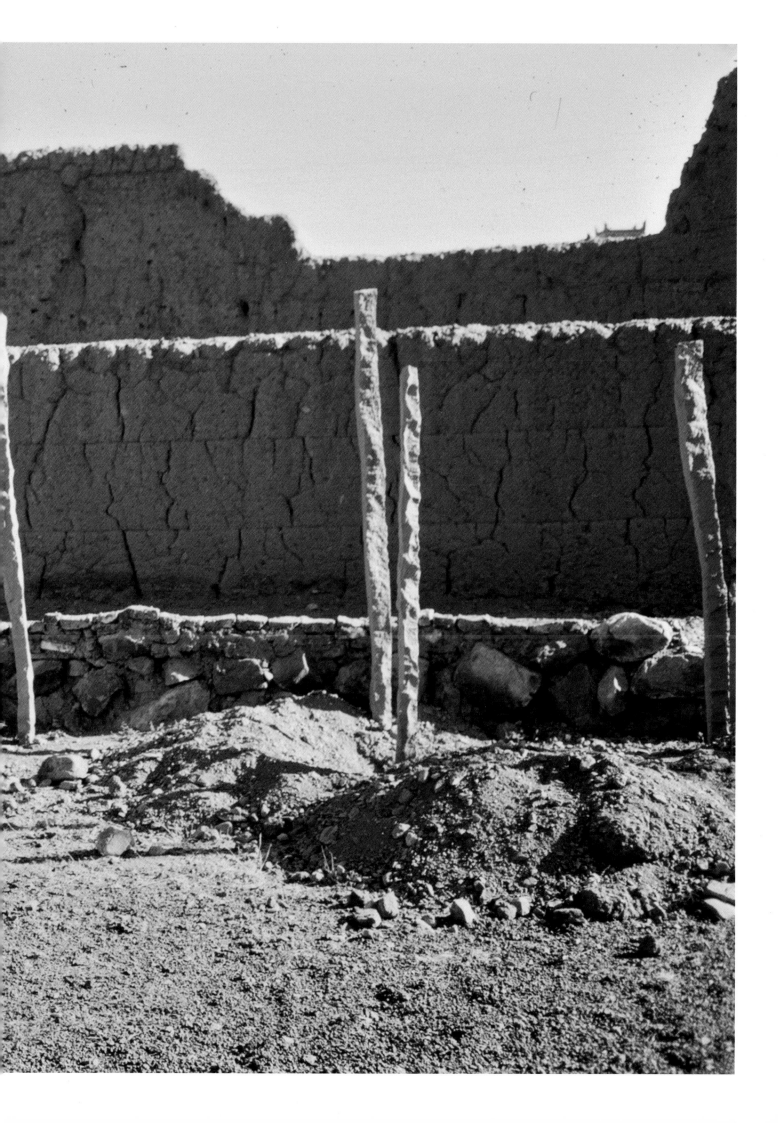

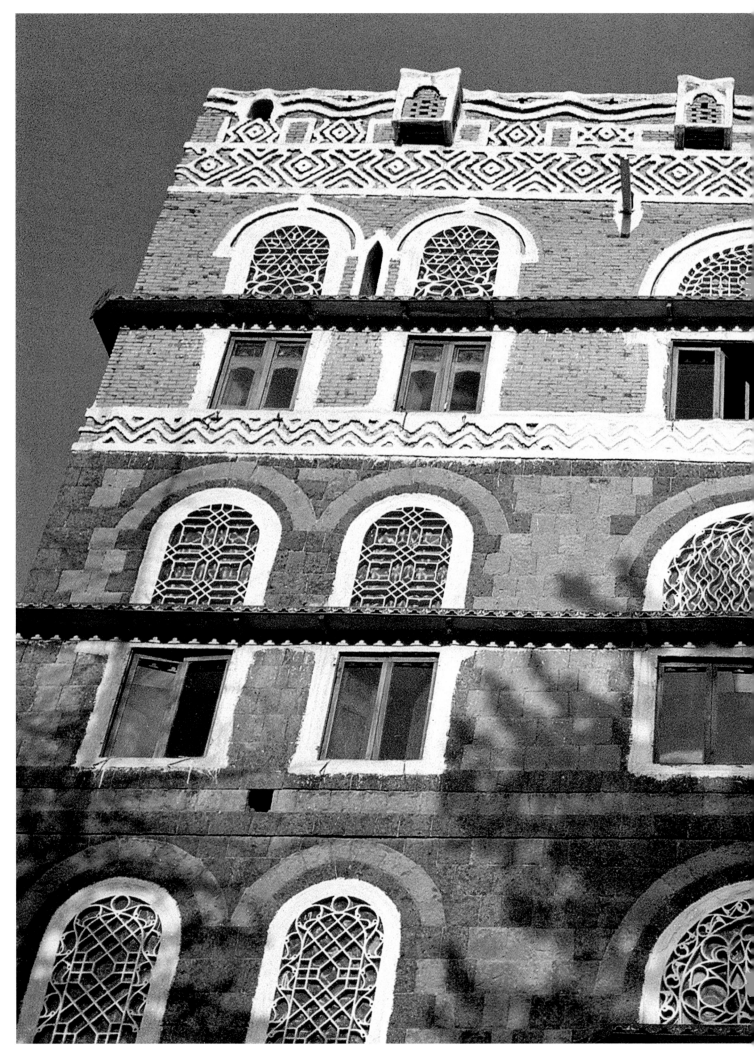

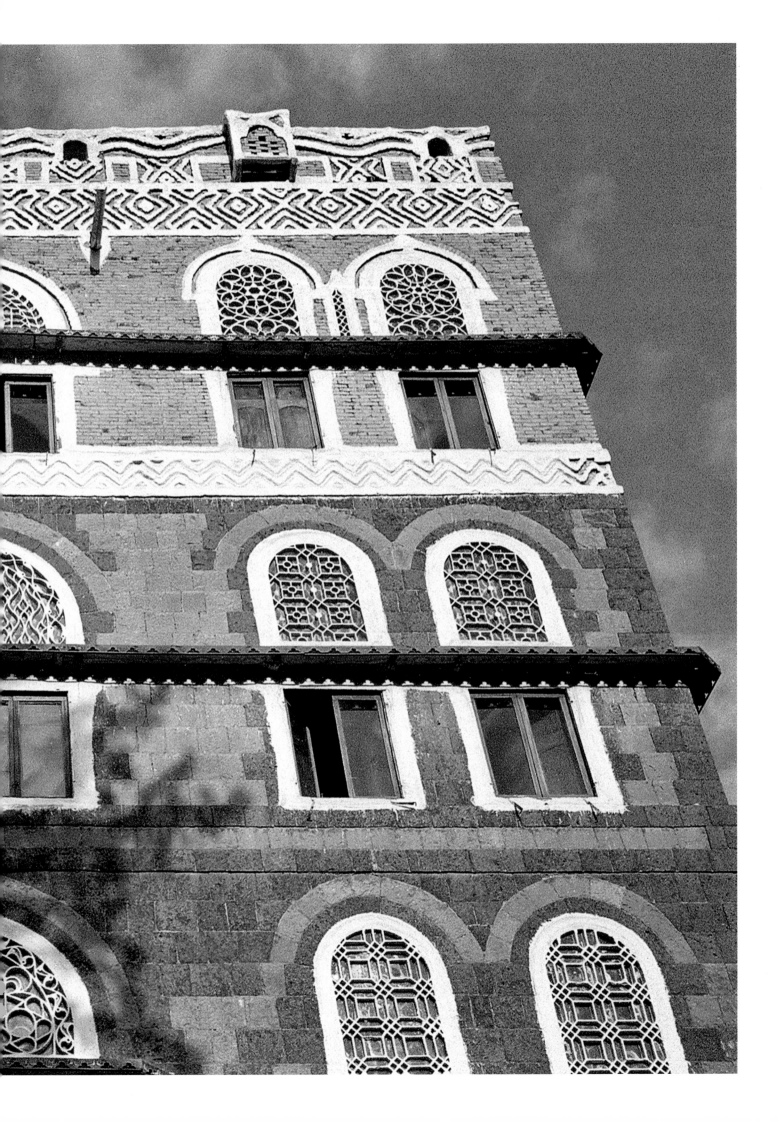

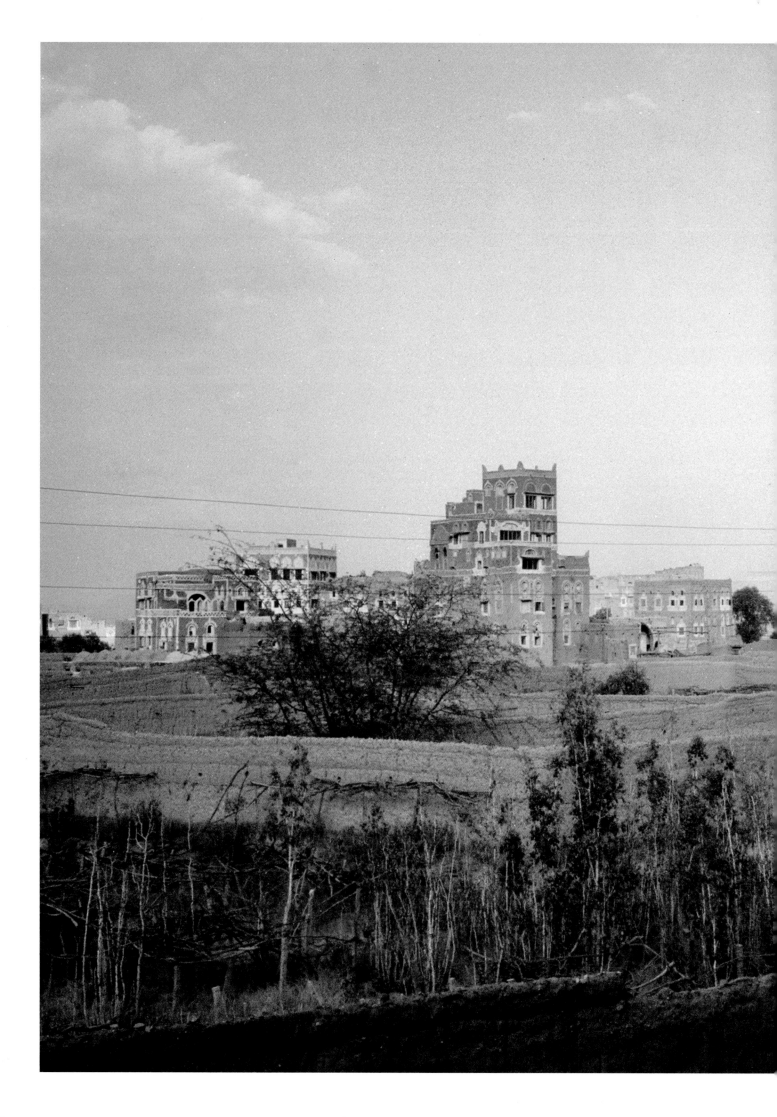

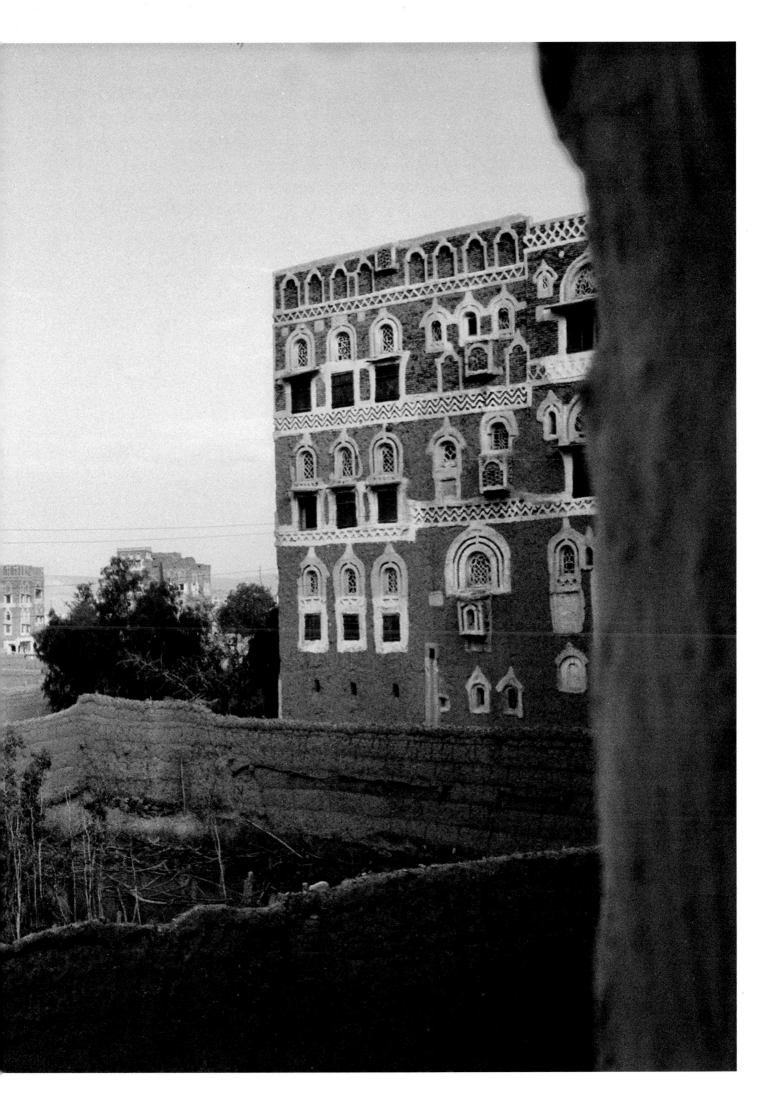

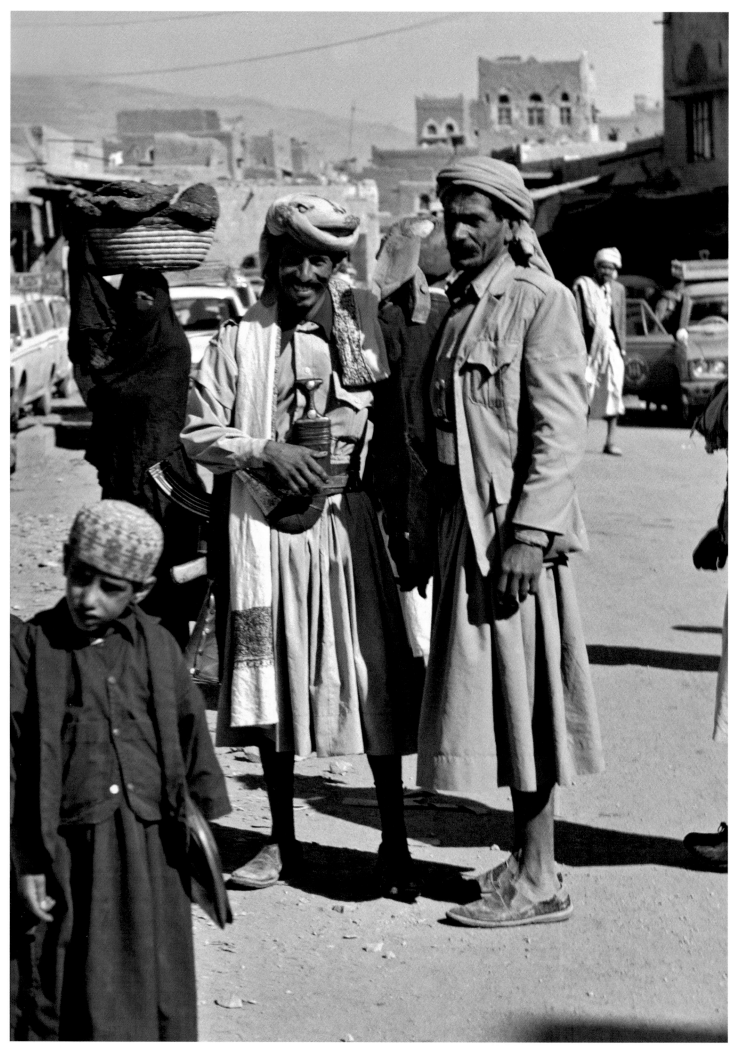

'AMRAN

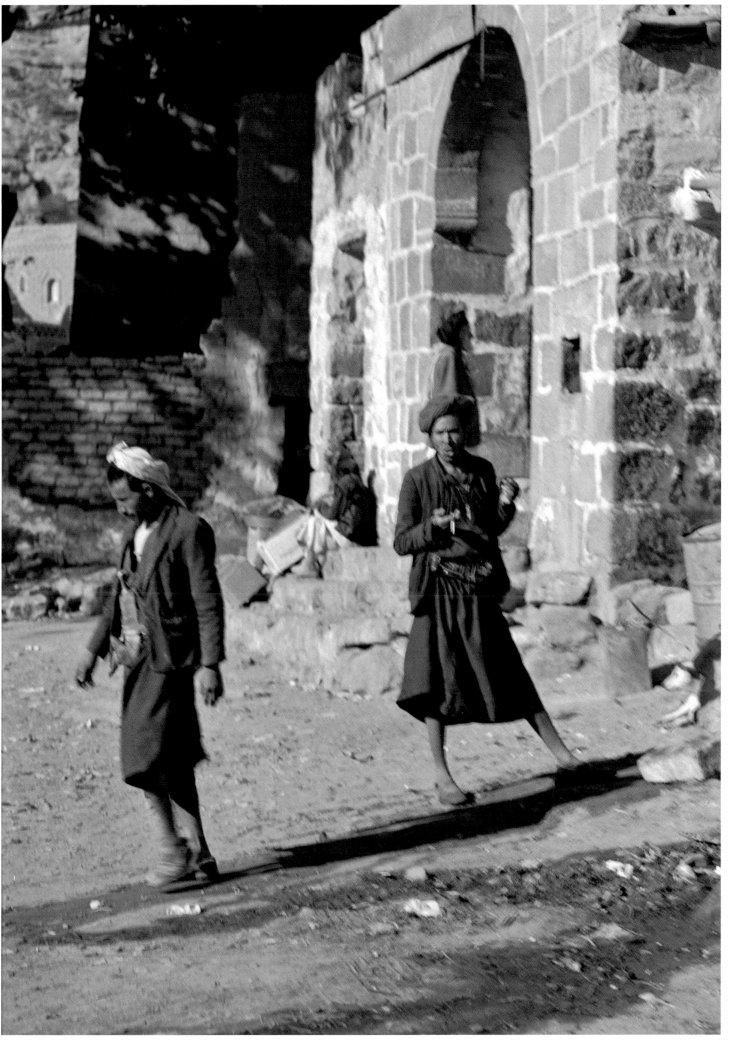

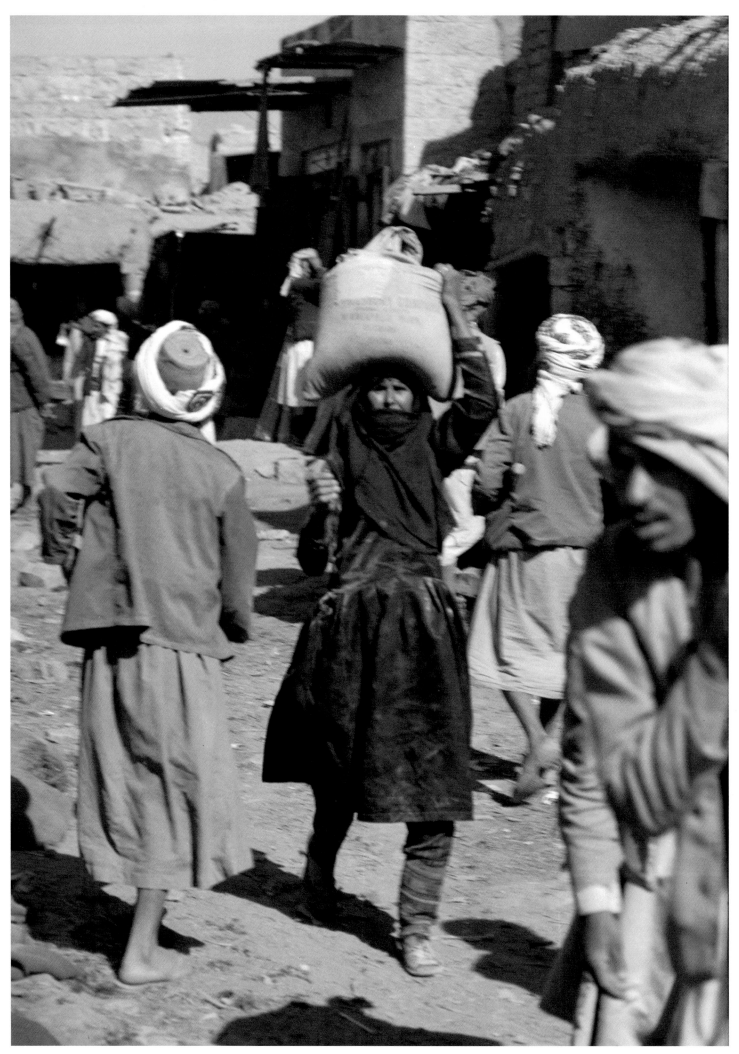

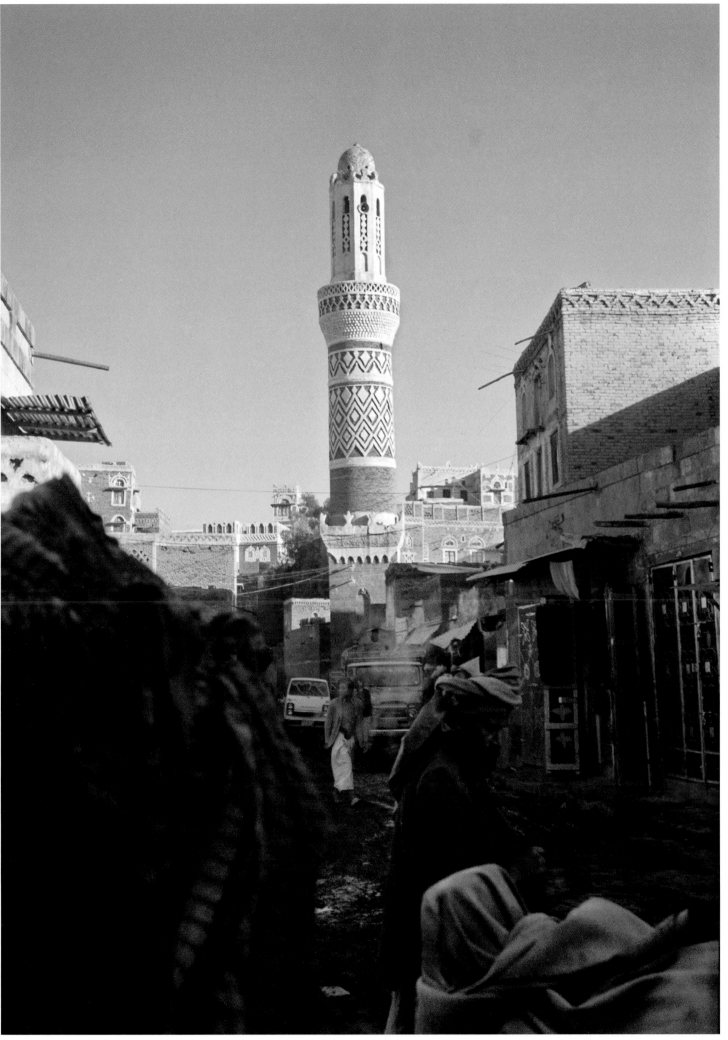

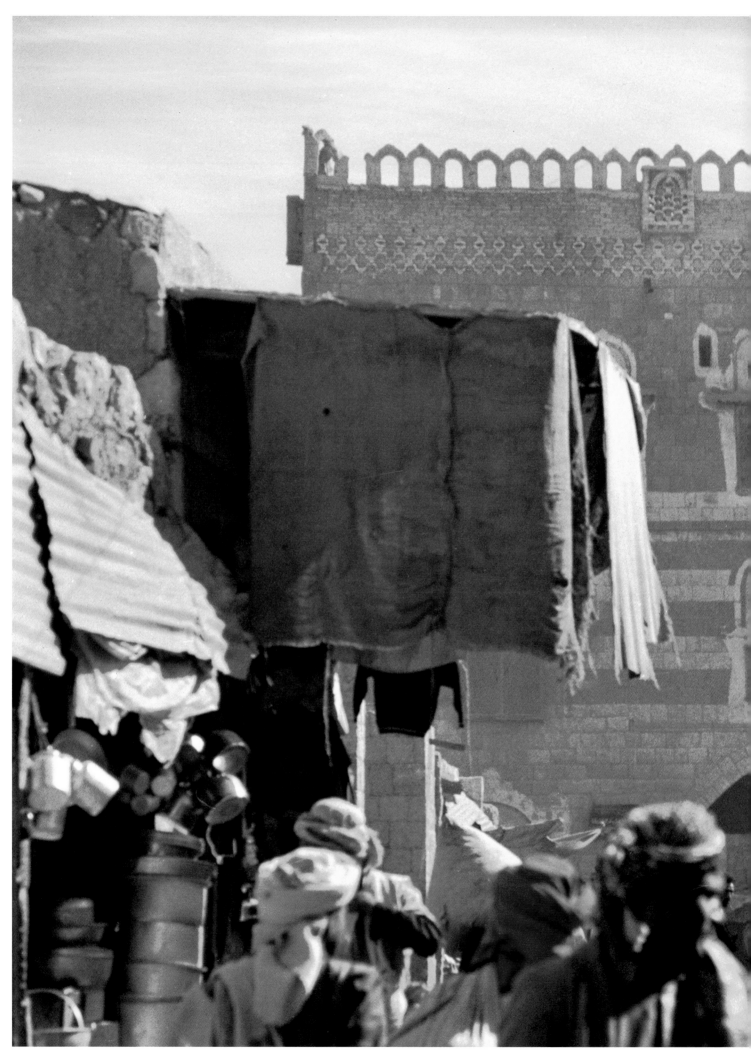

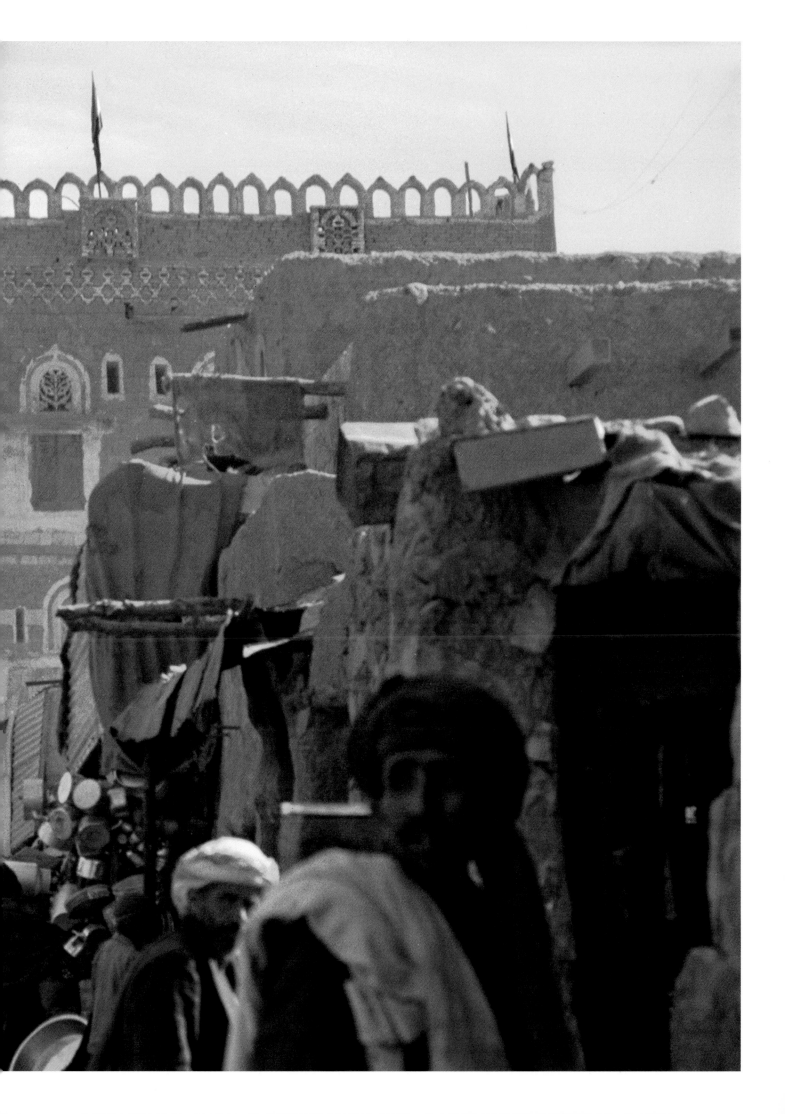

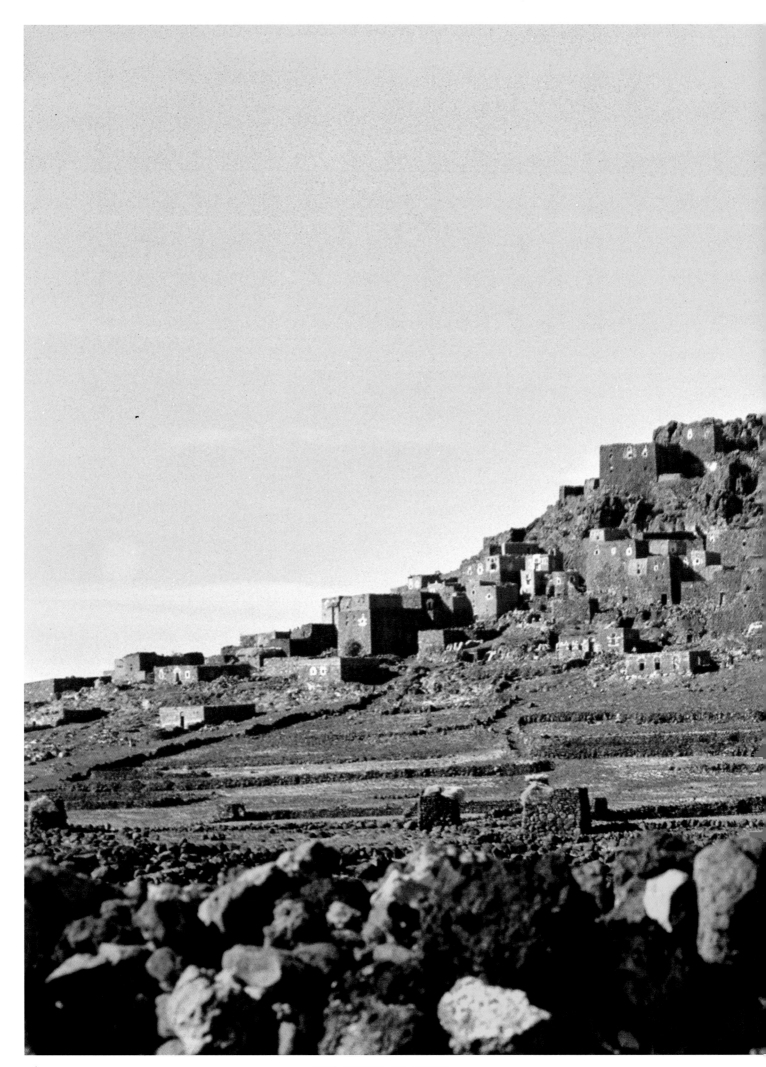

THE DRIVE TO SA'DA

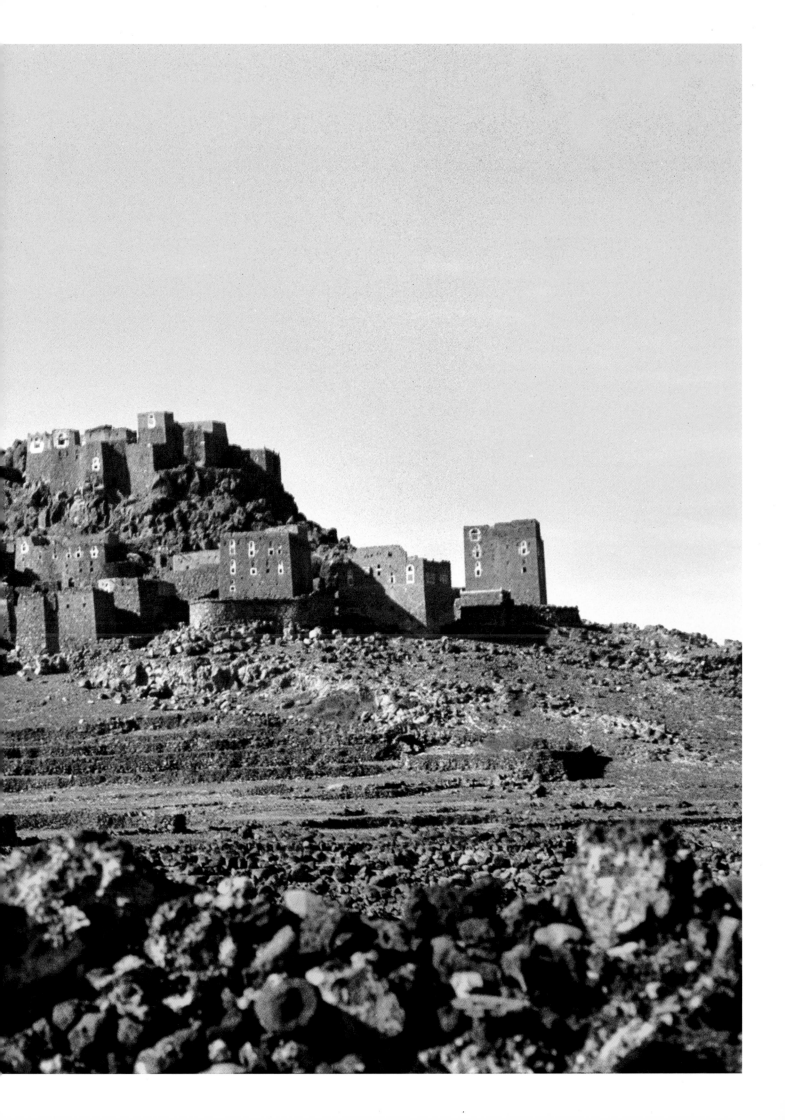

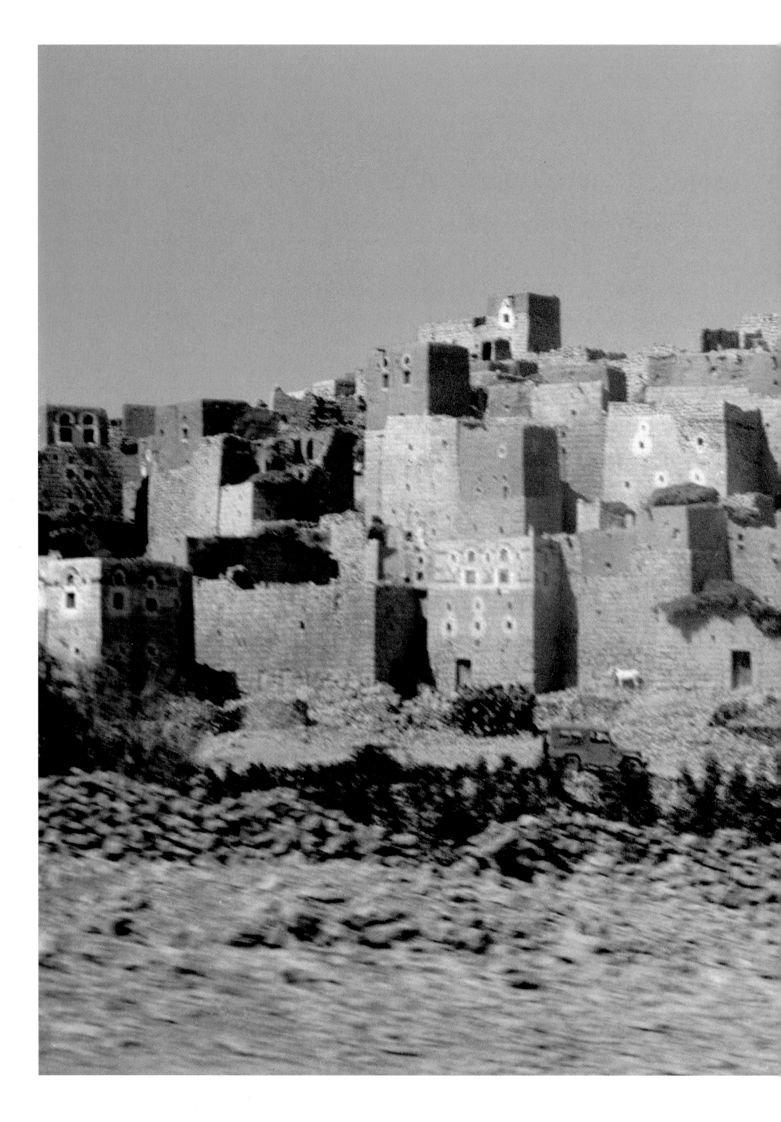

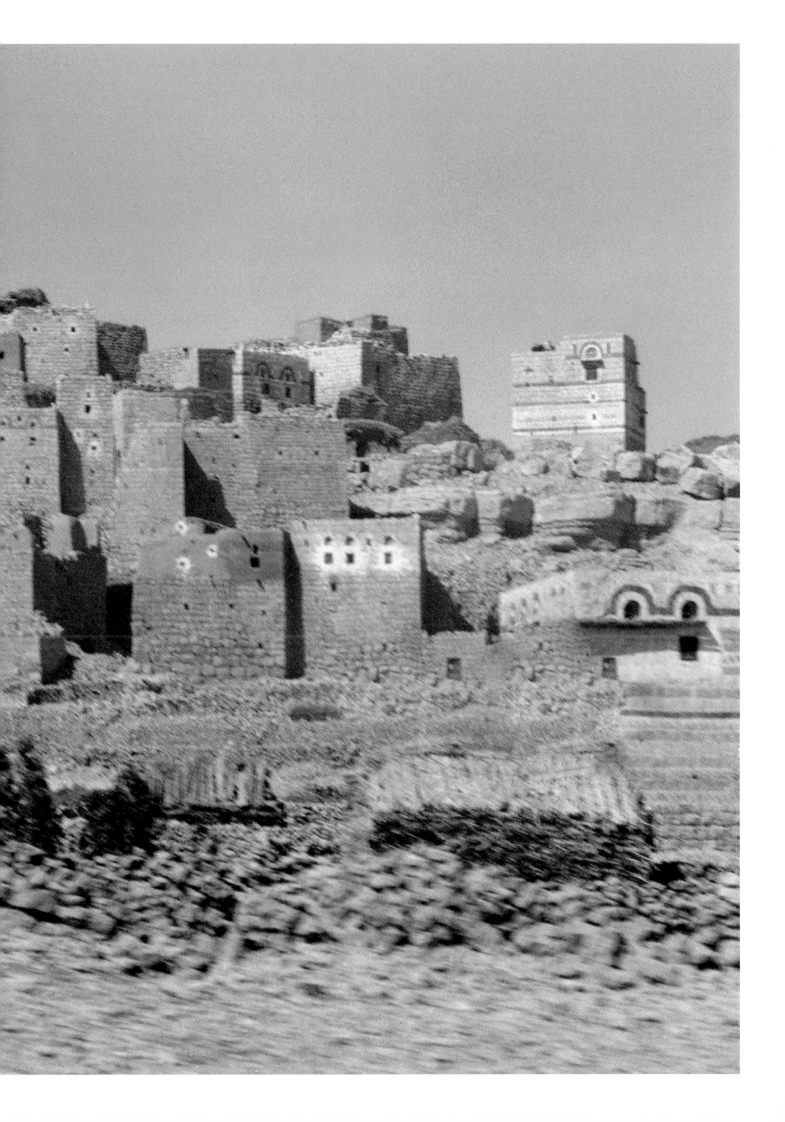

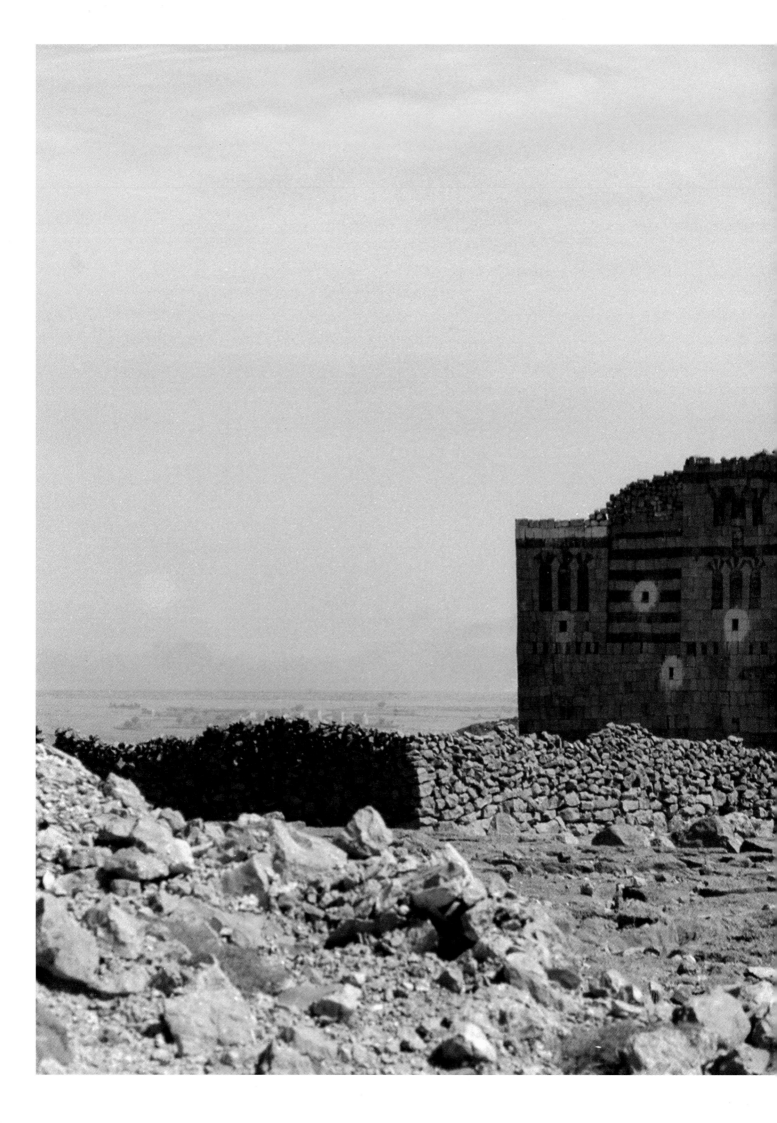

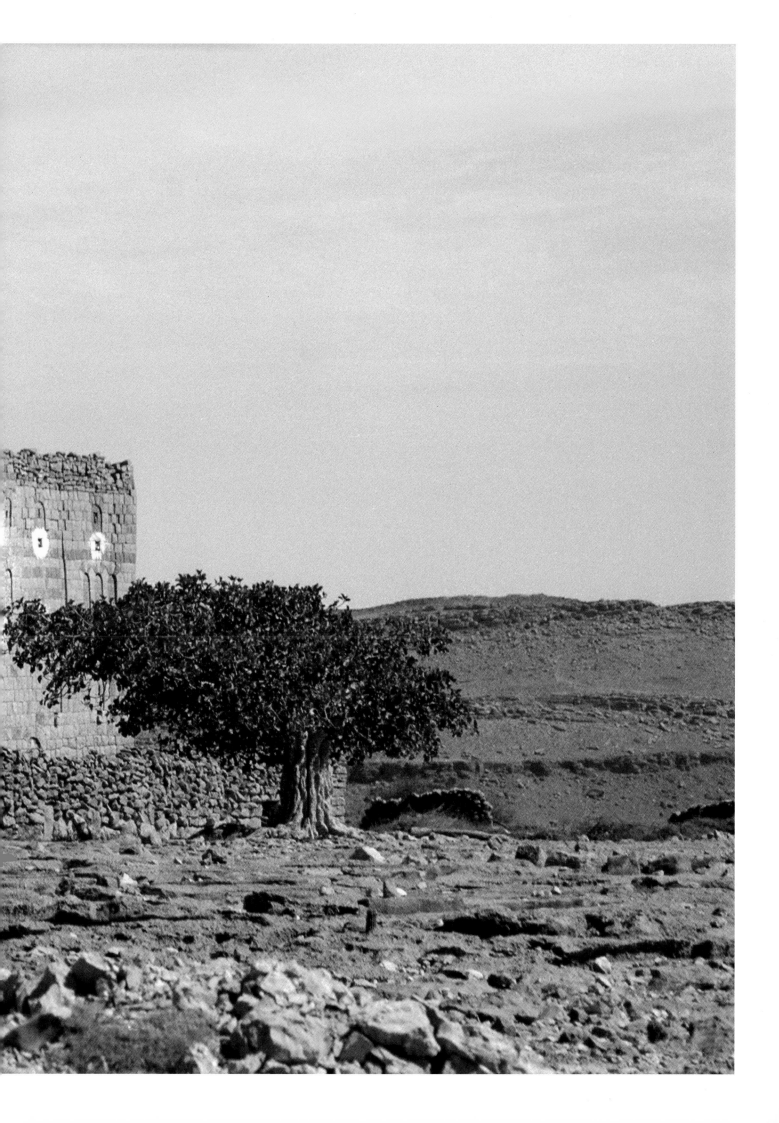

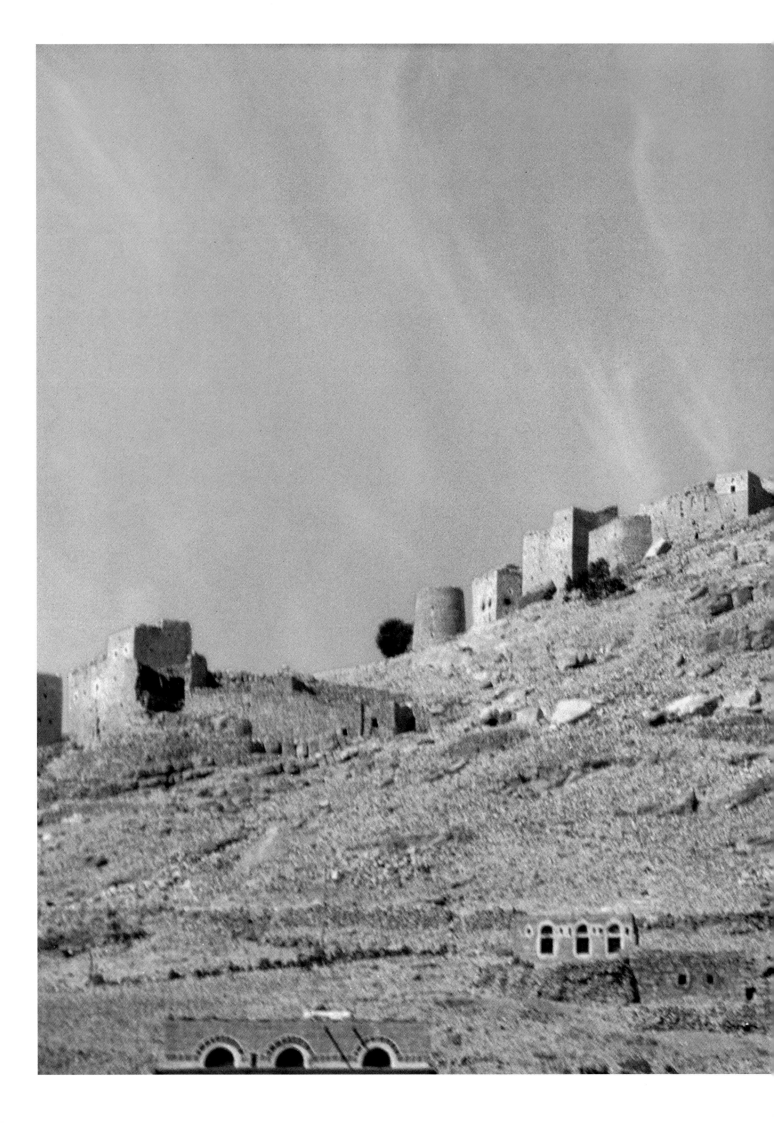

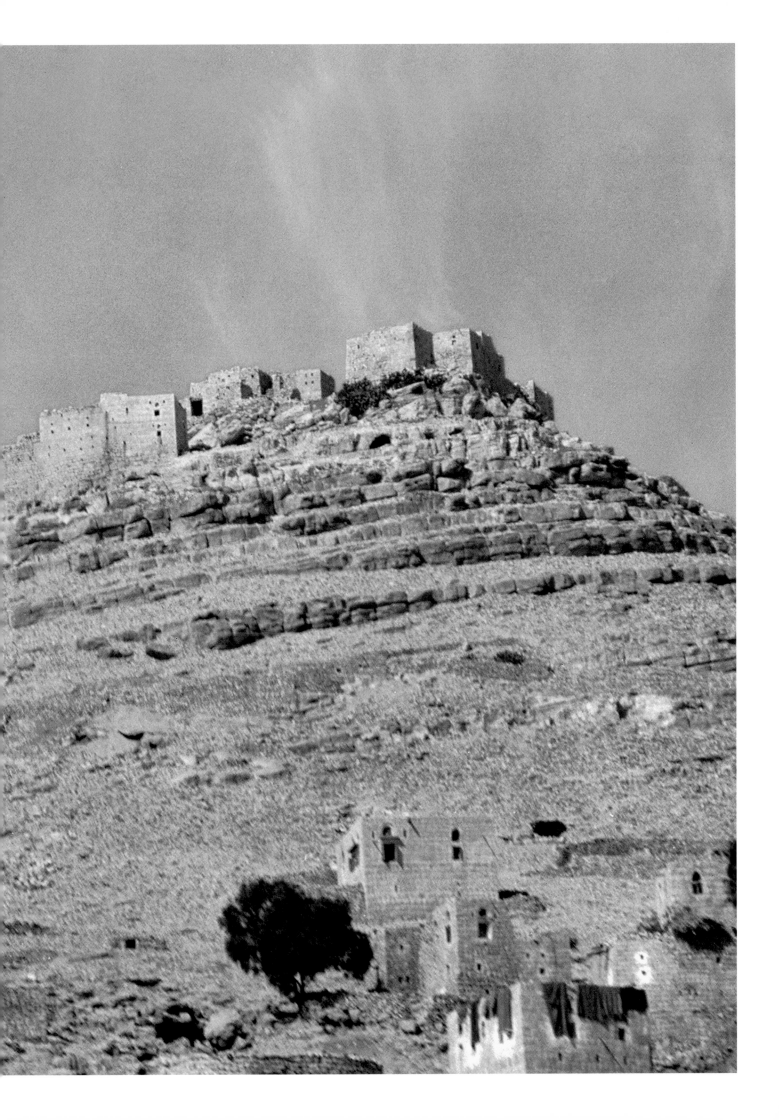

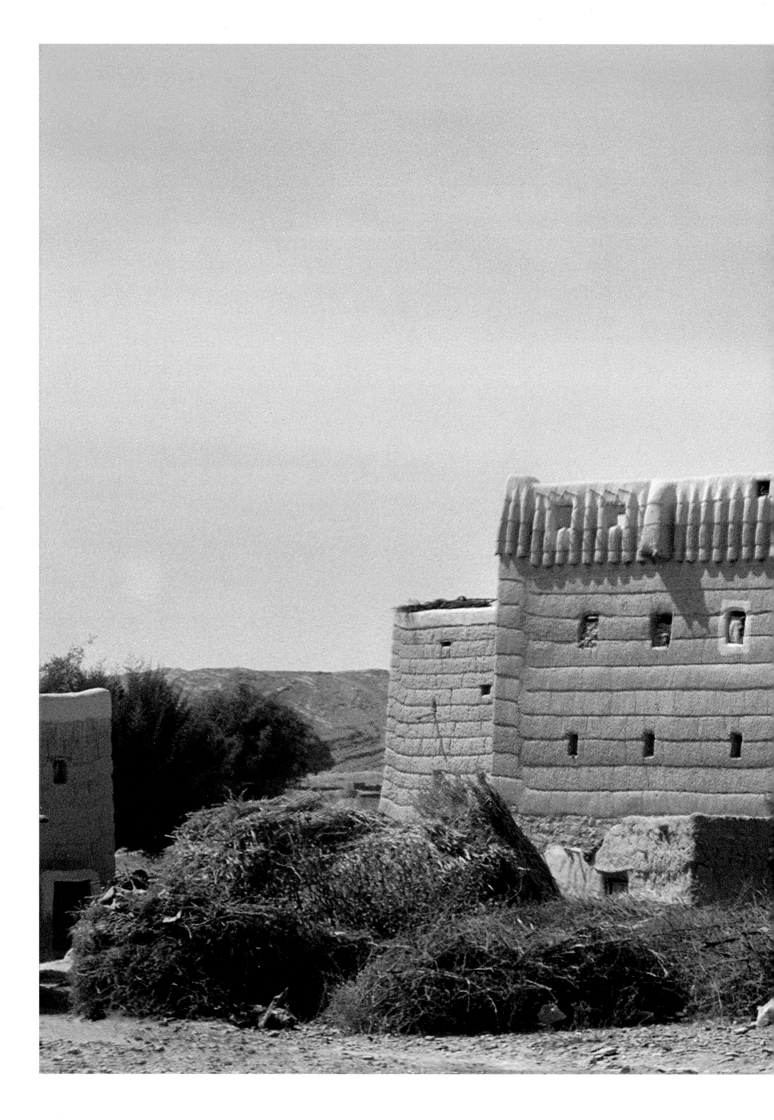

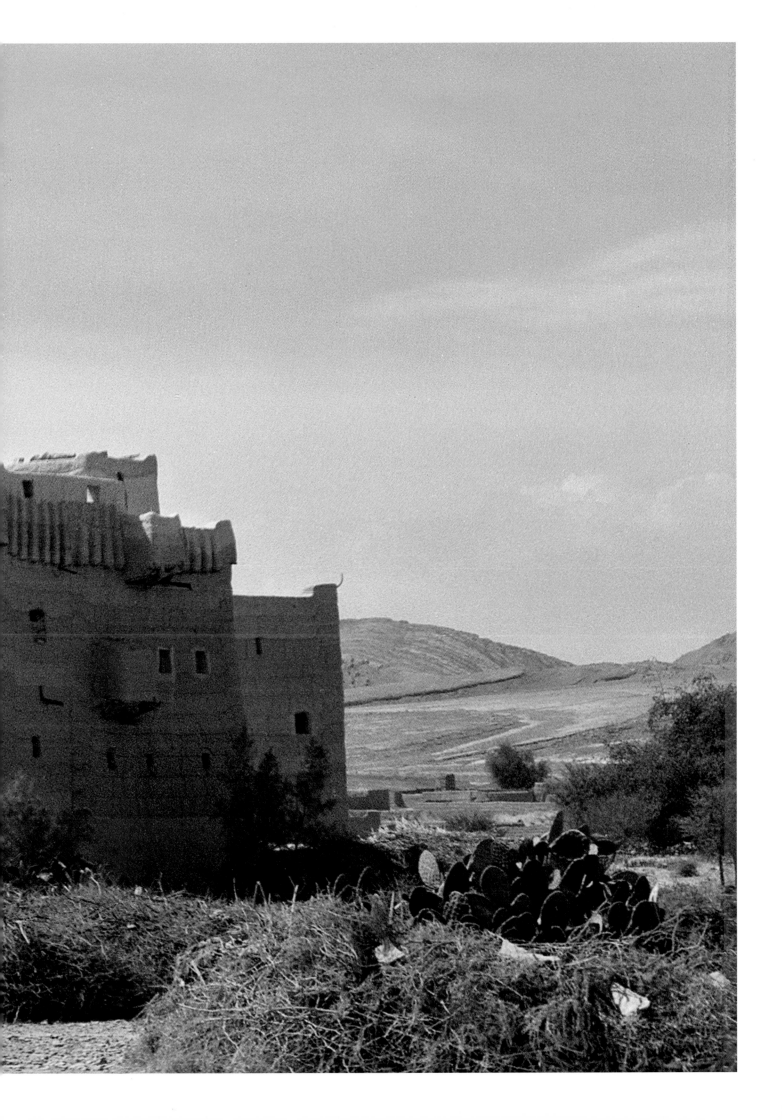

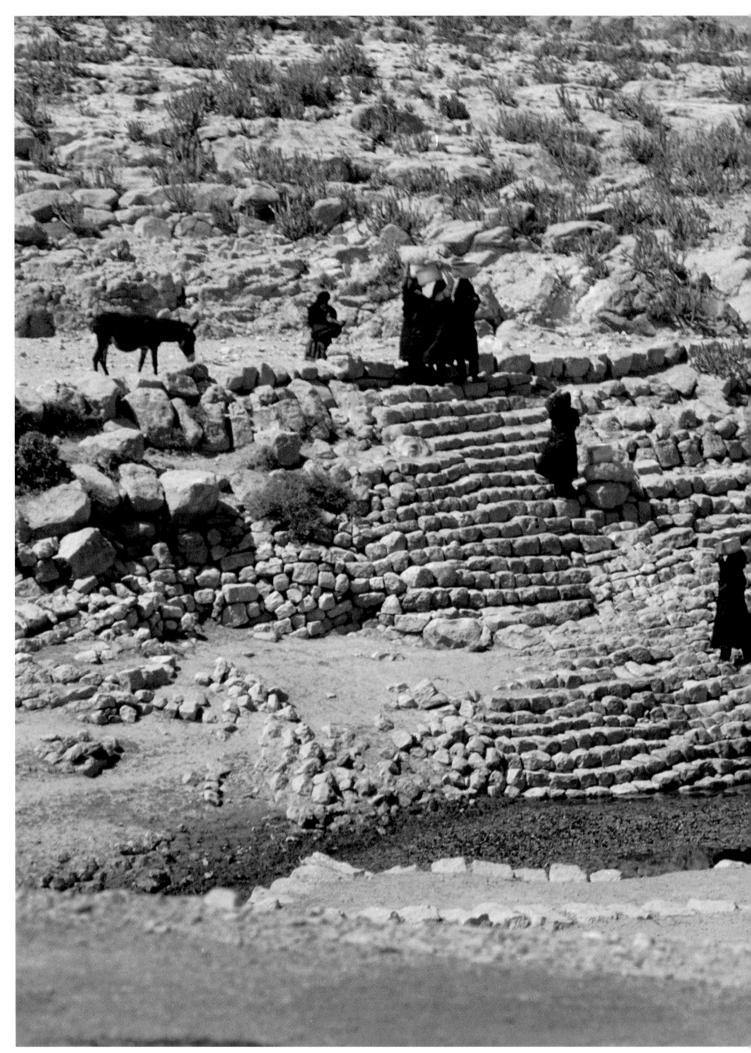

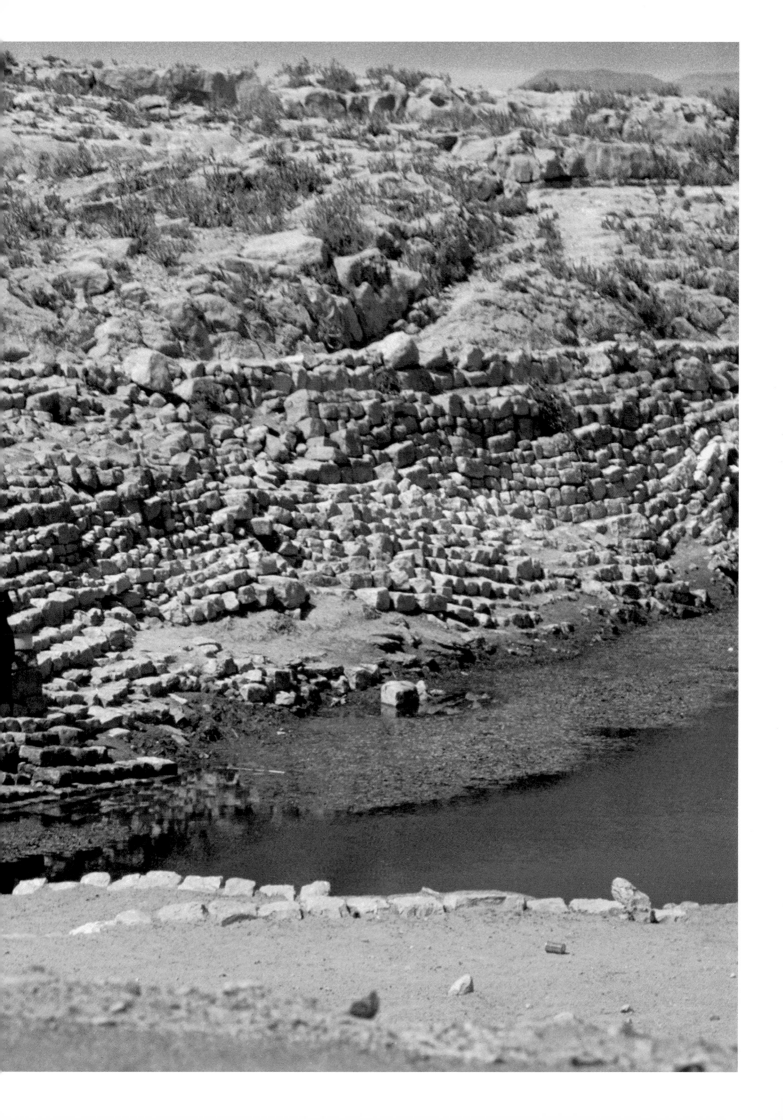

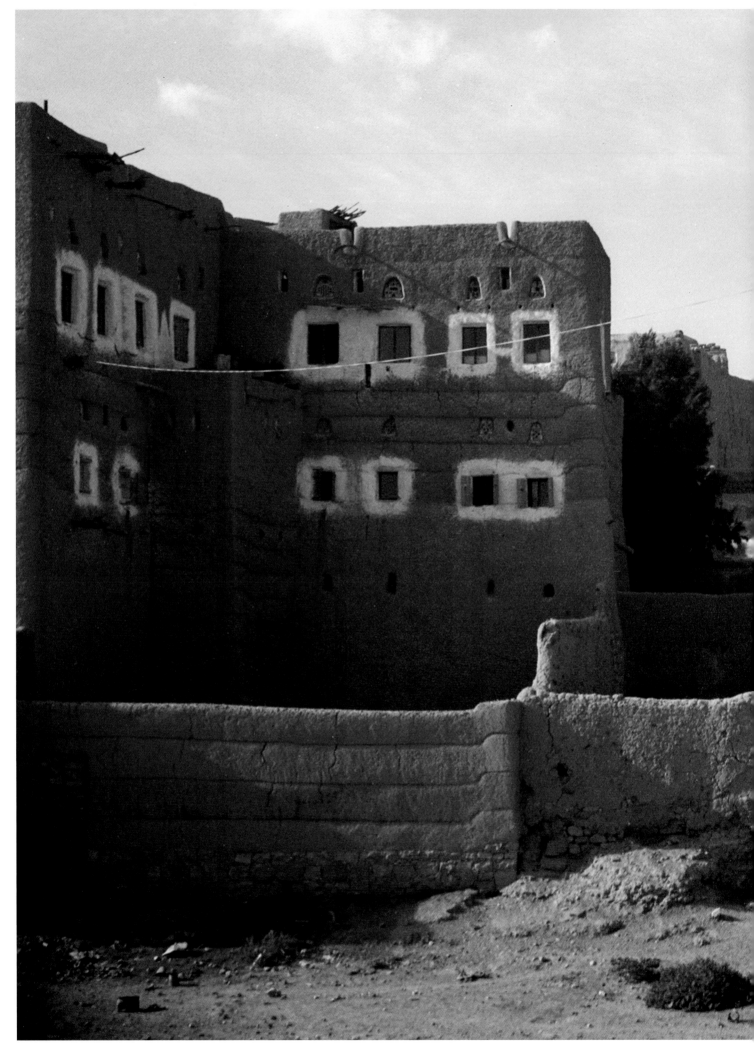

SA´DA

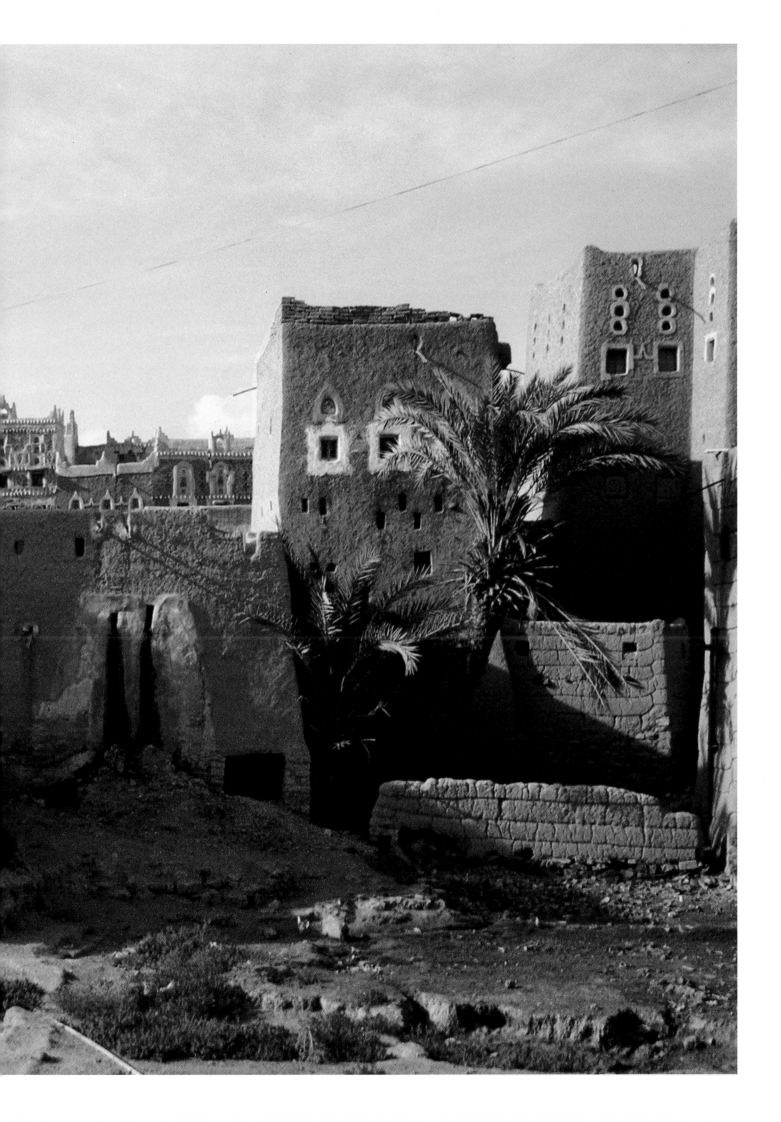

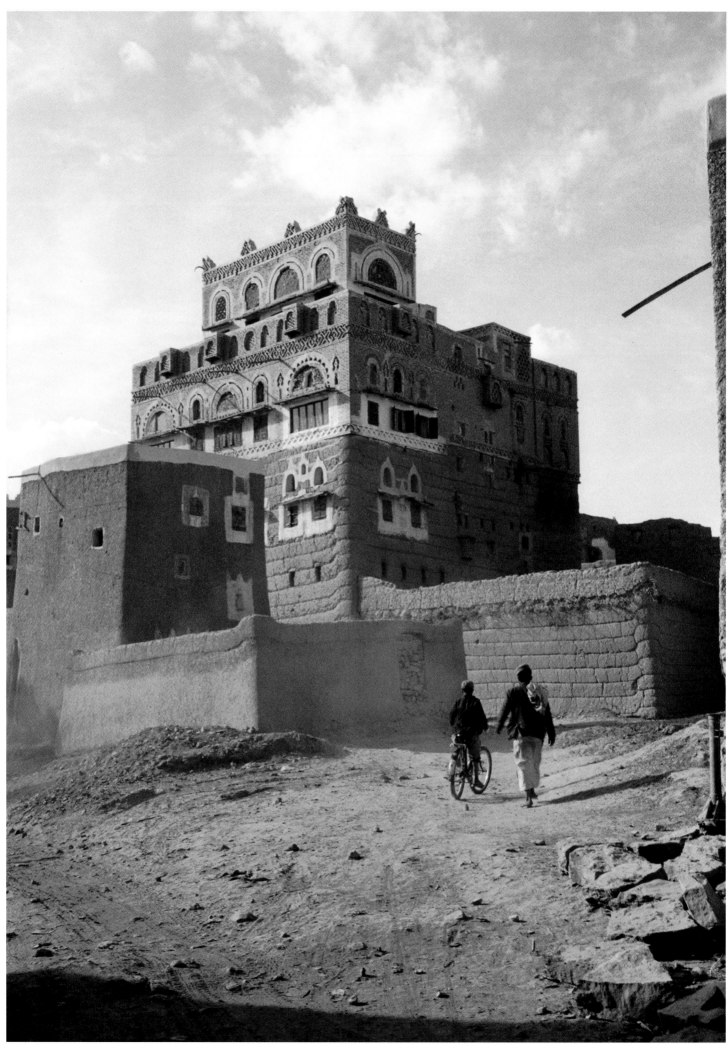

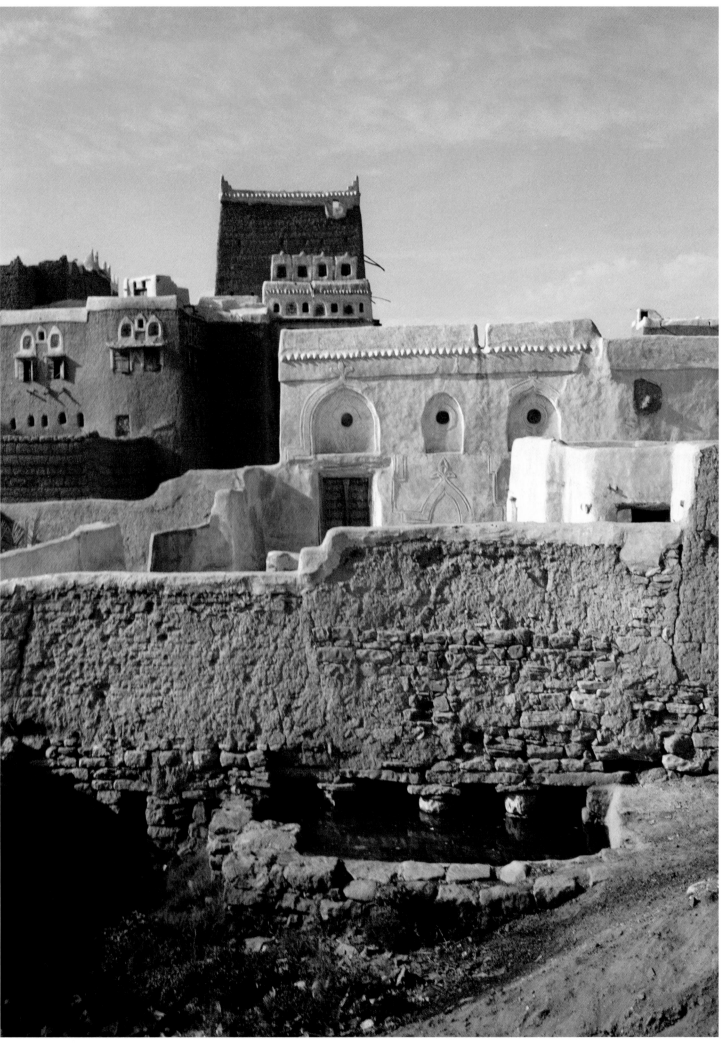

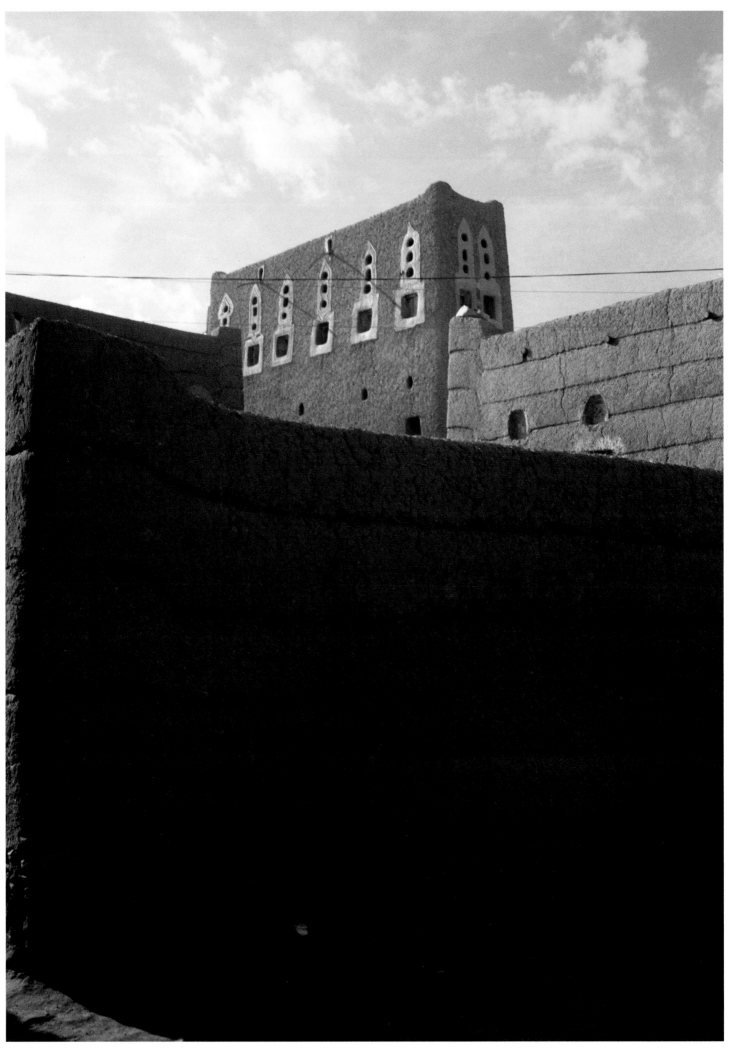

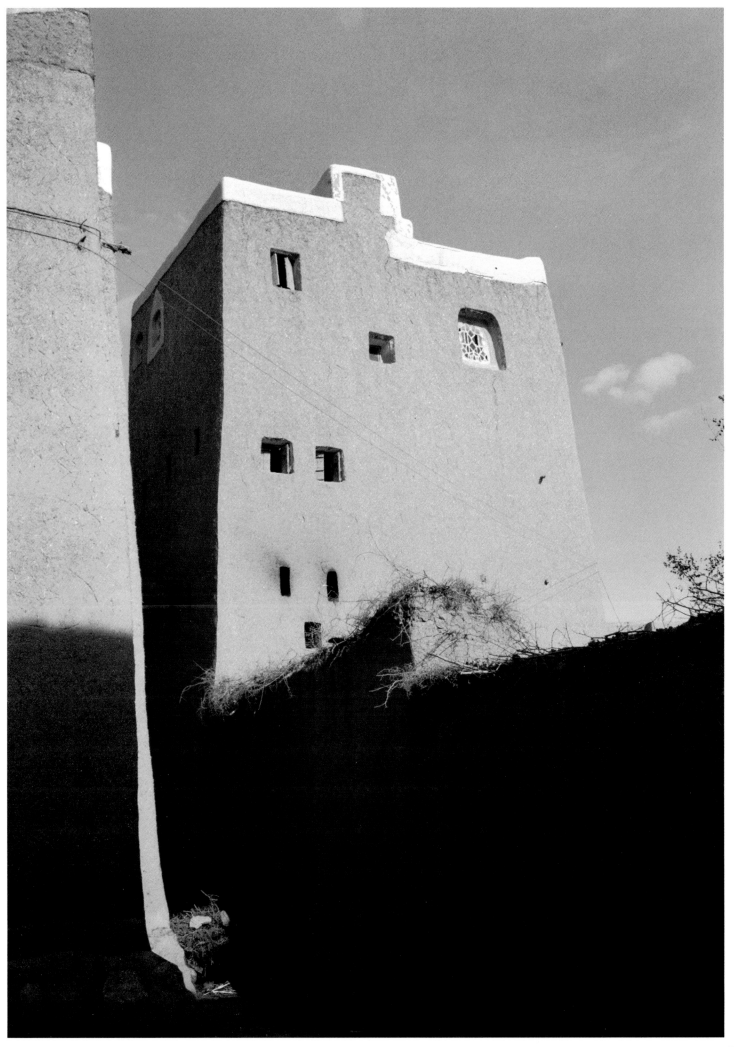

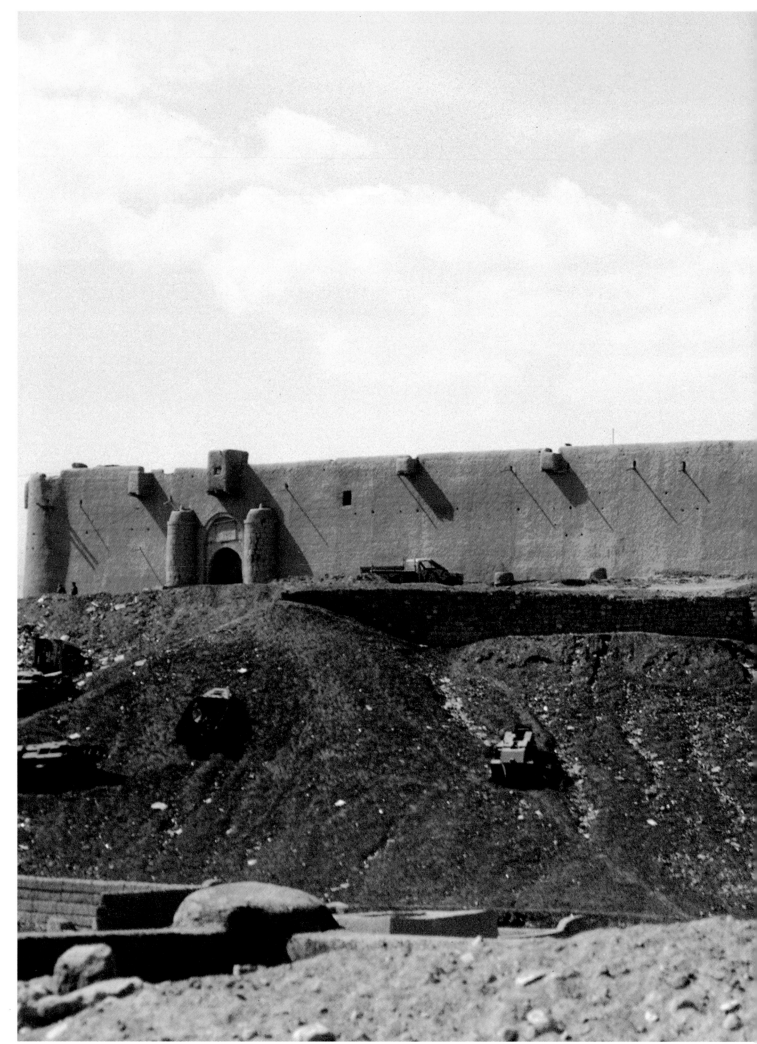

THE OLD FORT OF SA'DA

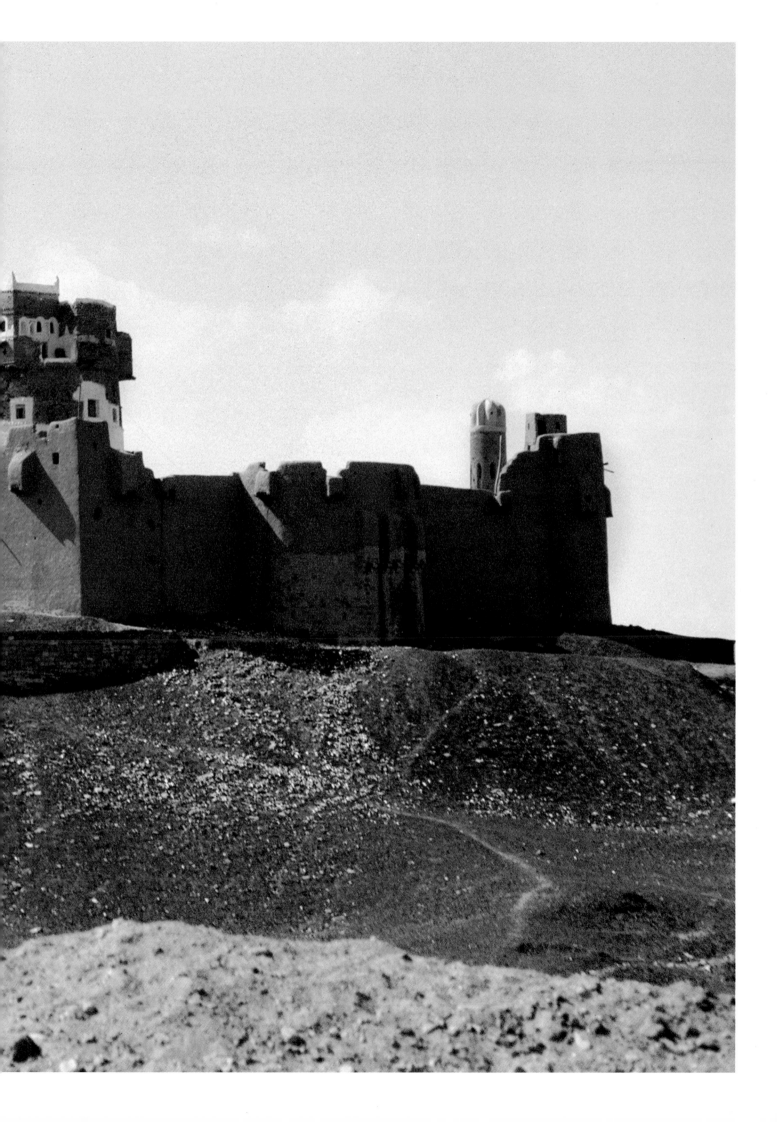

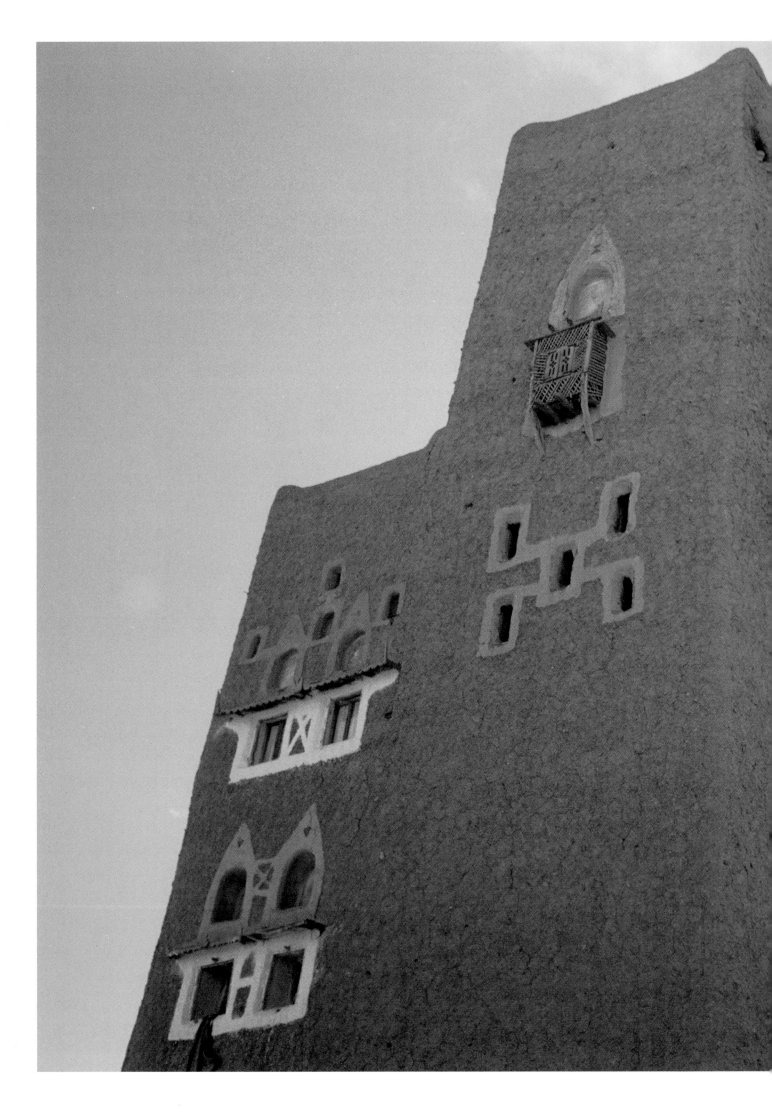

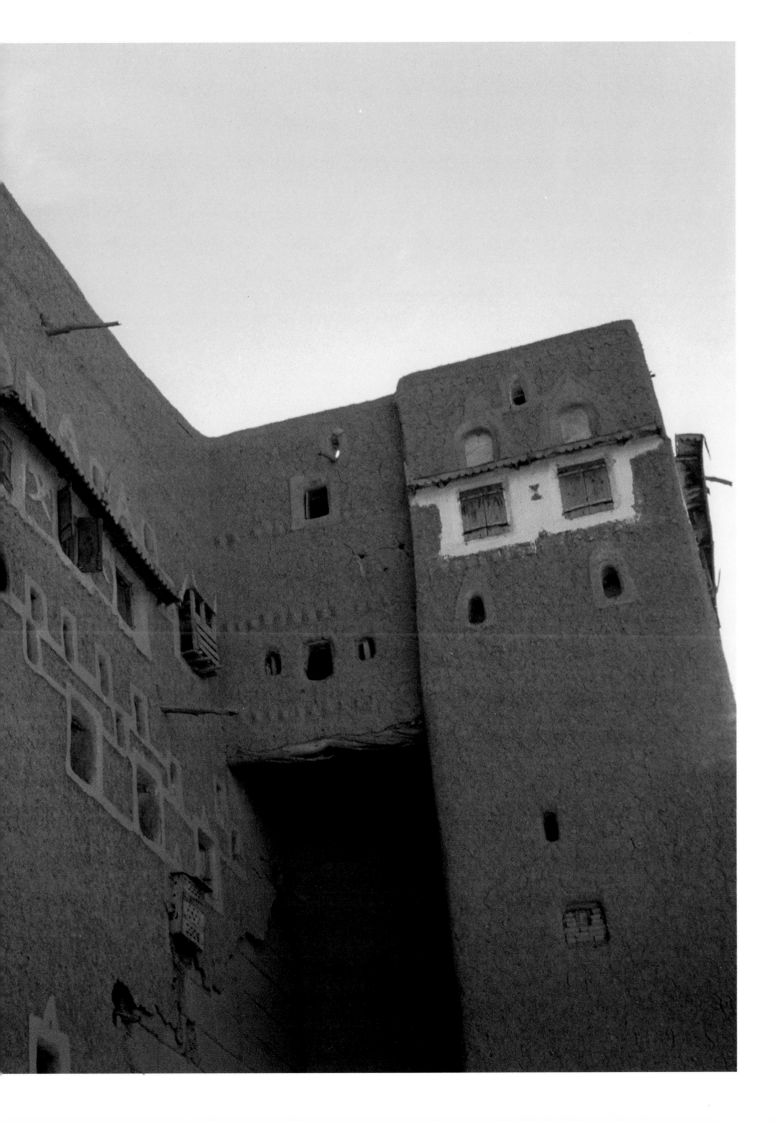

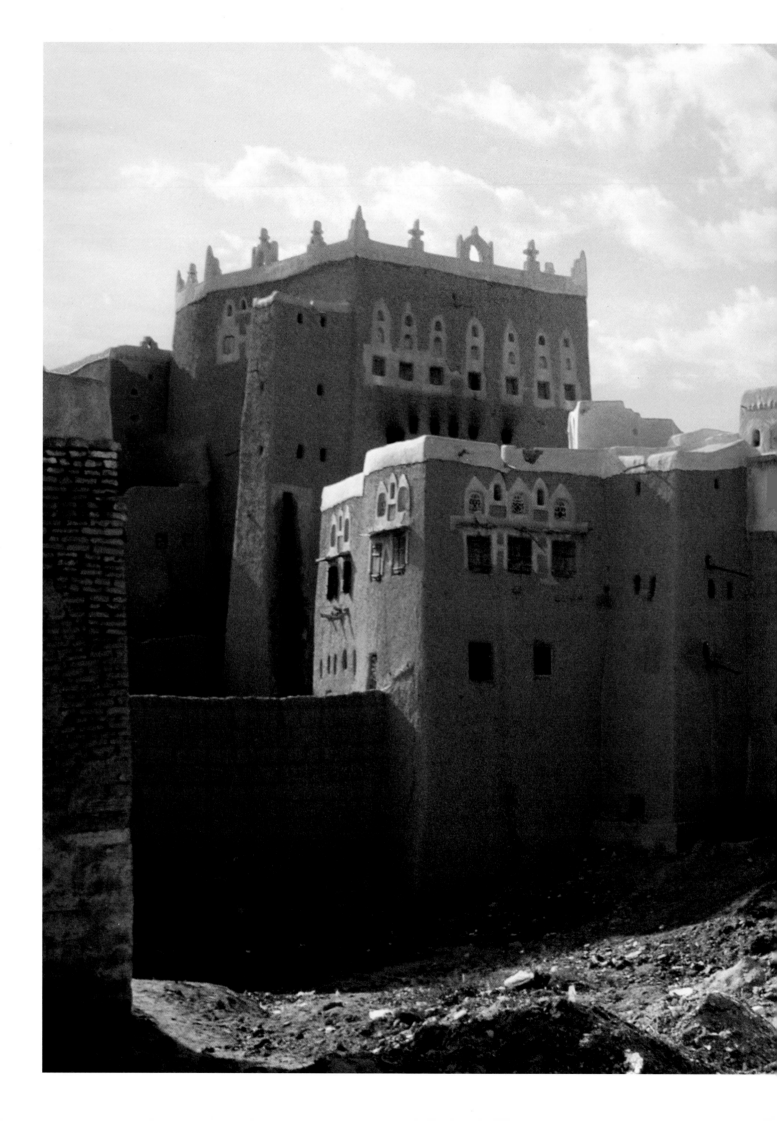

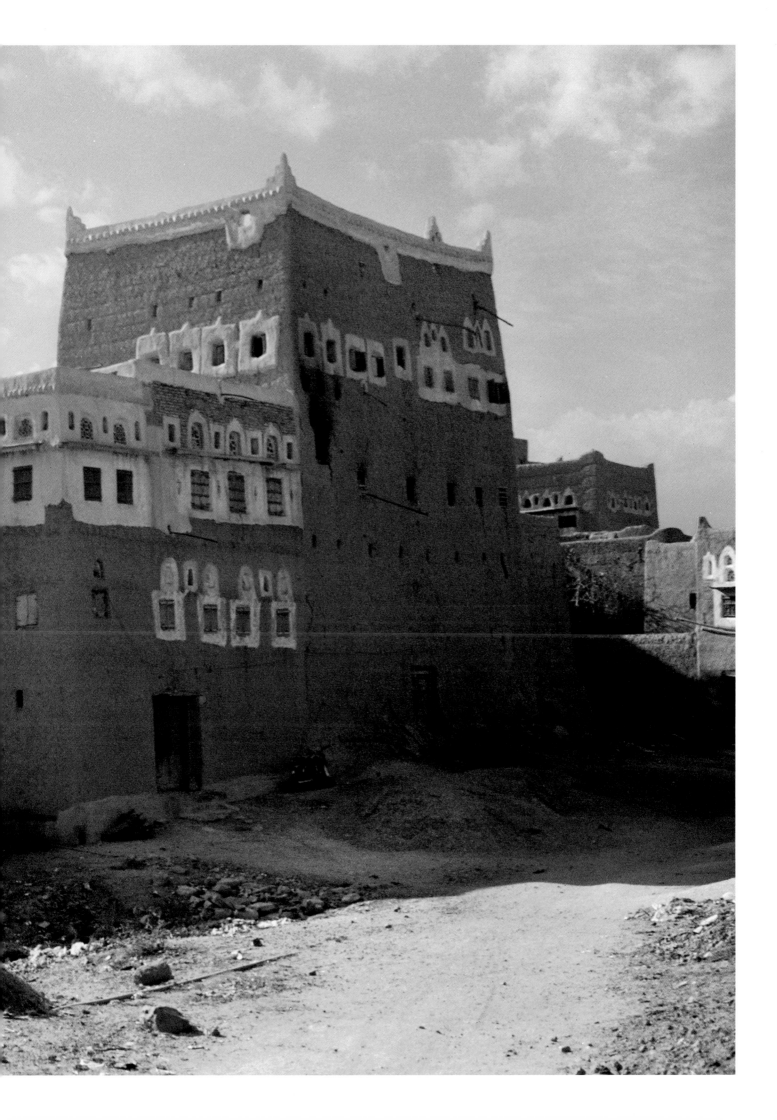

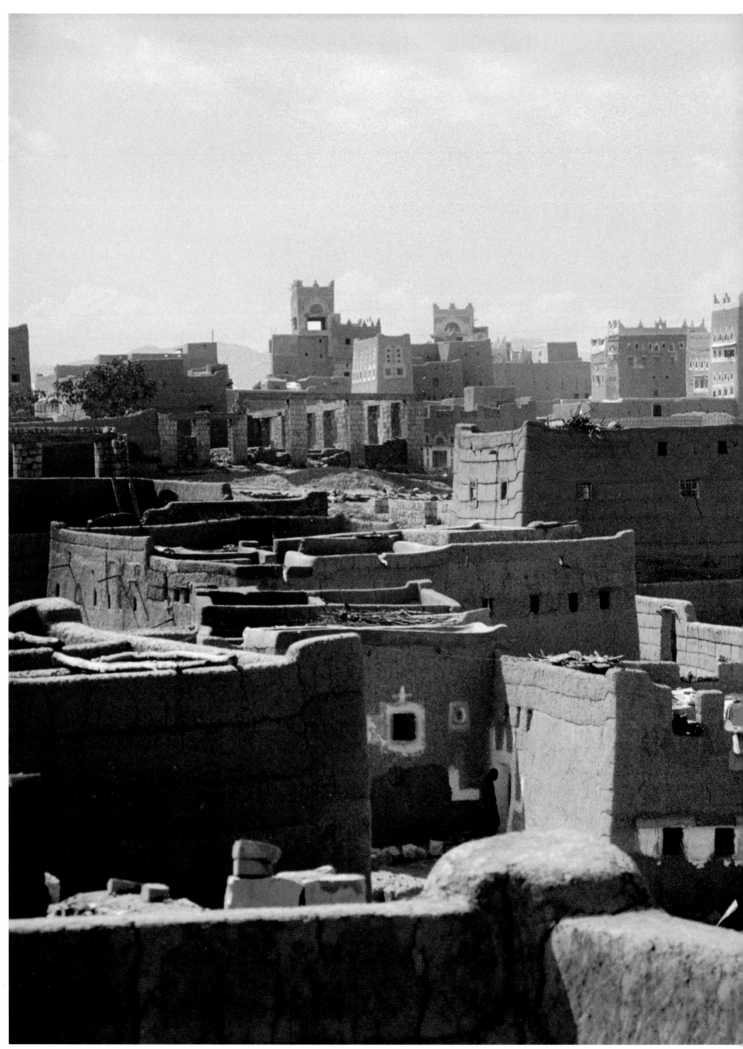

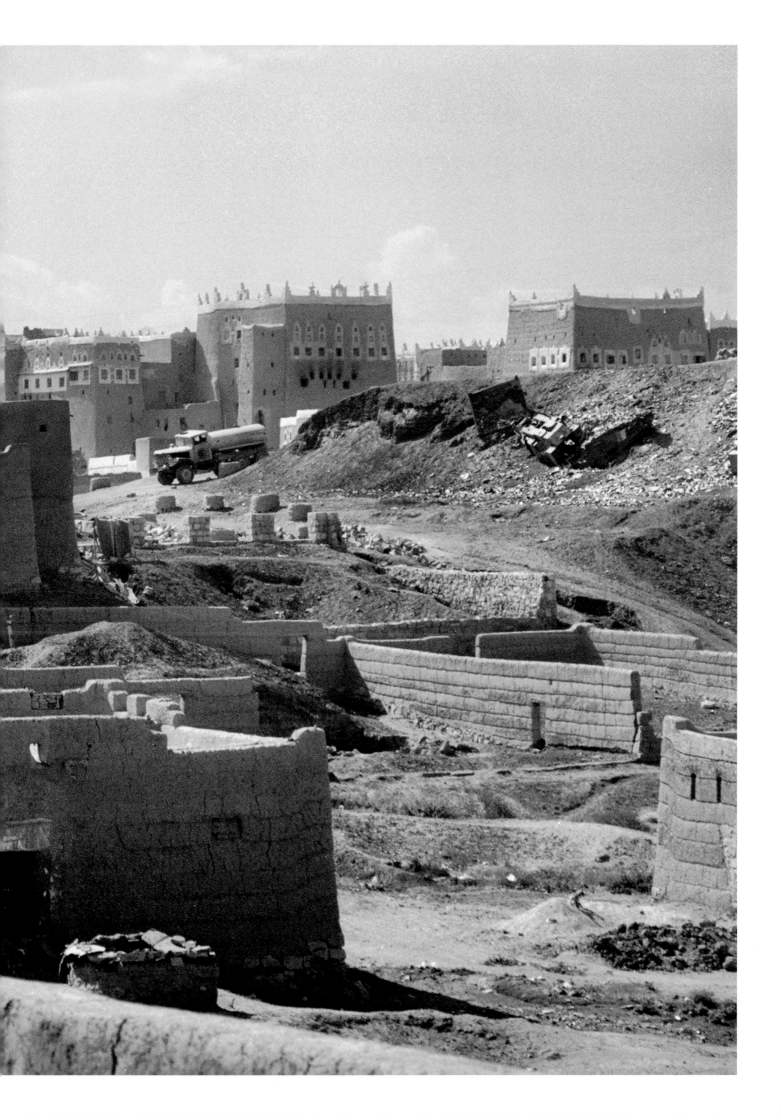

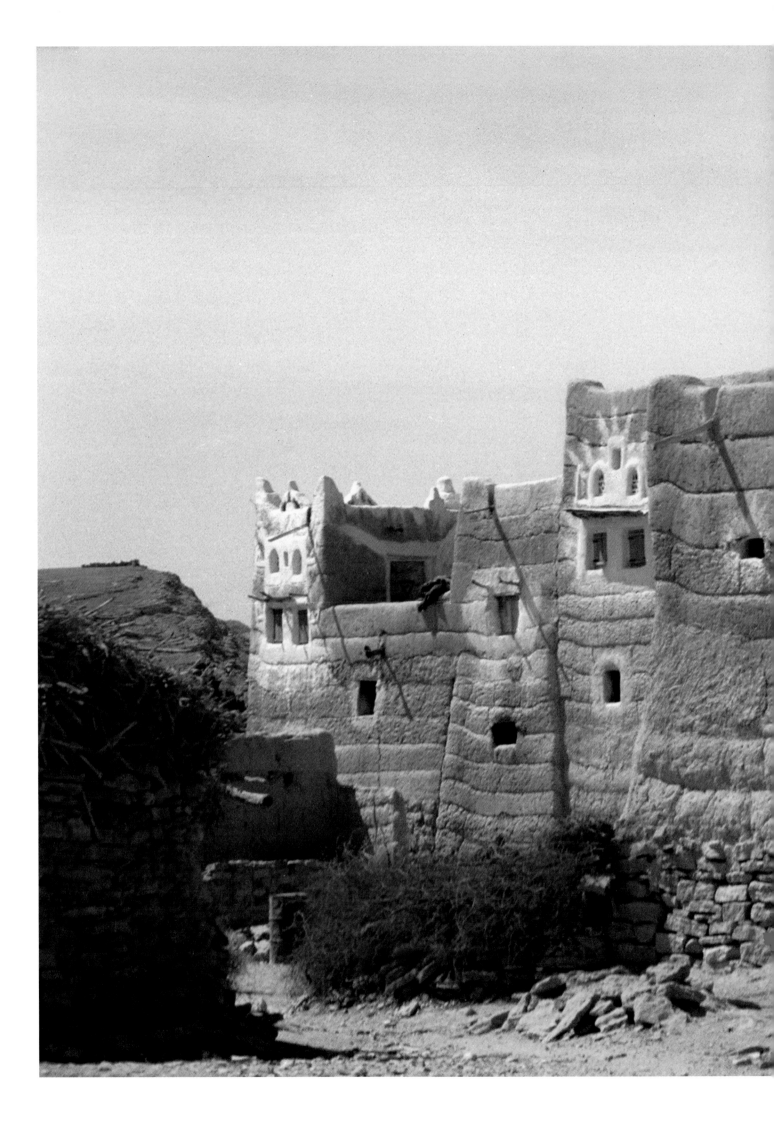

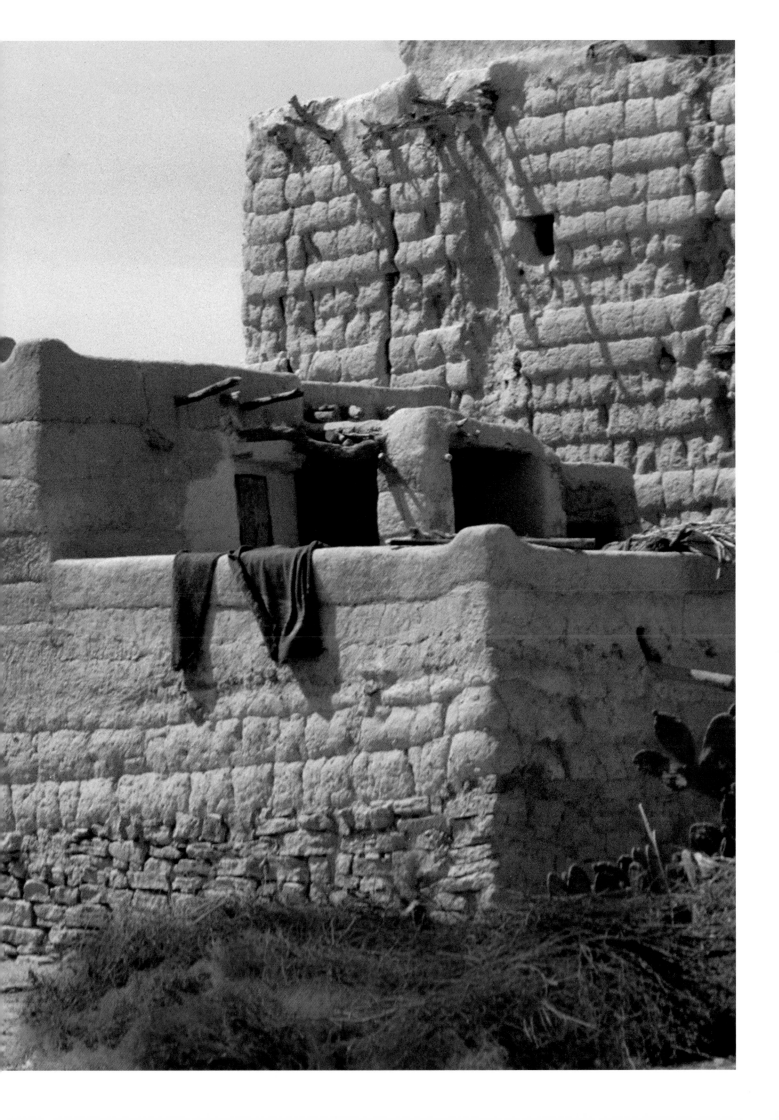

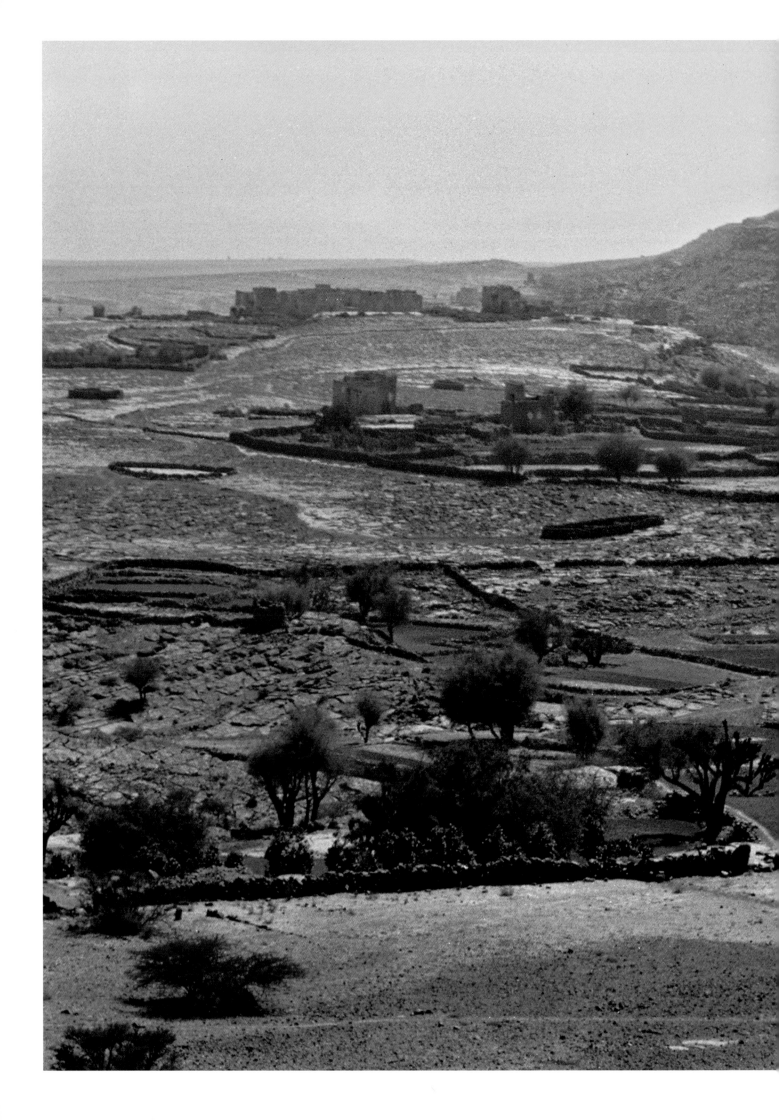

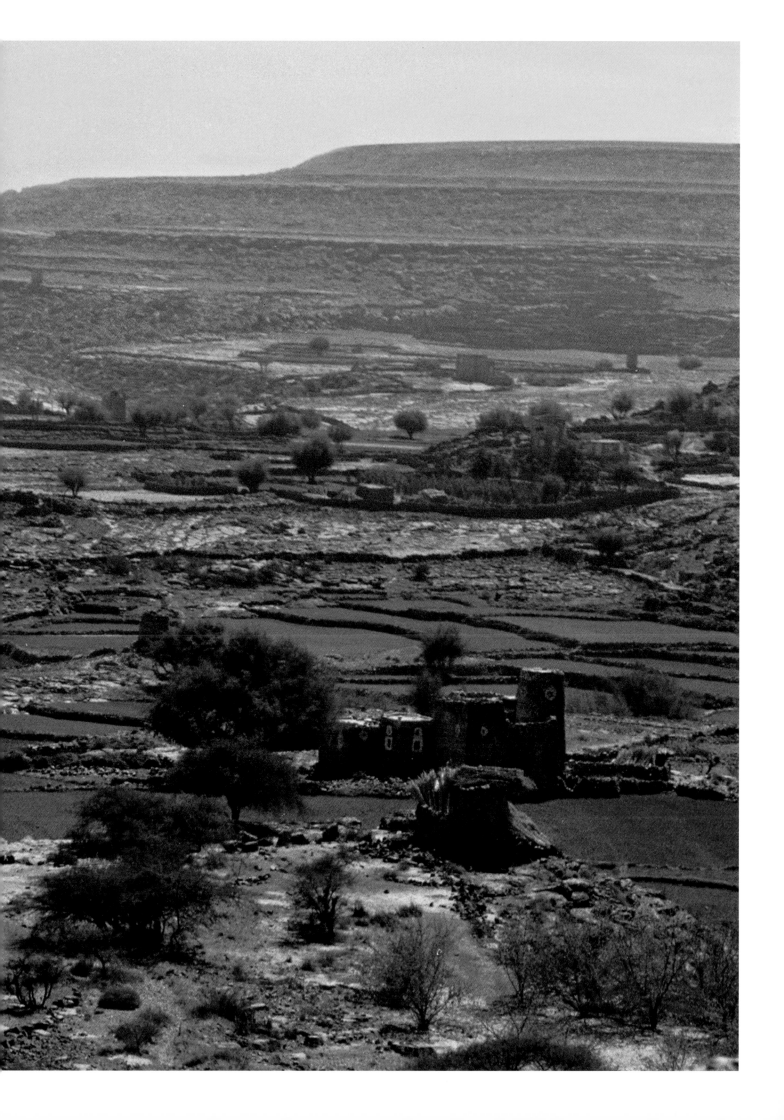

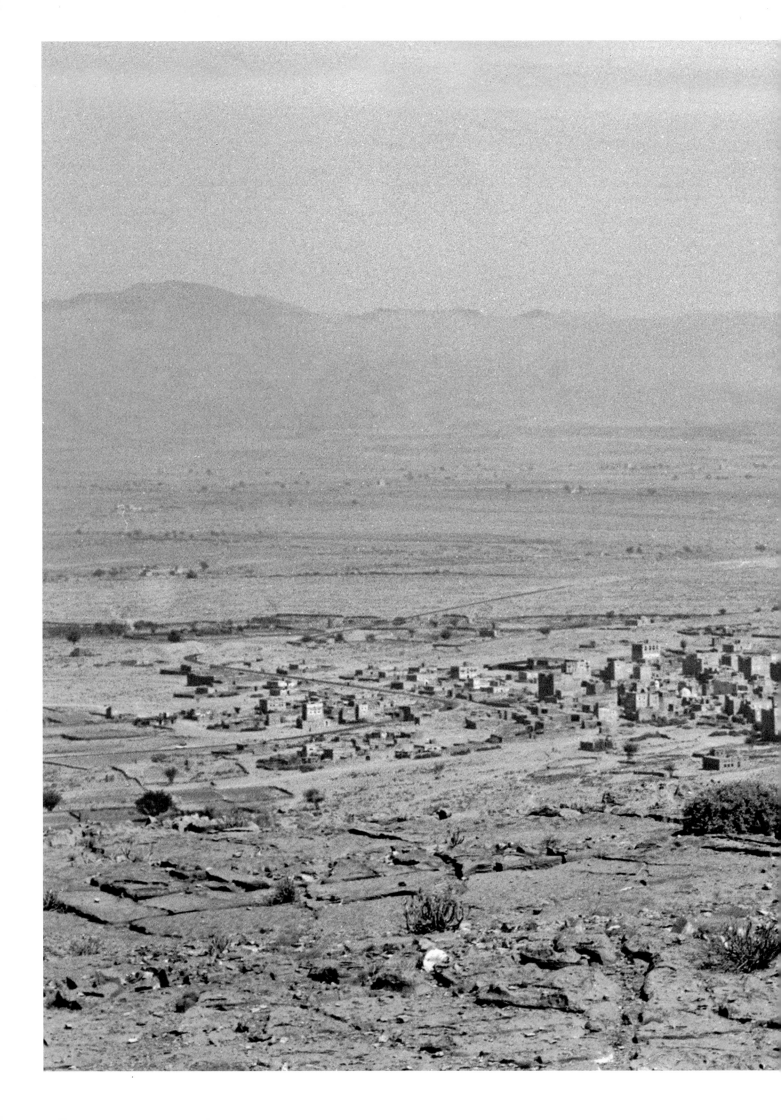

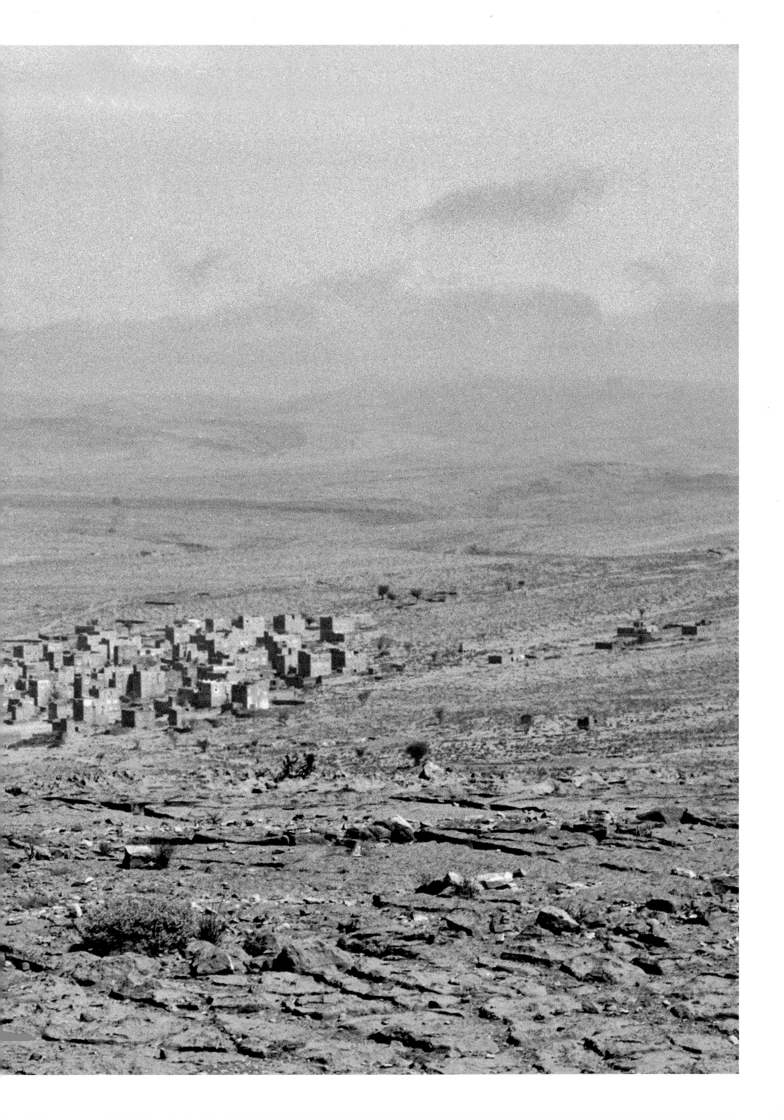

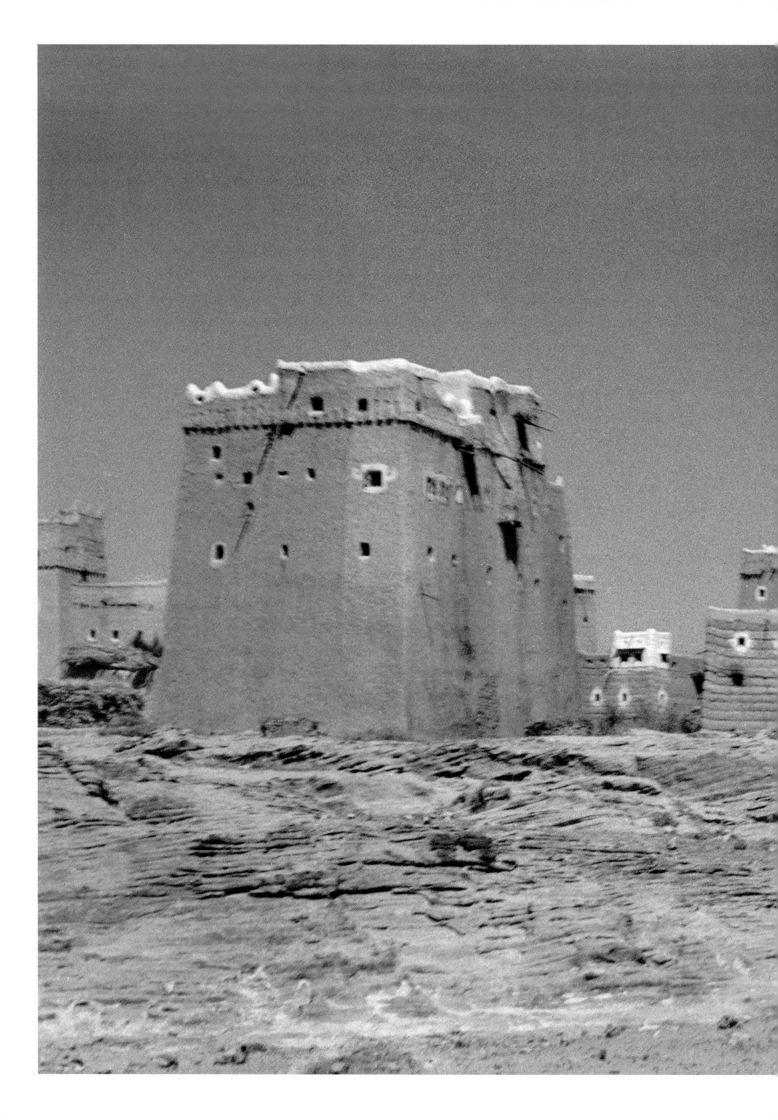

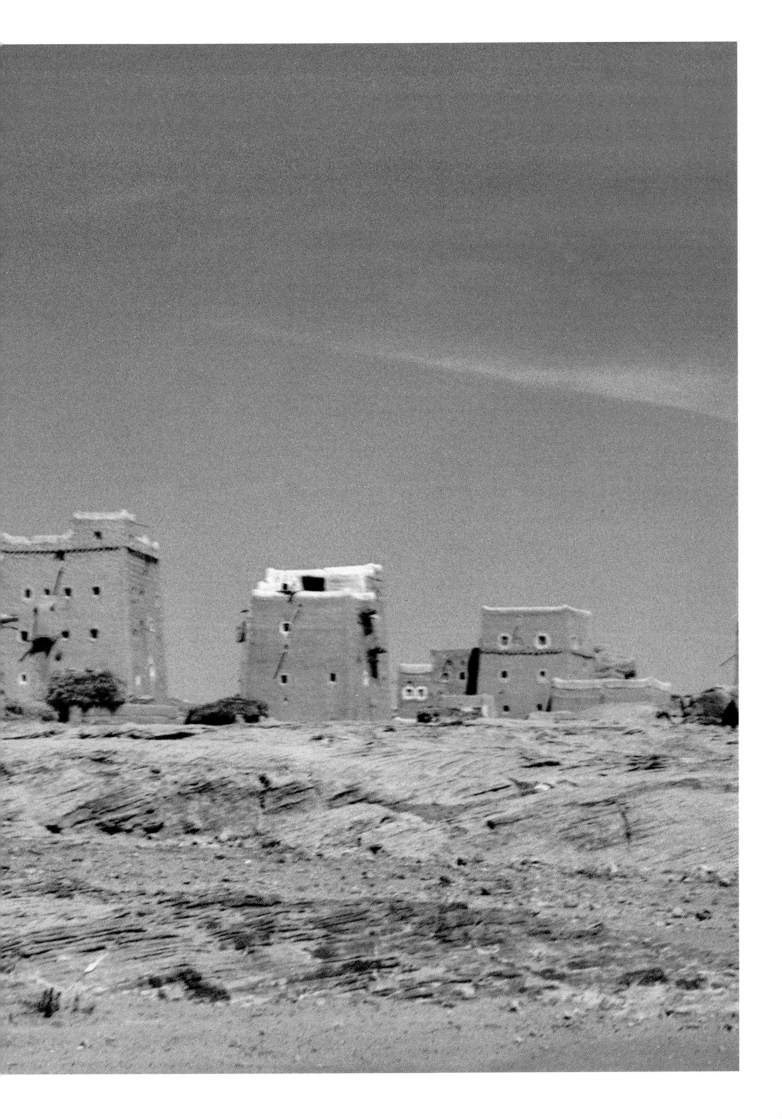

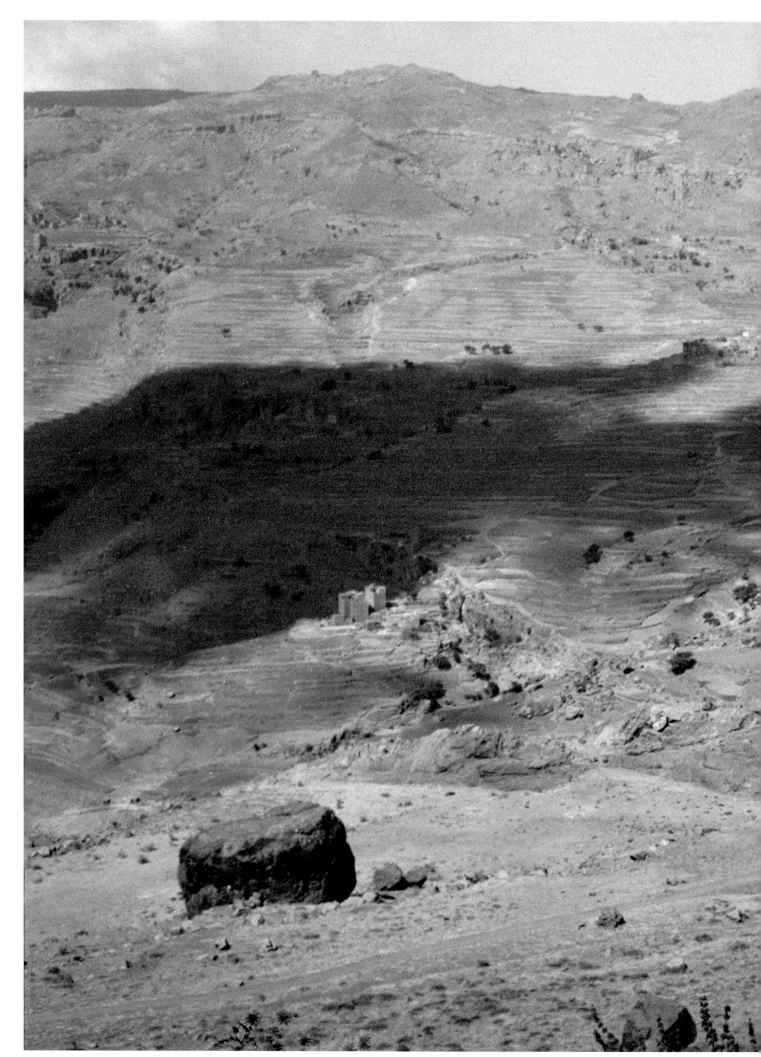

ON THE WAY TO MAHERAK

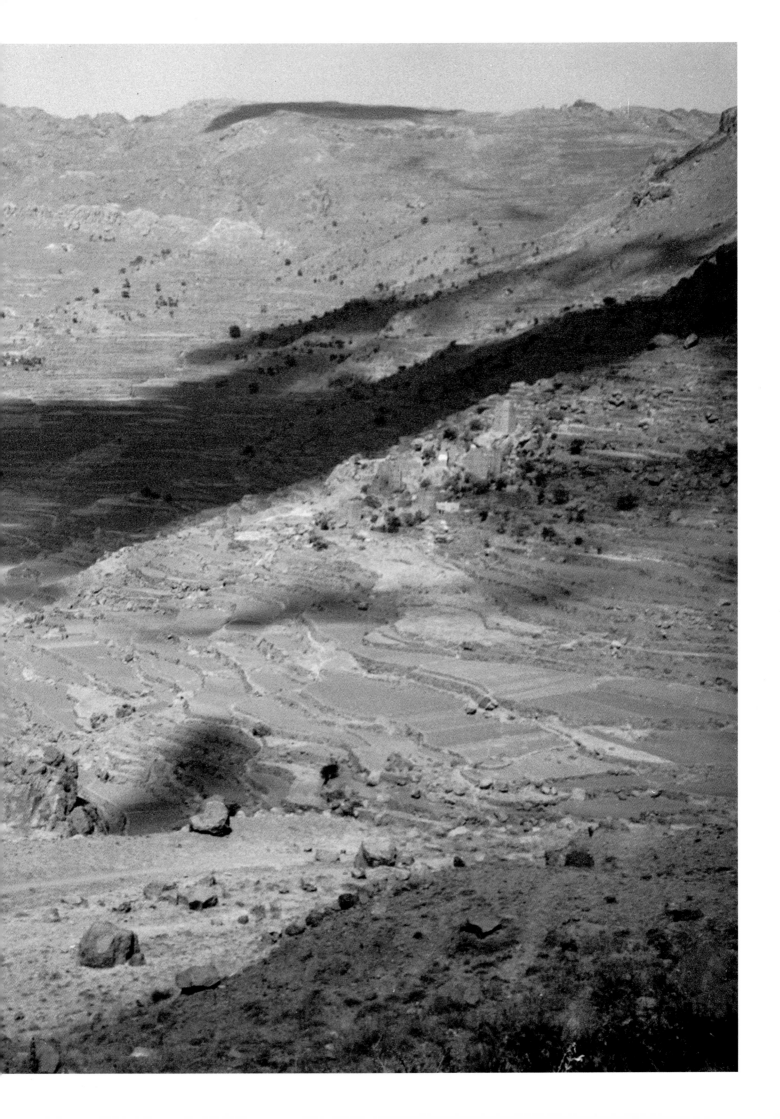

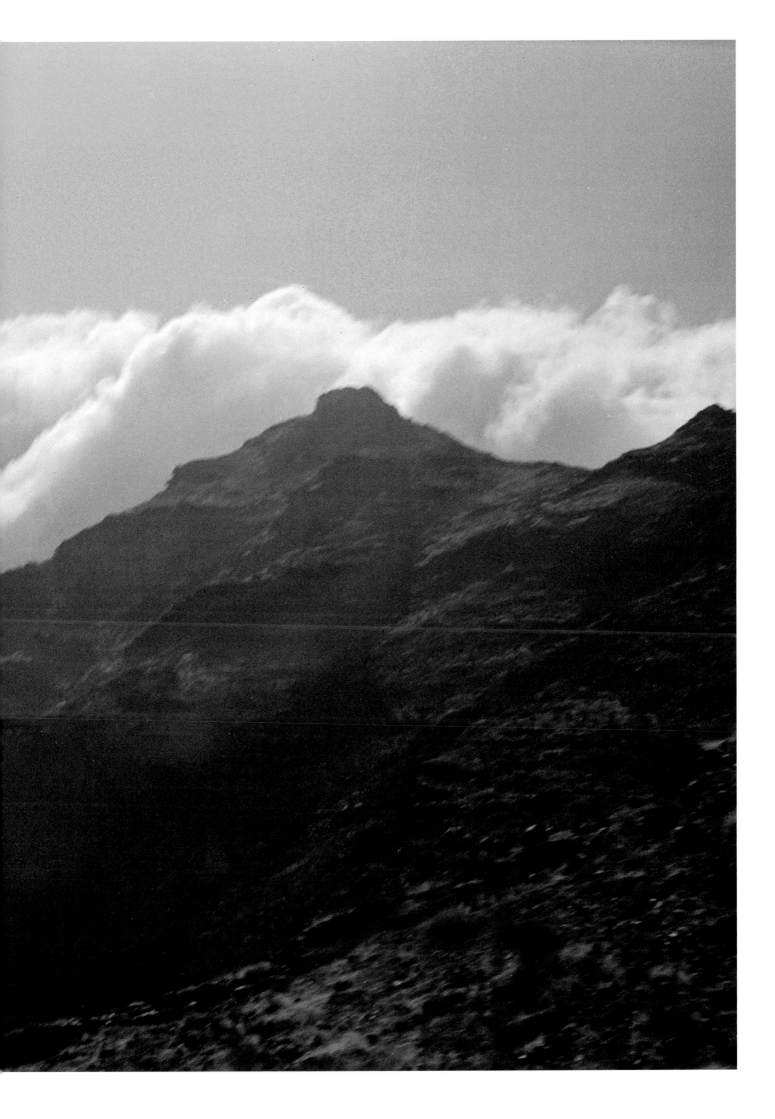

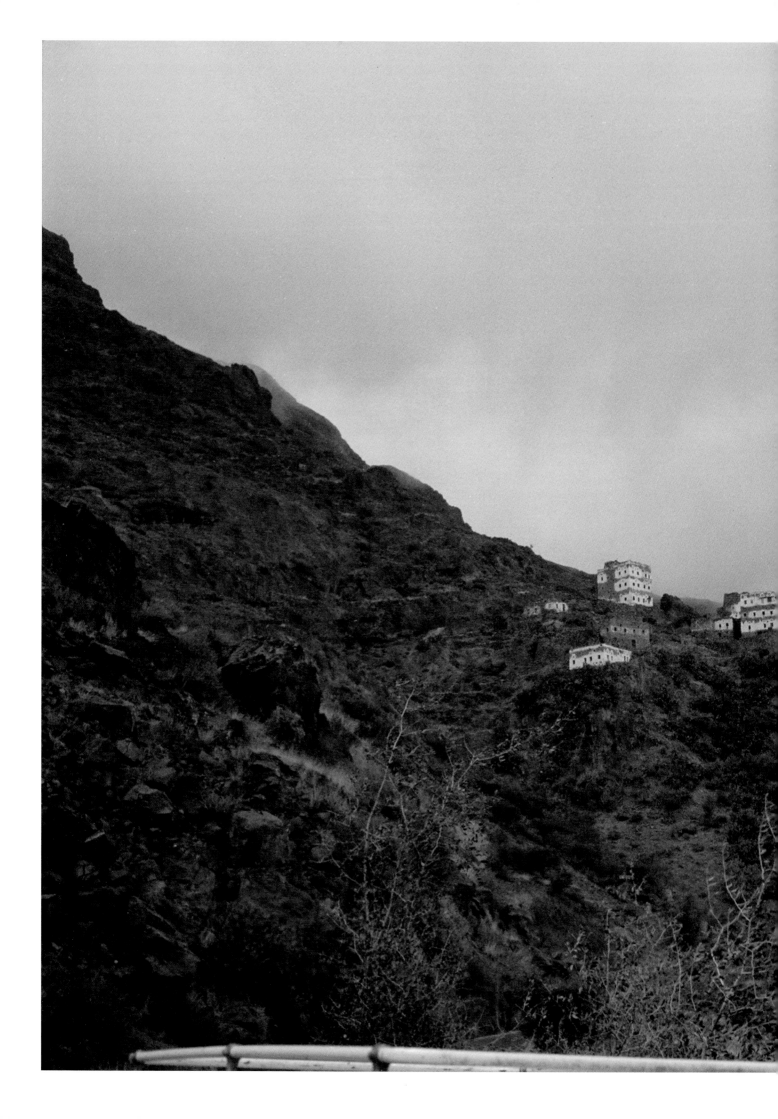

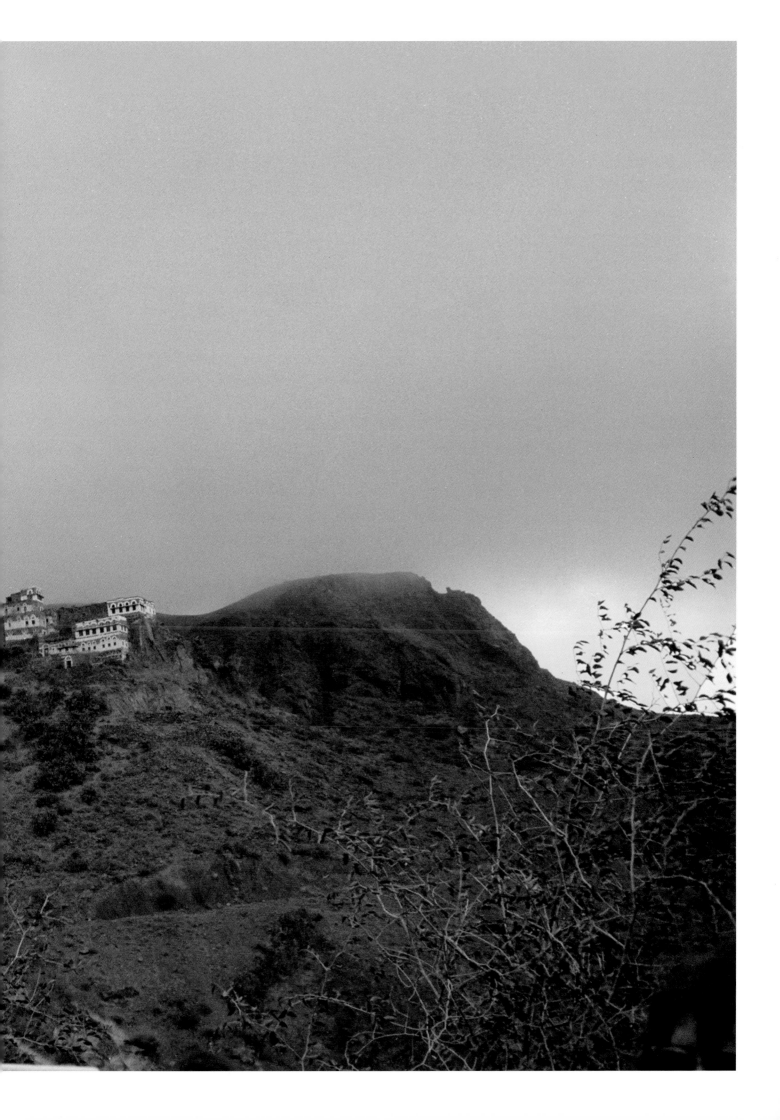

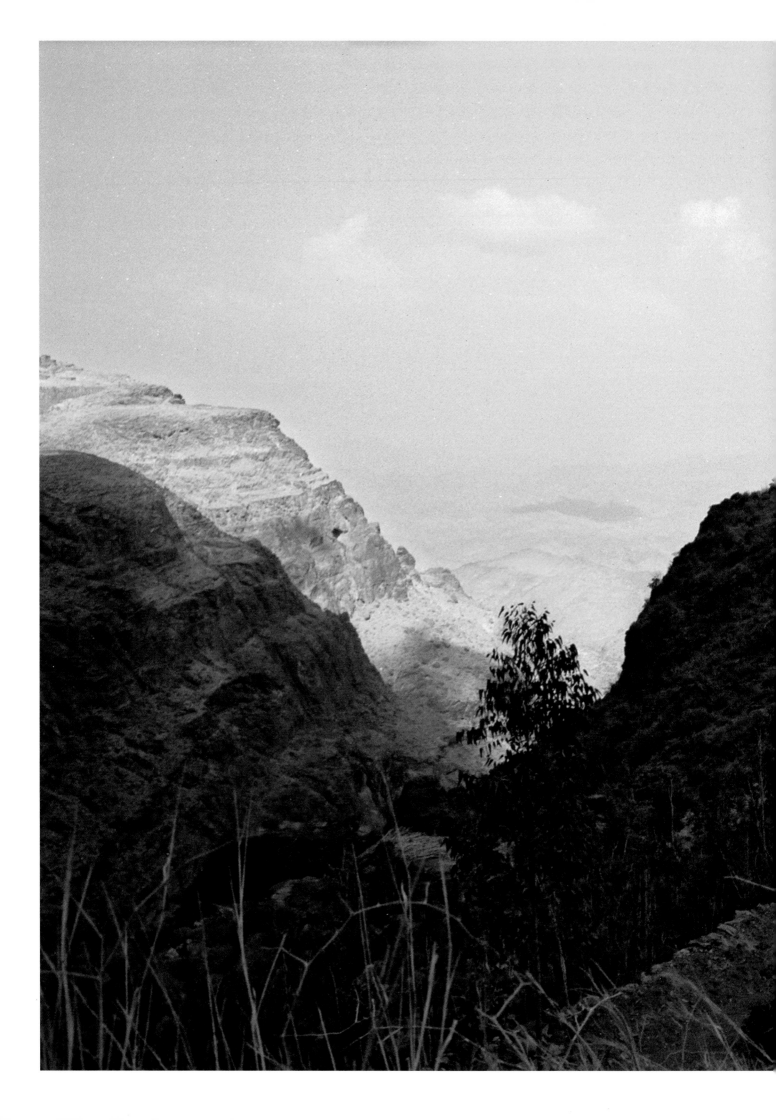

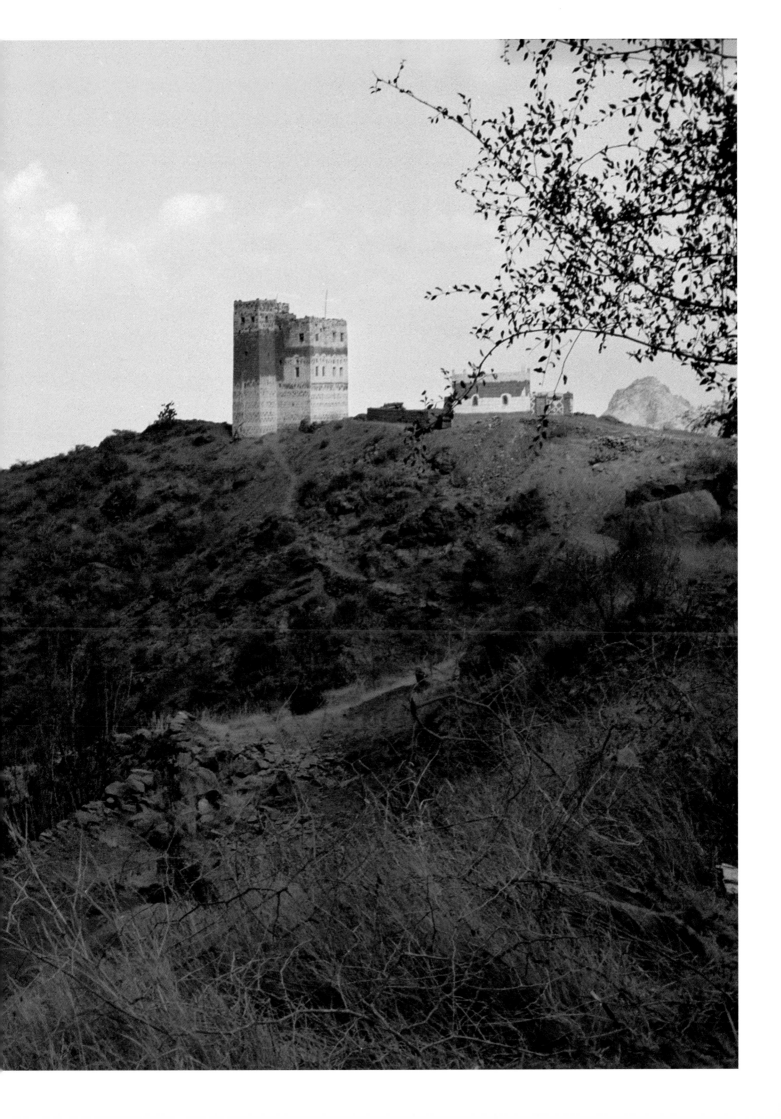

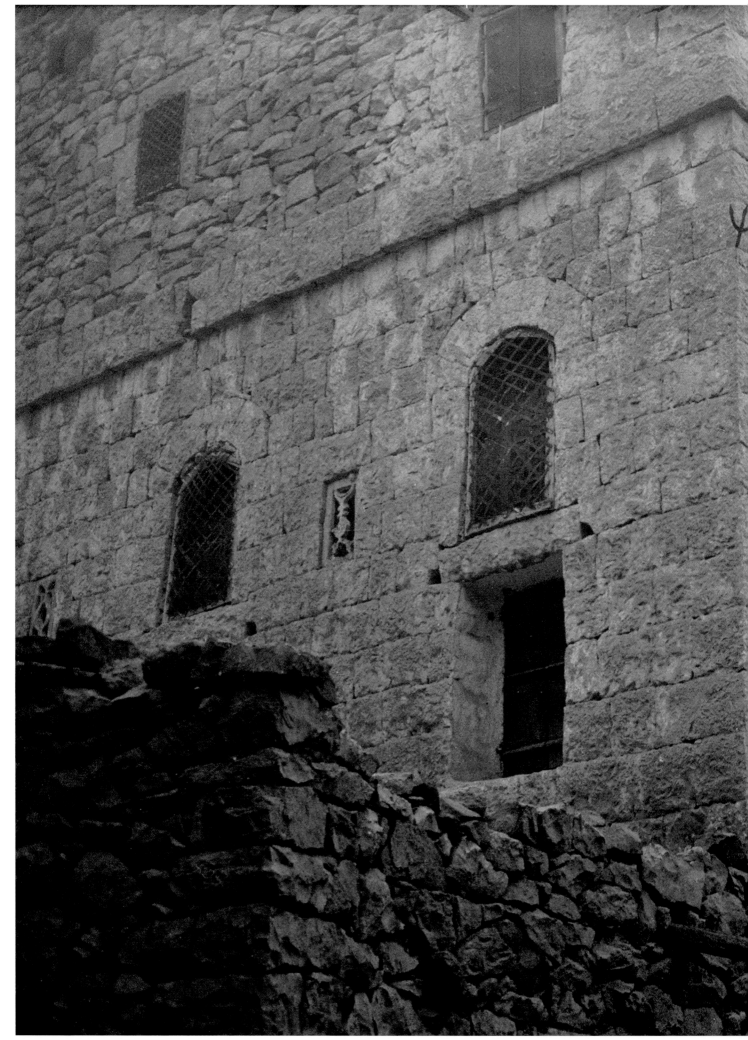

AL−MURRAQ

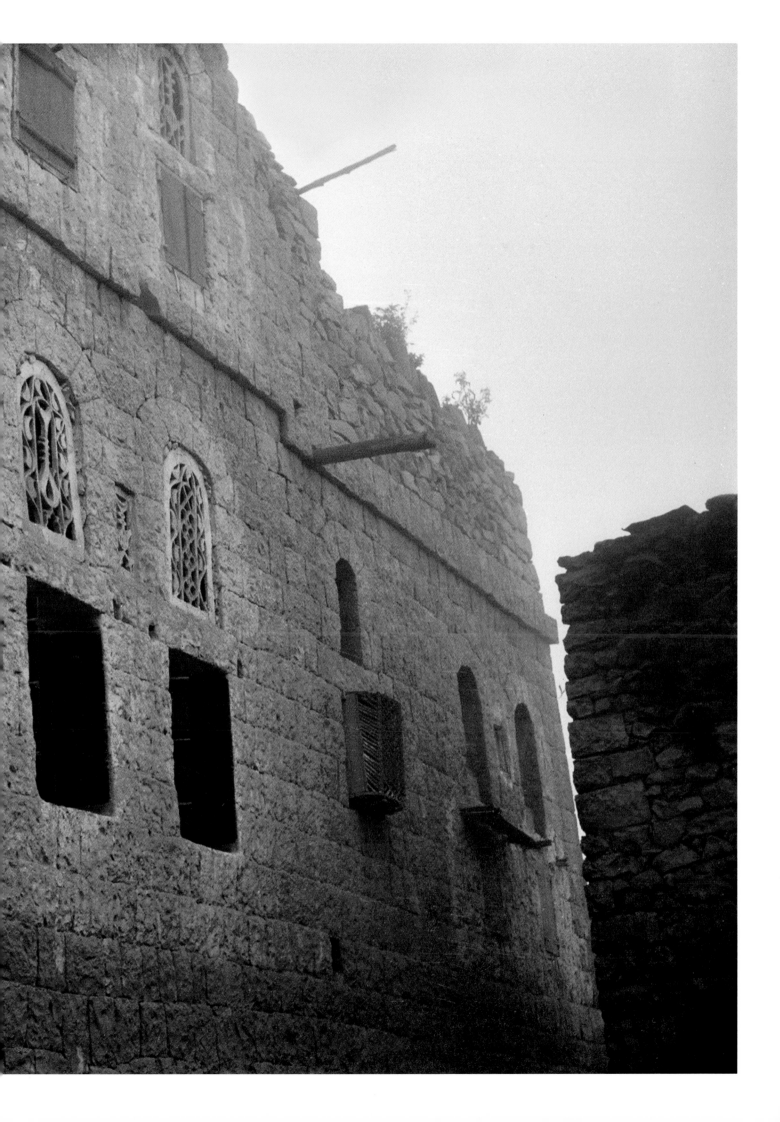

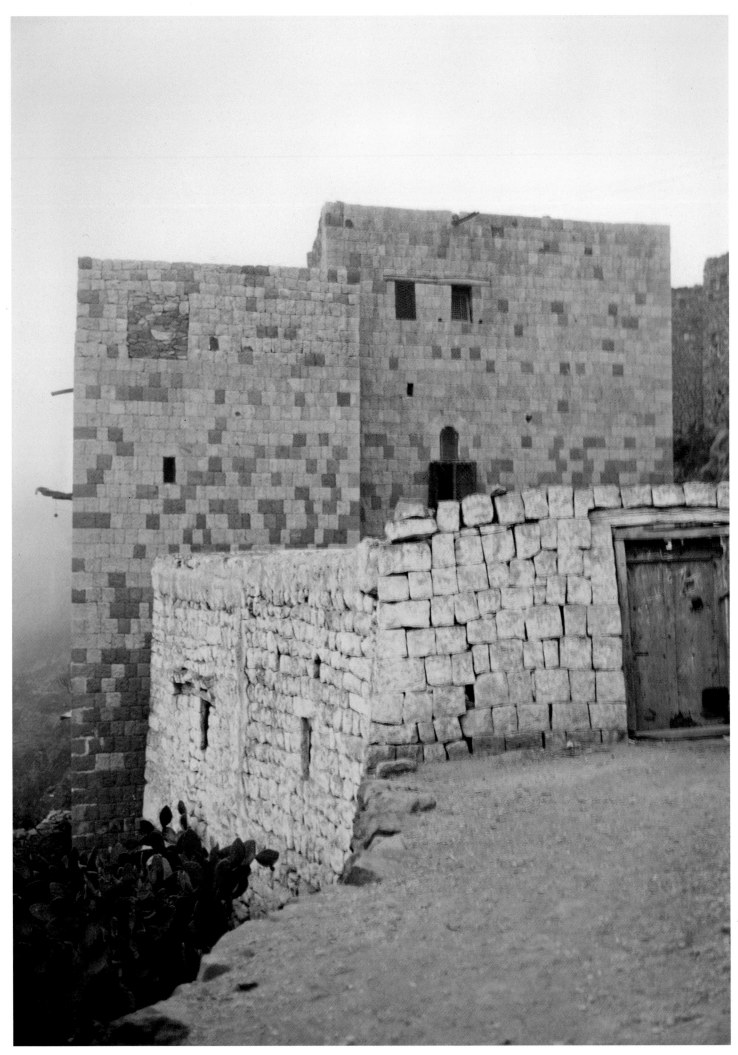

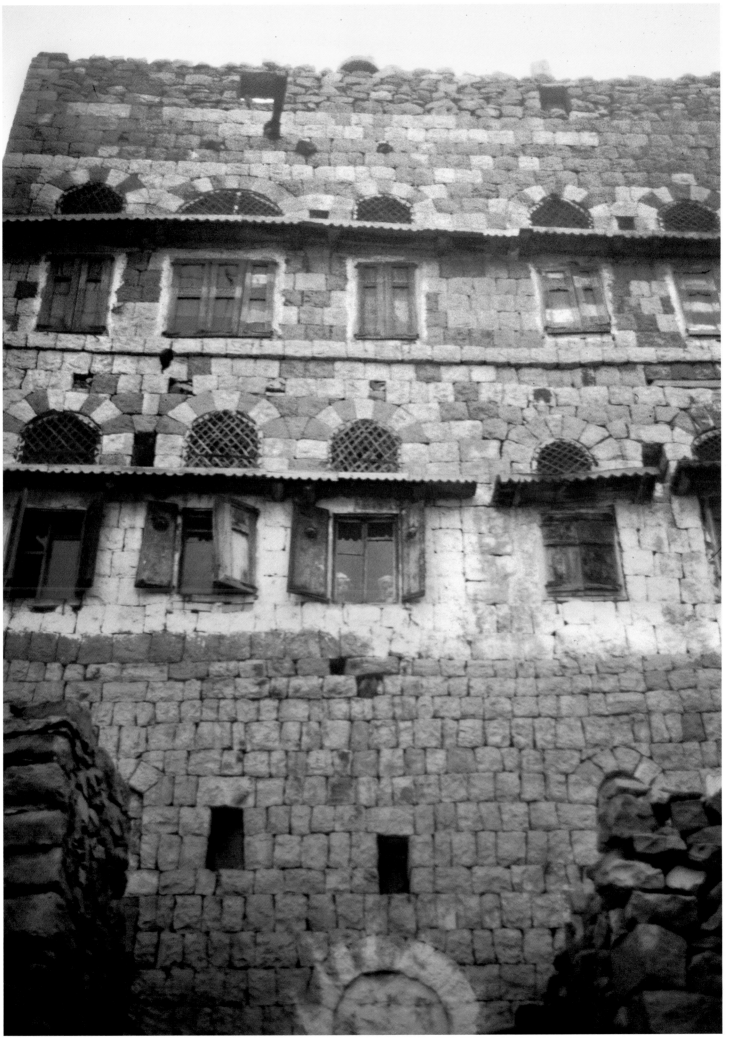

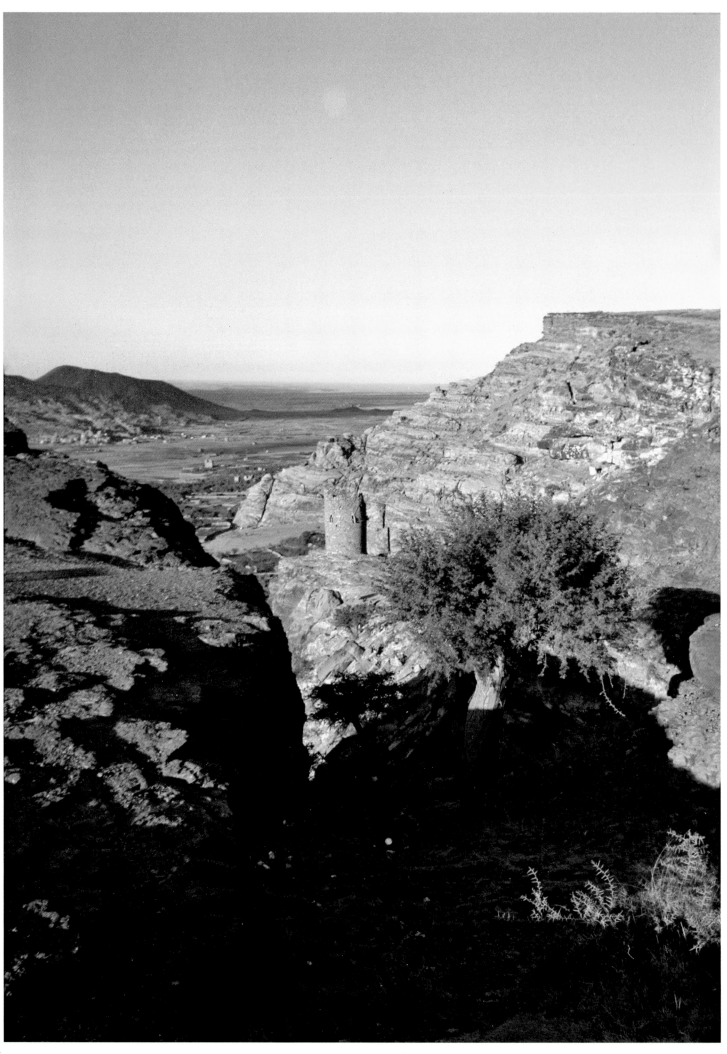

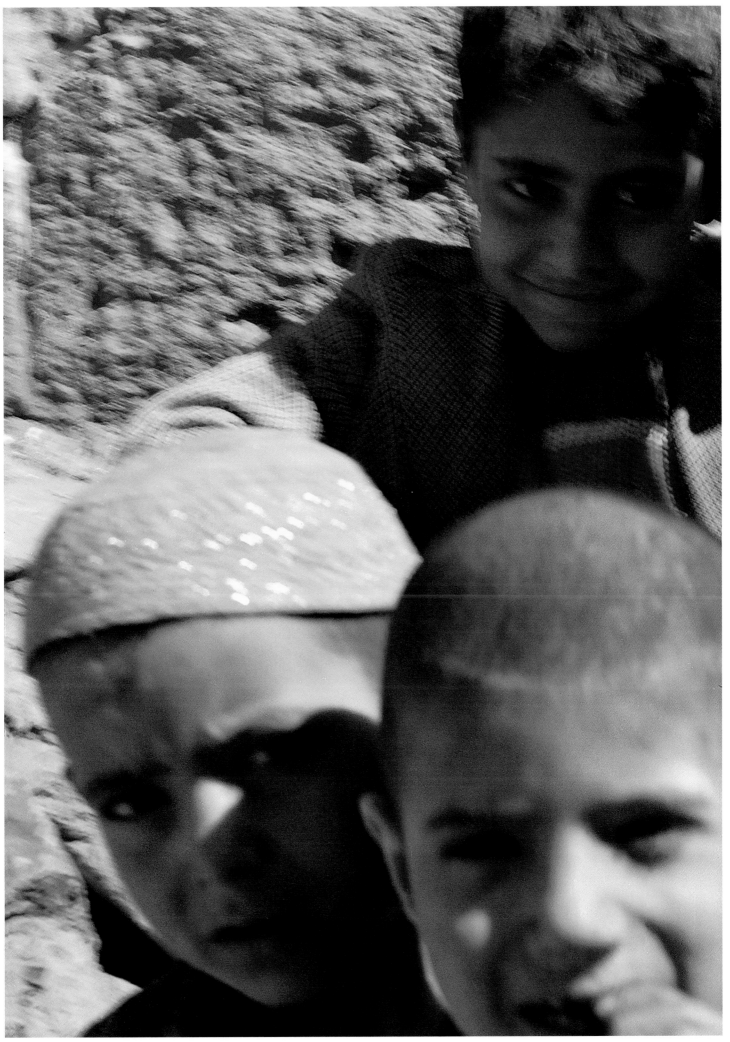

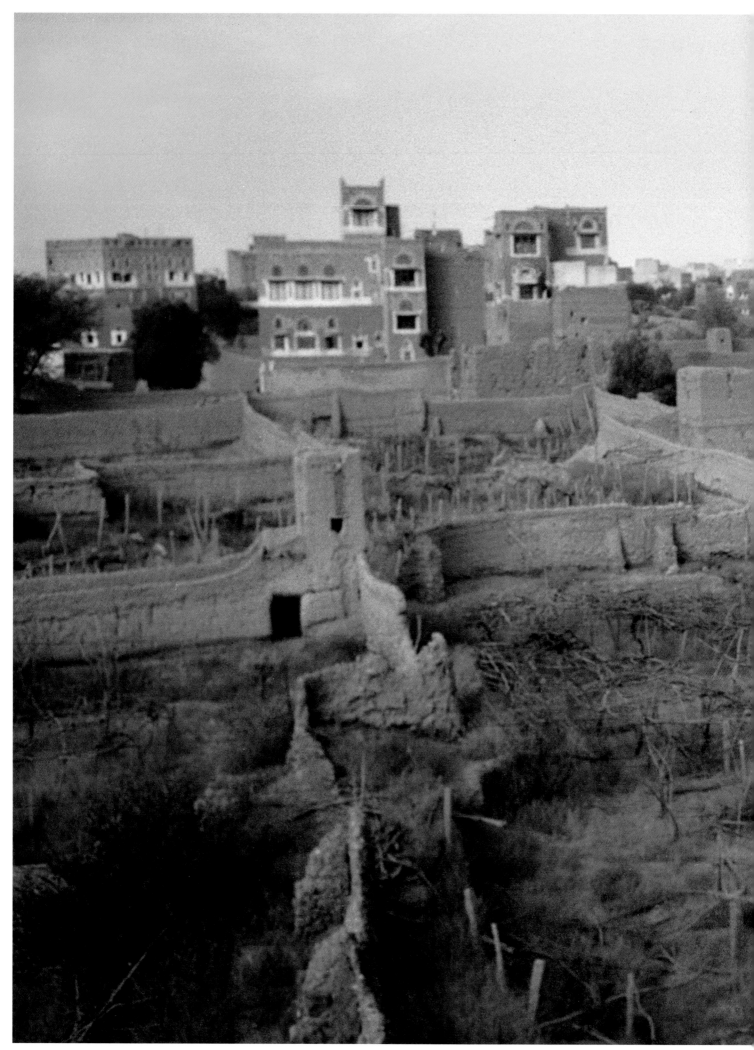

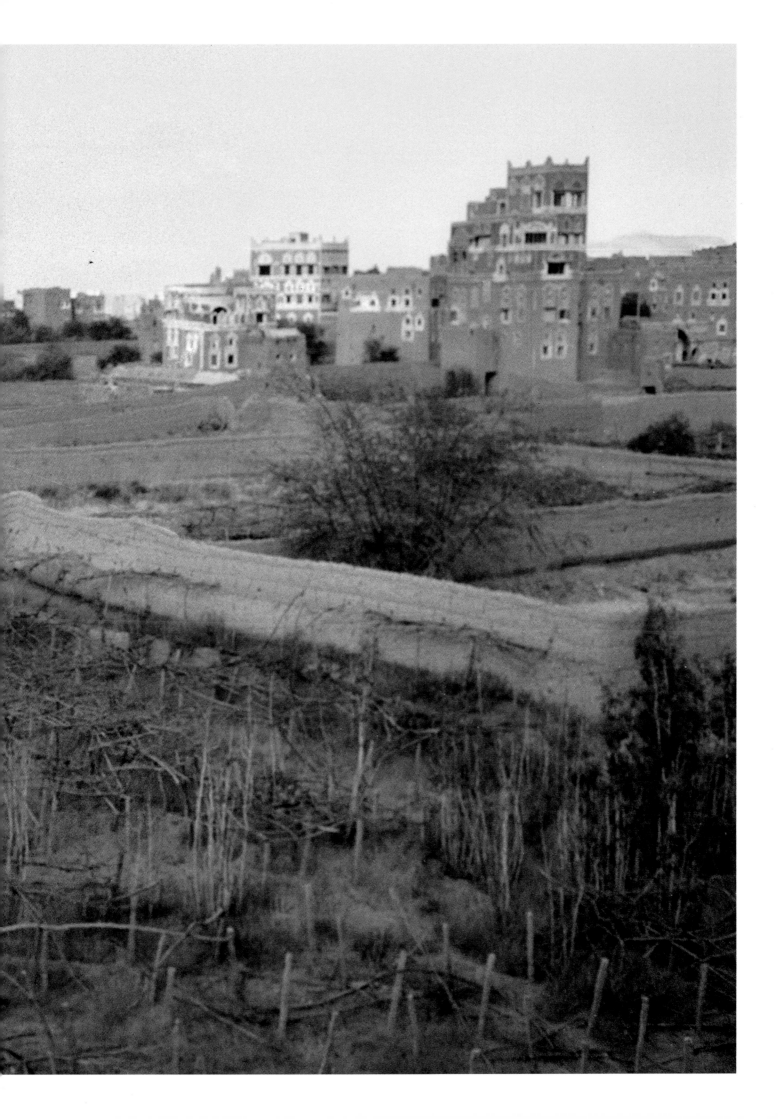

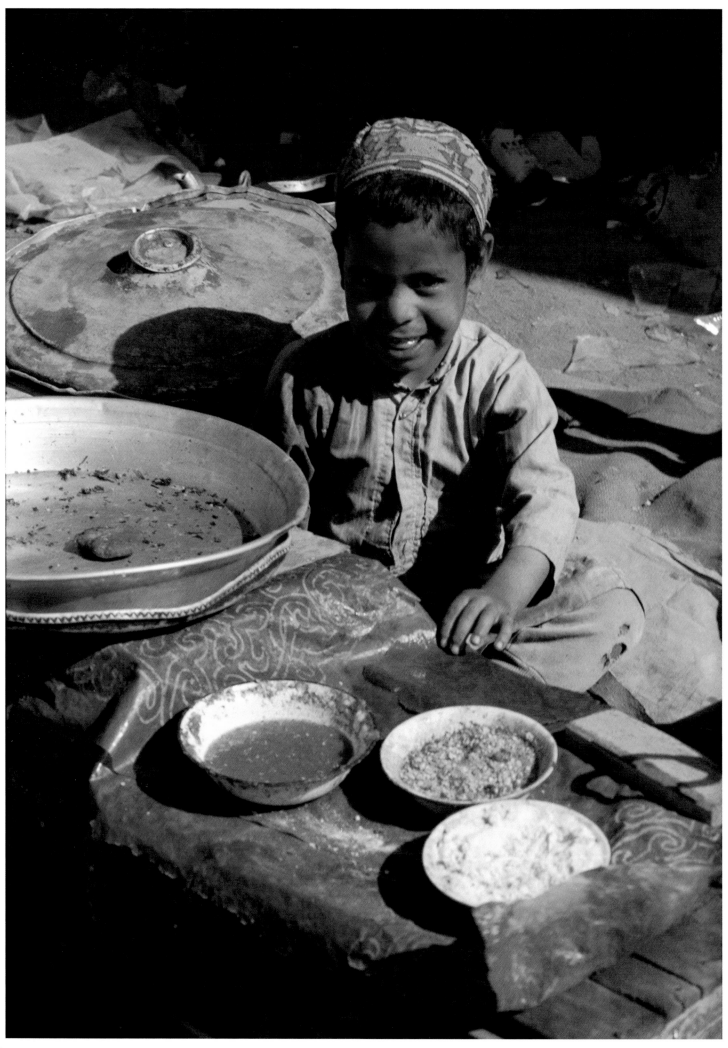

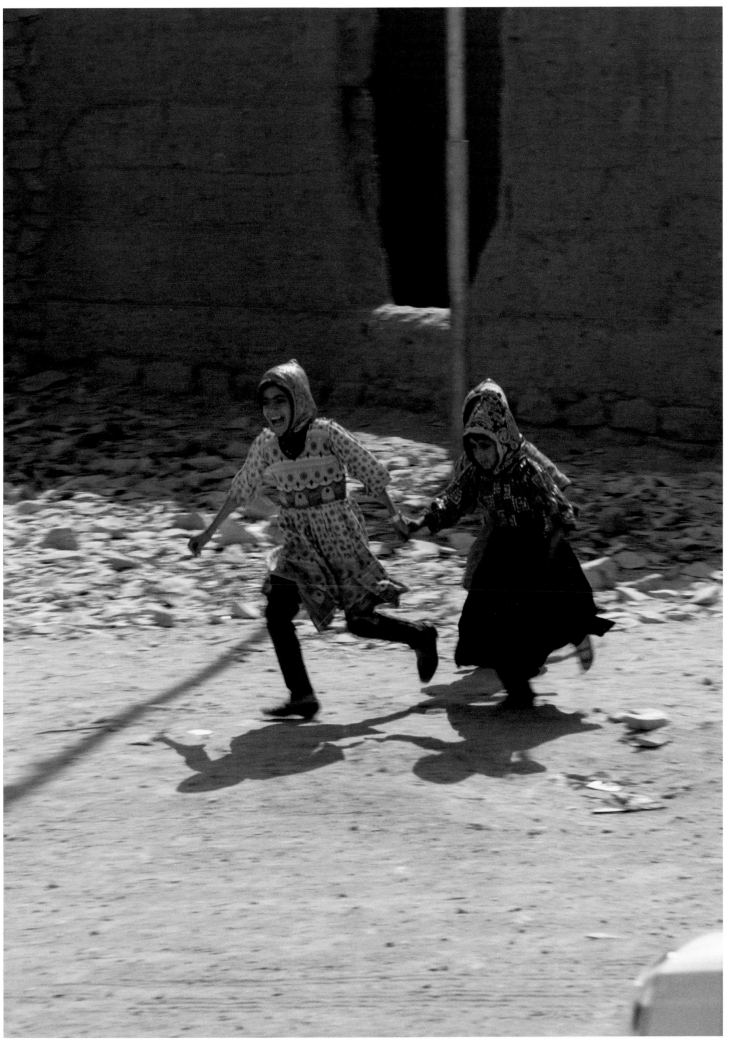

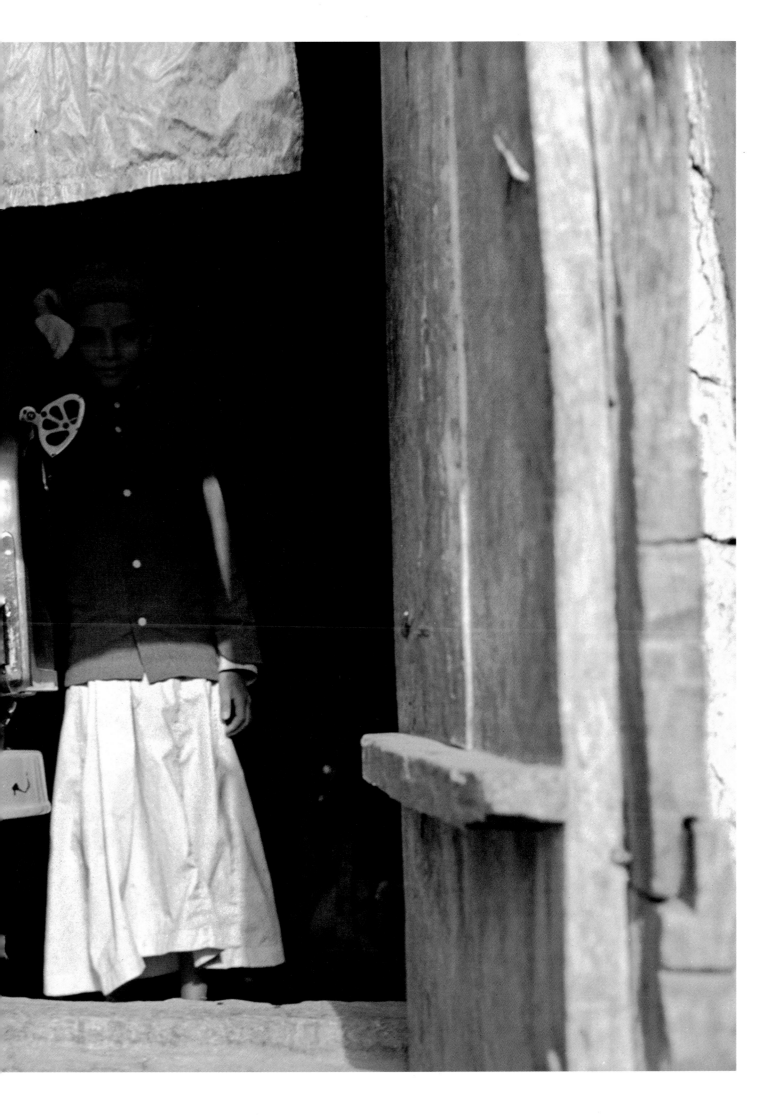

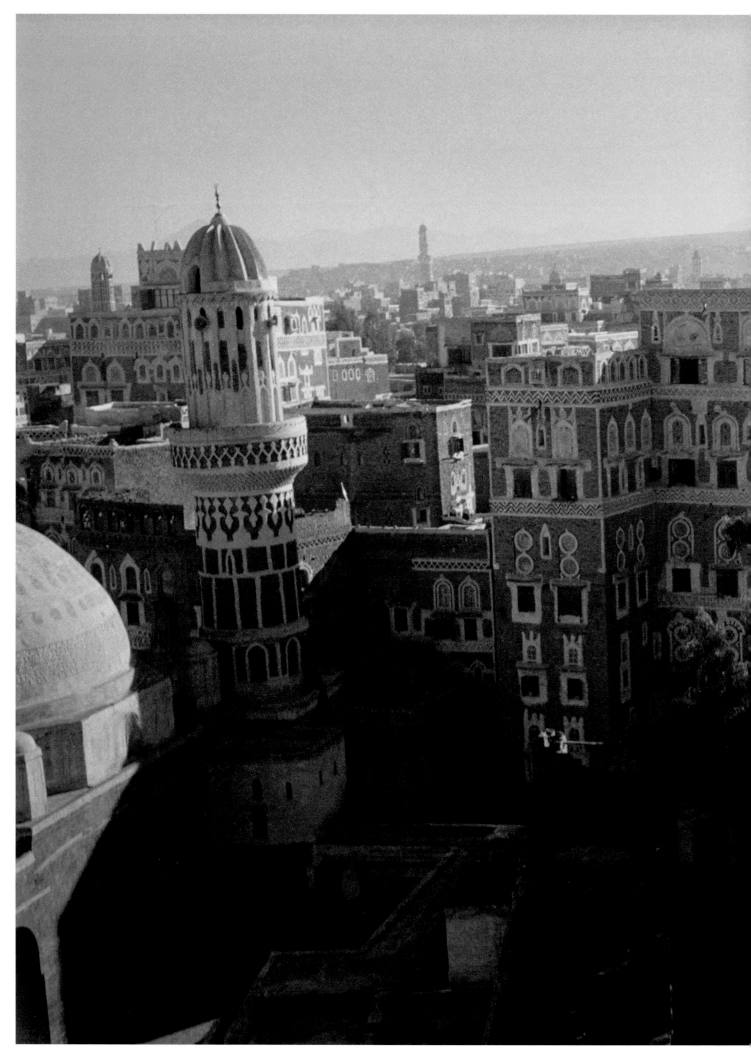

SANAA

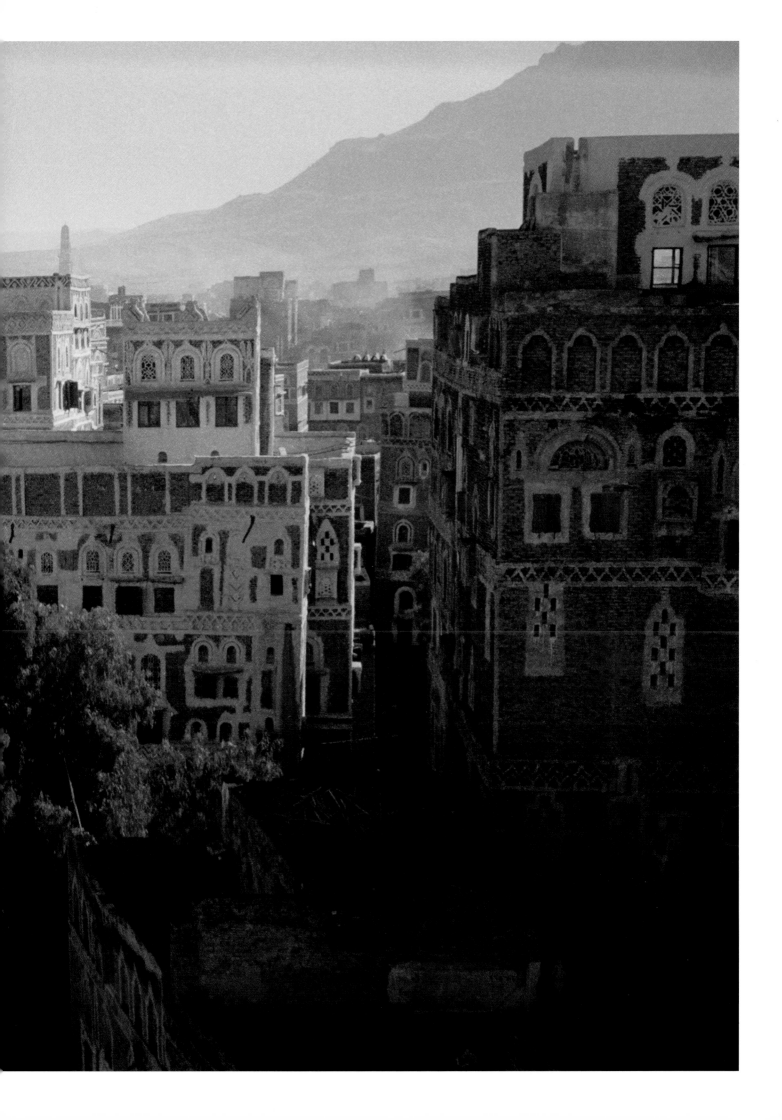

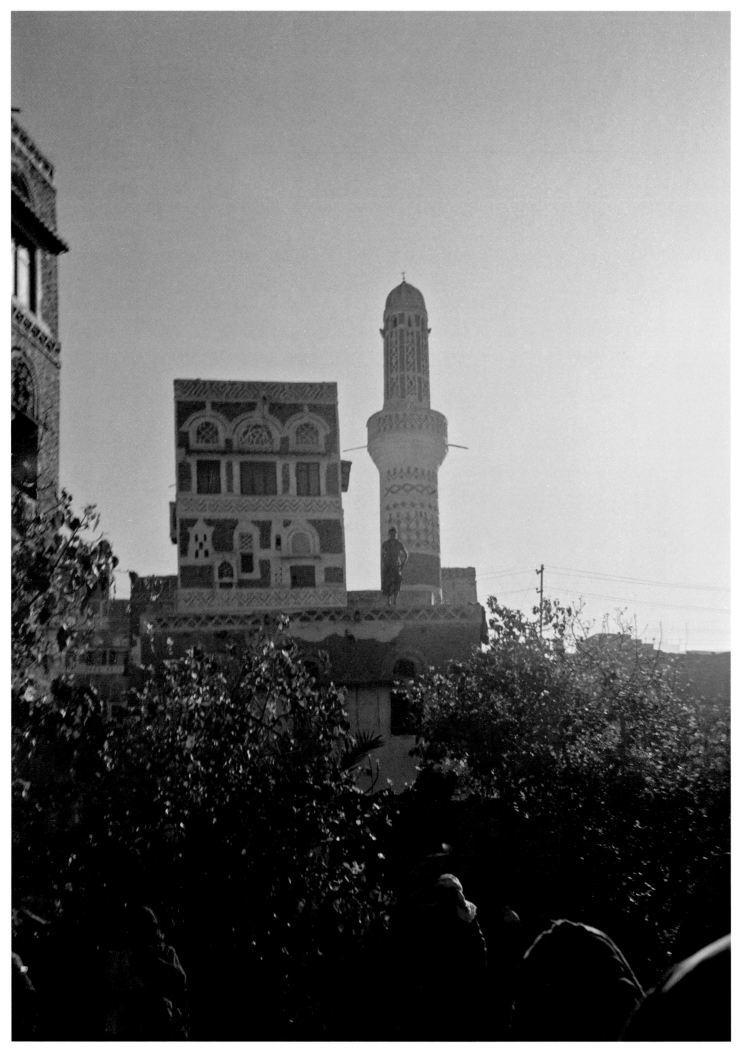

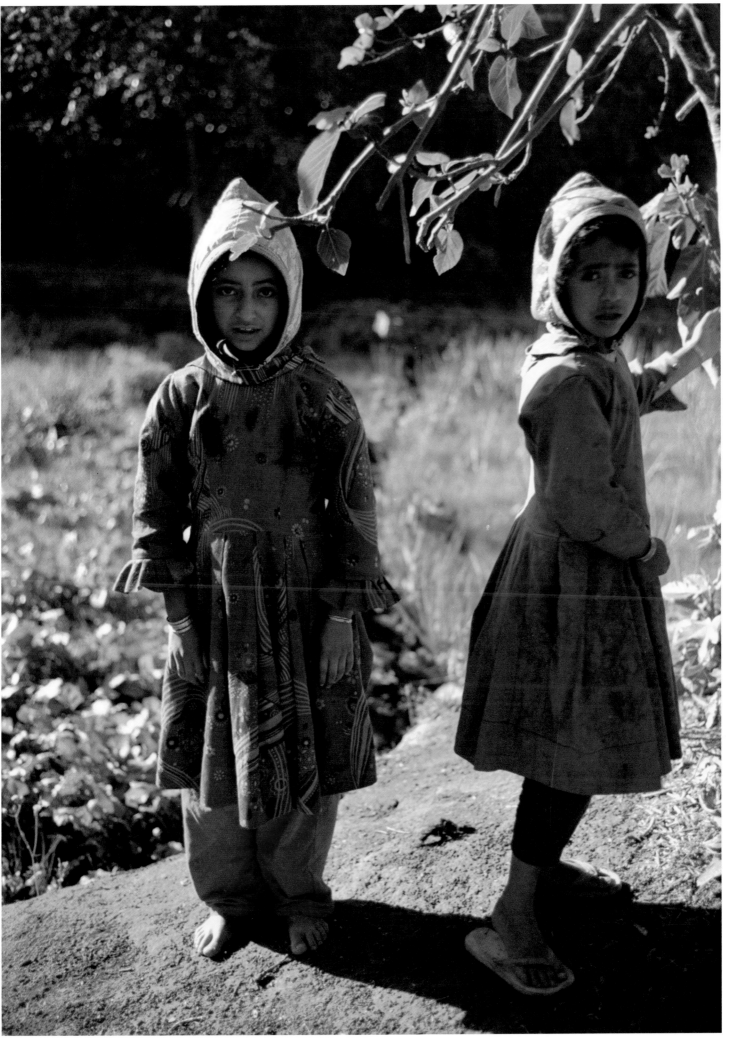

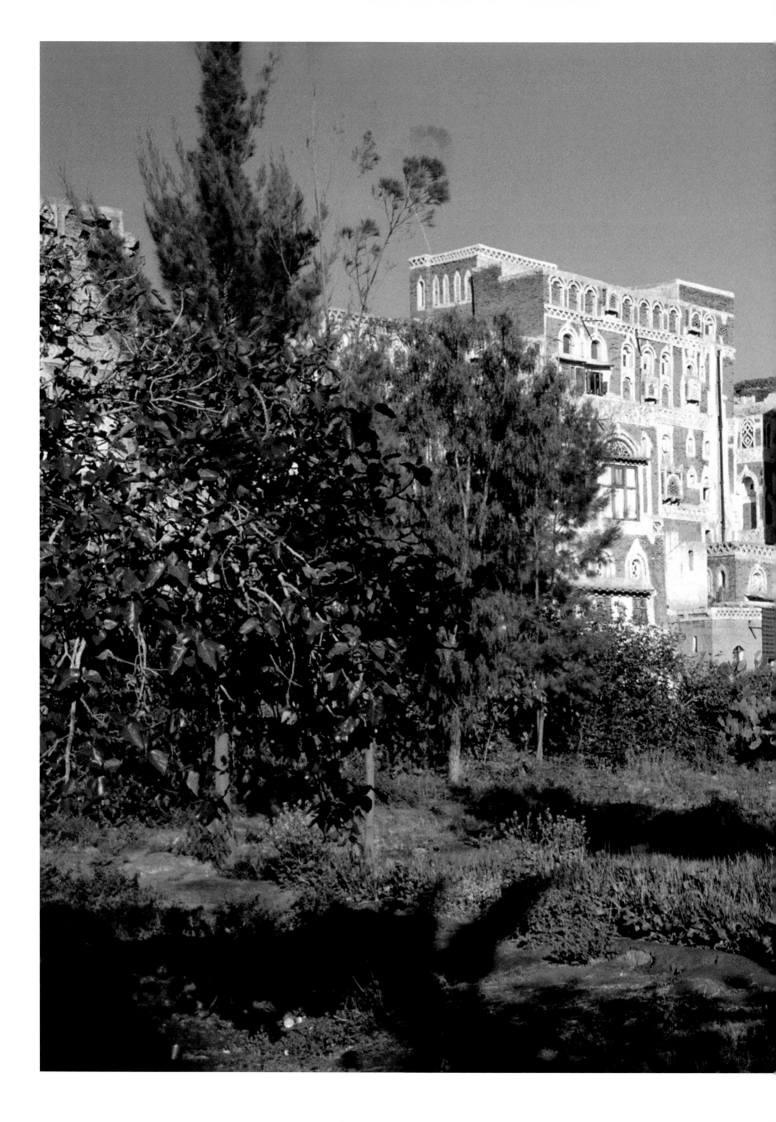

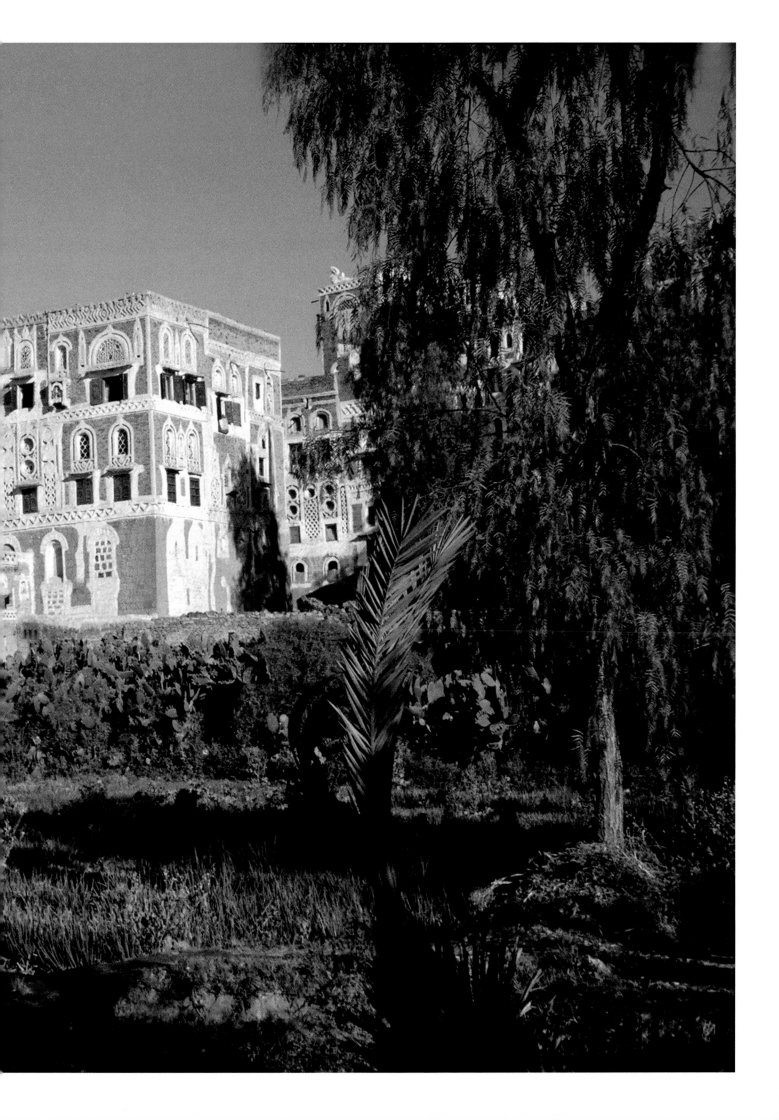

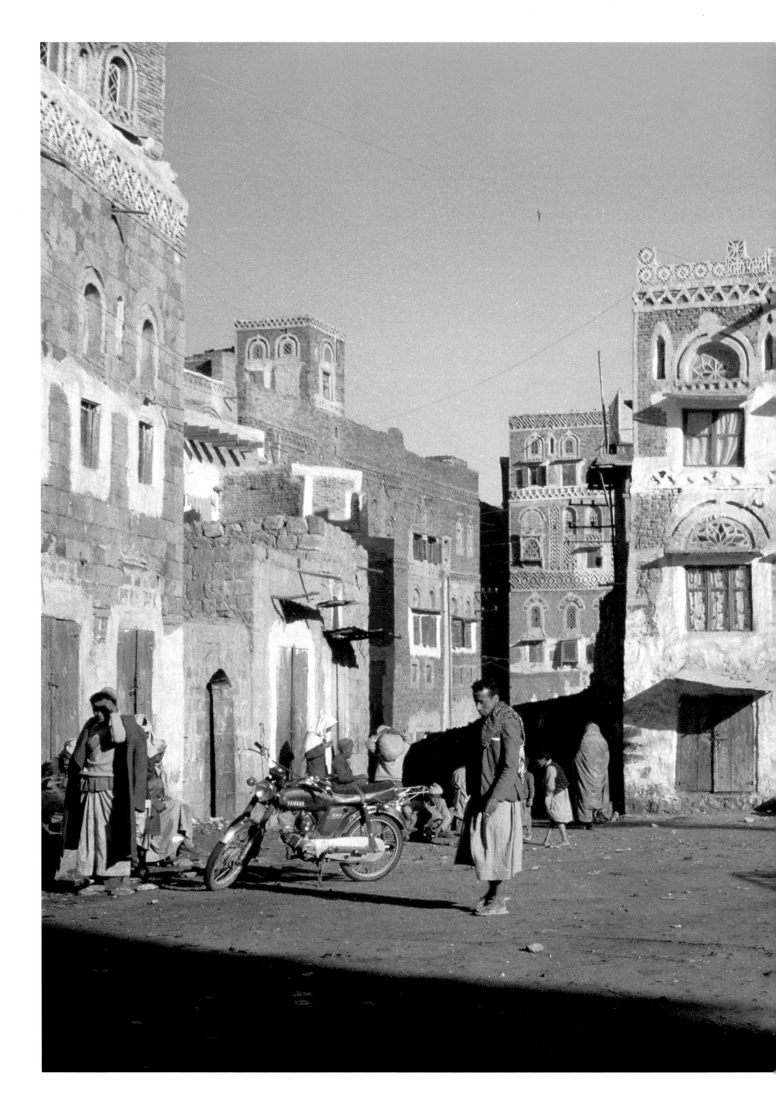

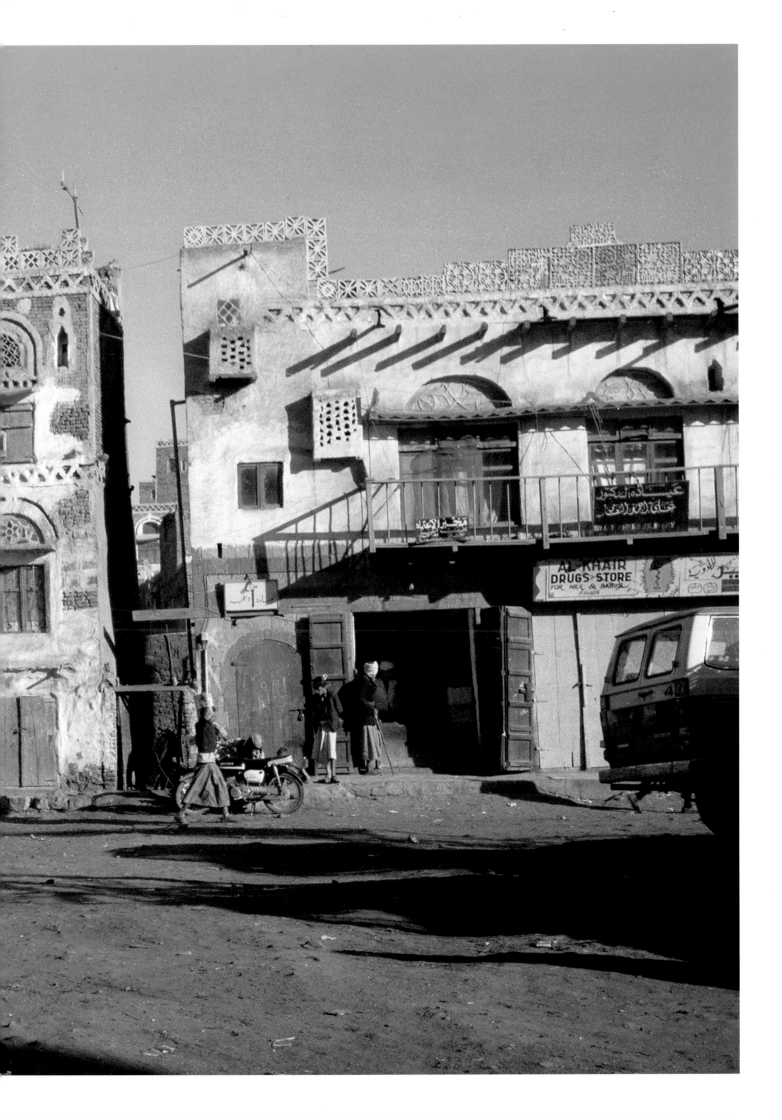

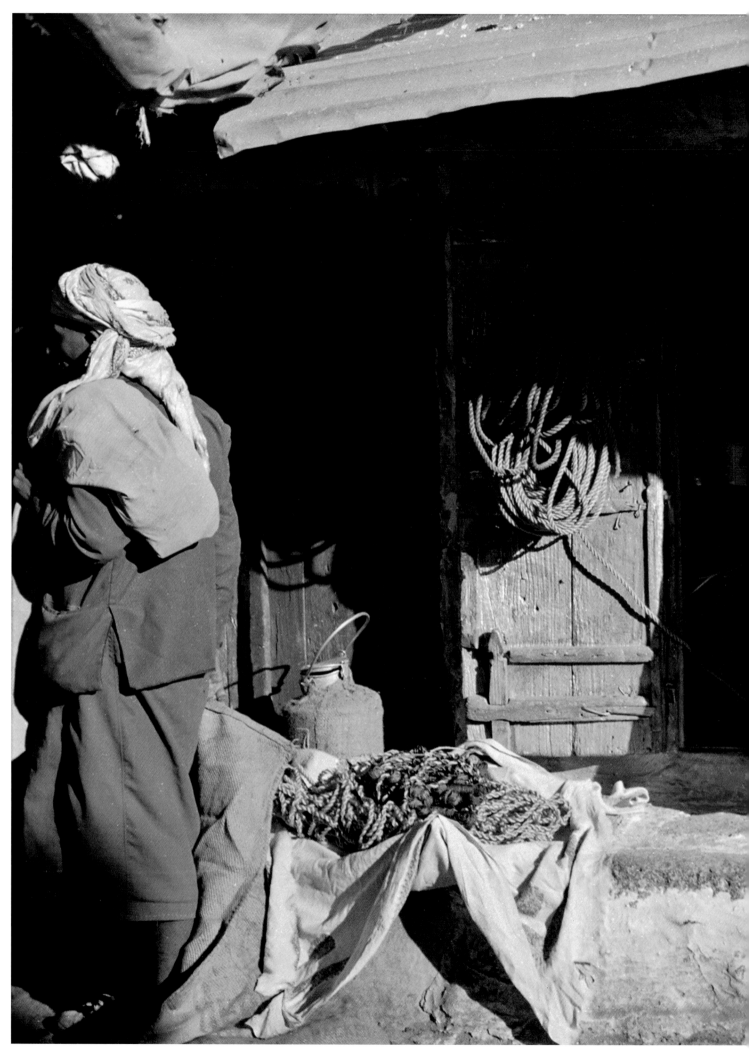

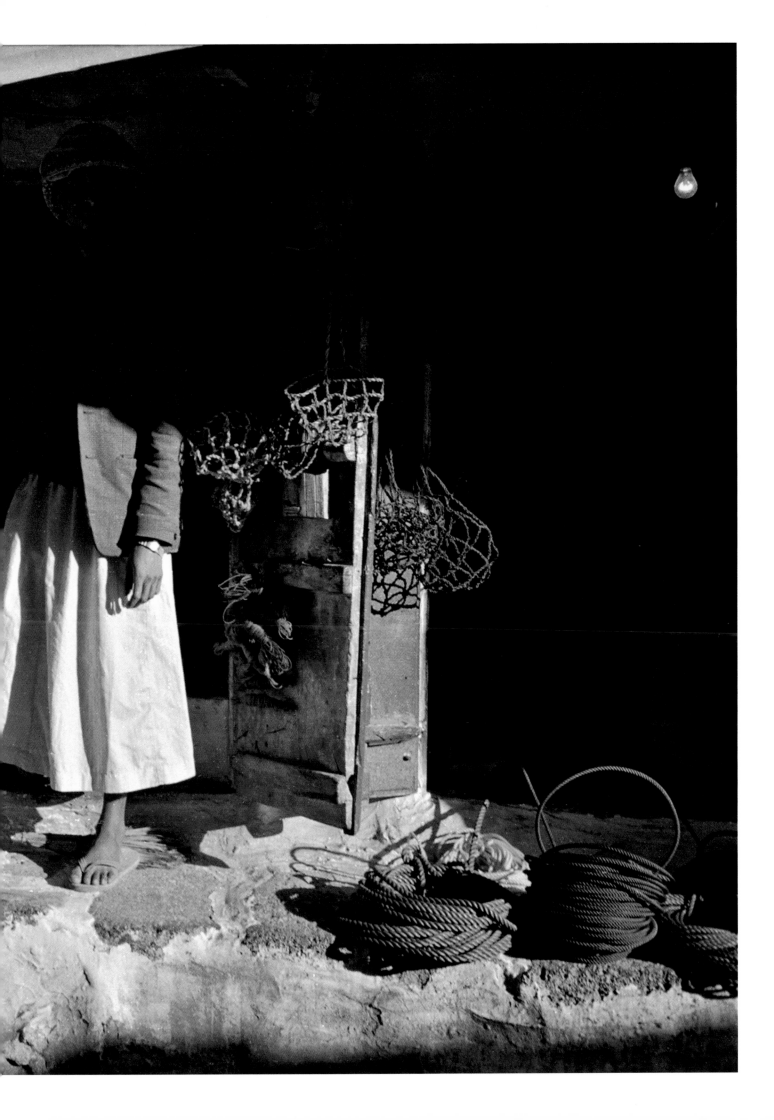

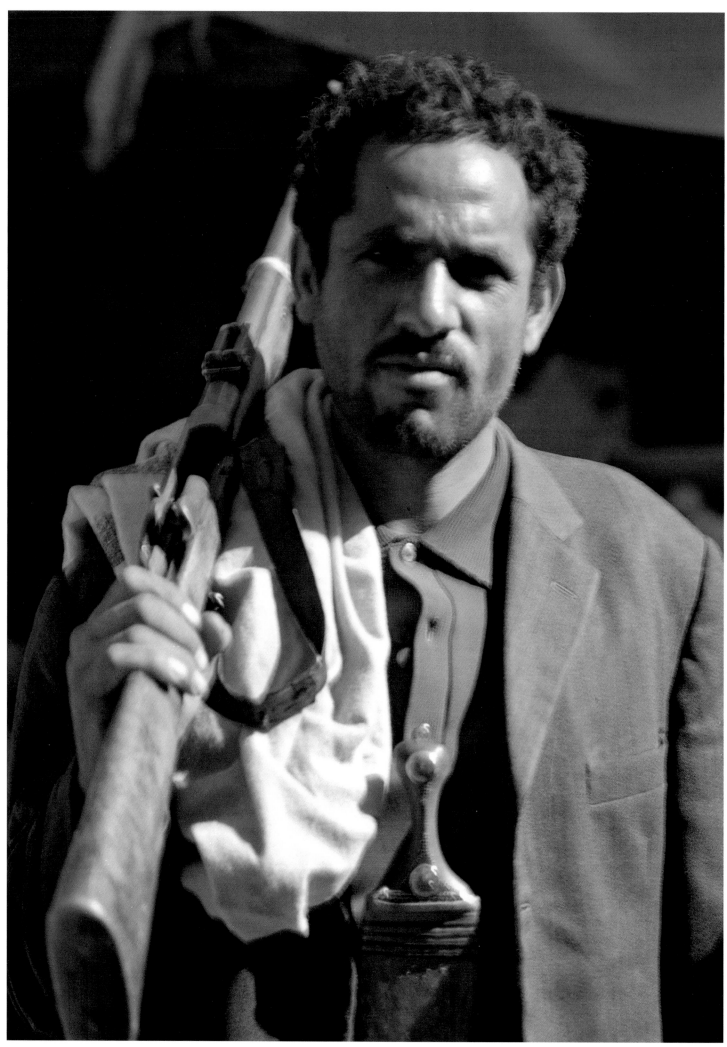

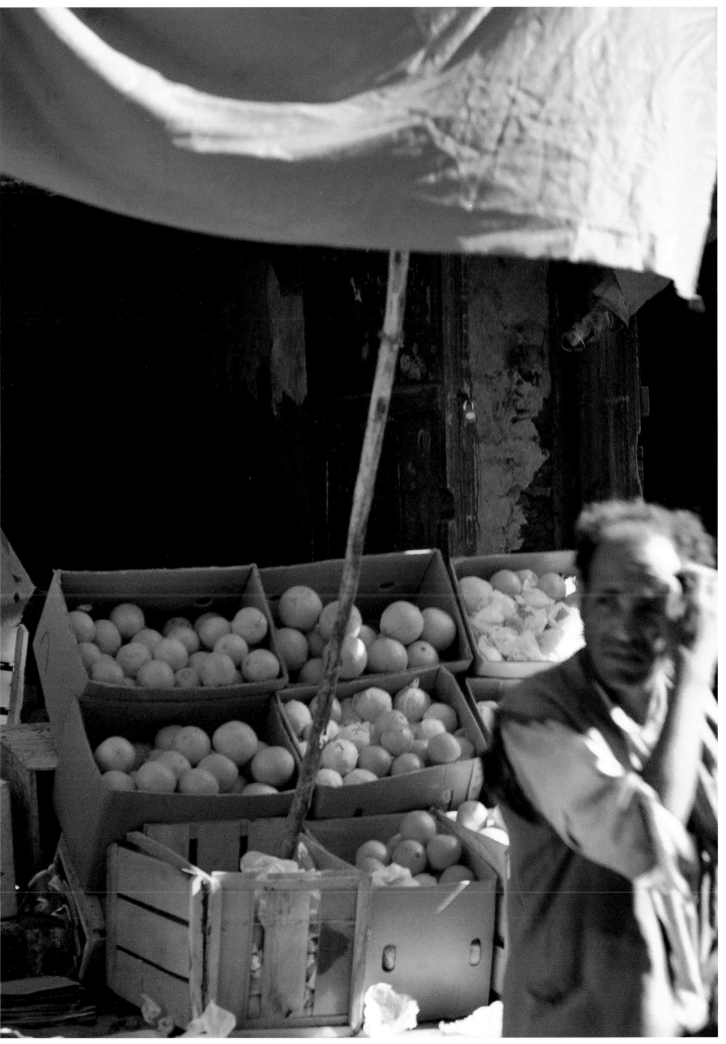

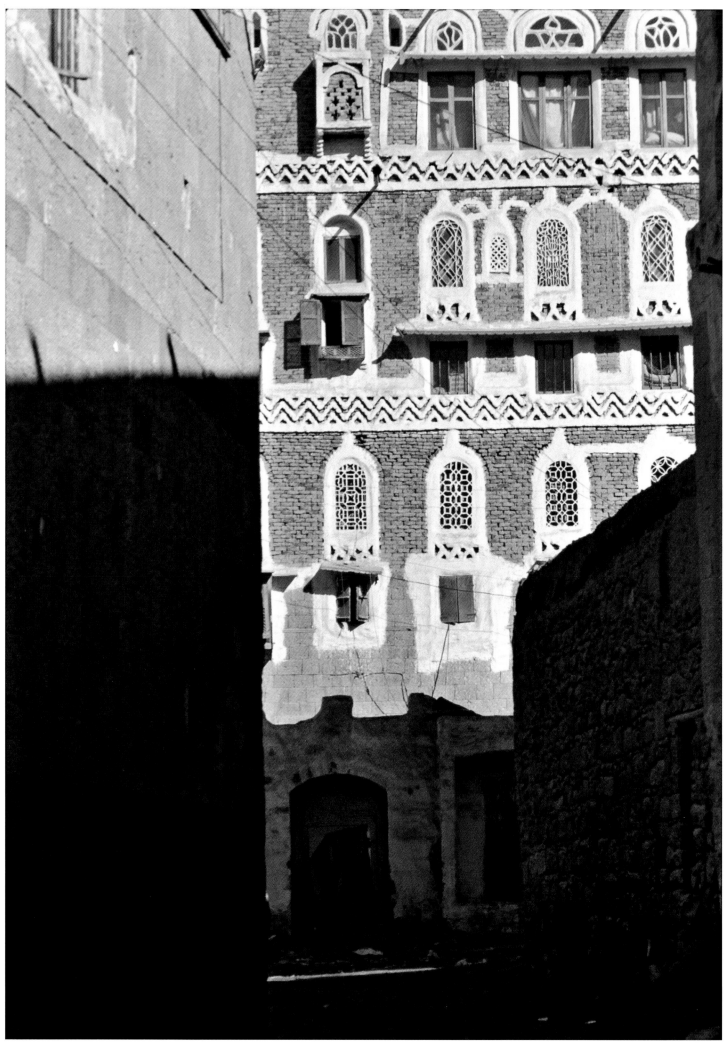

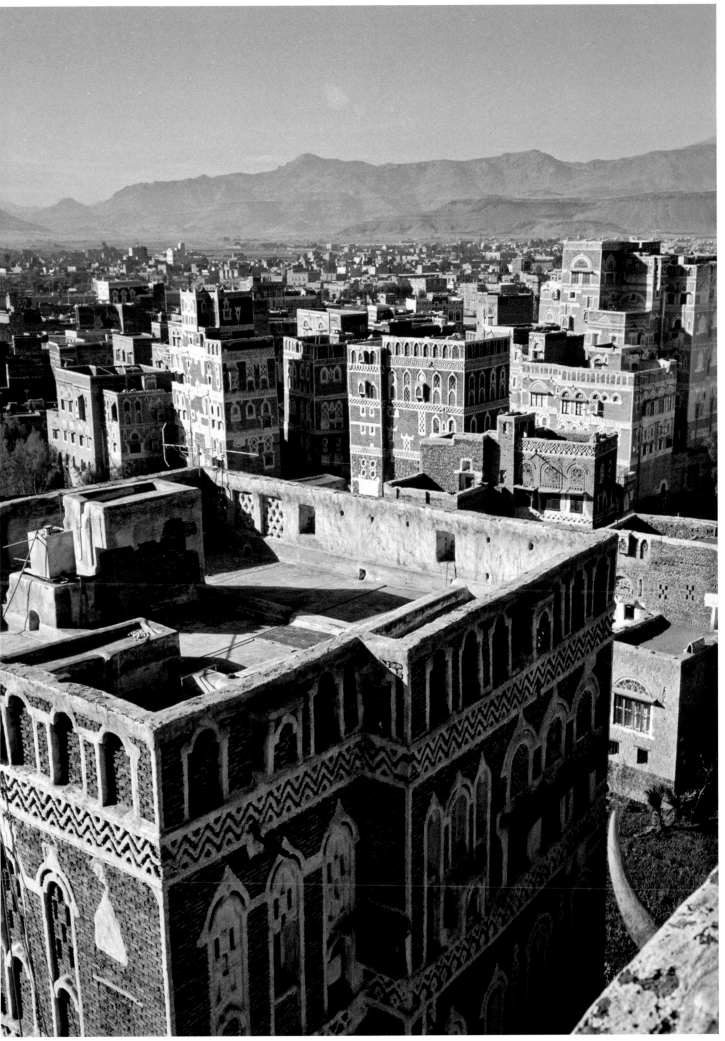

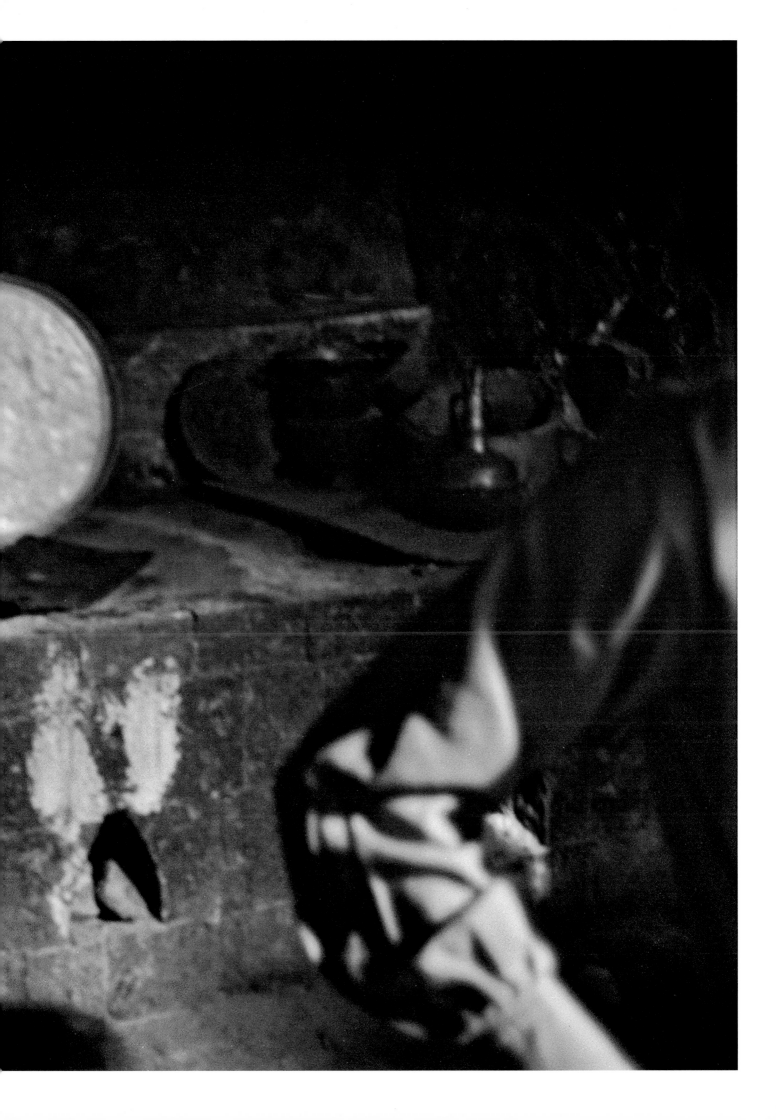

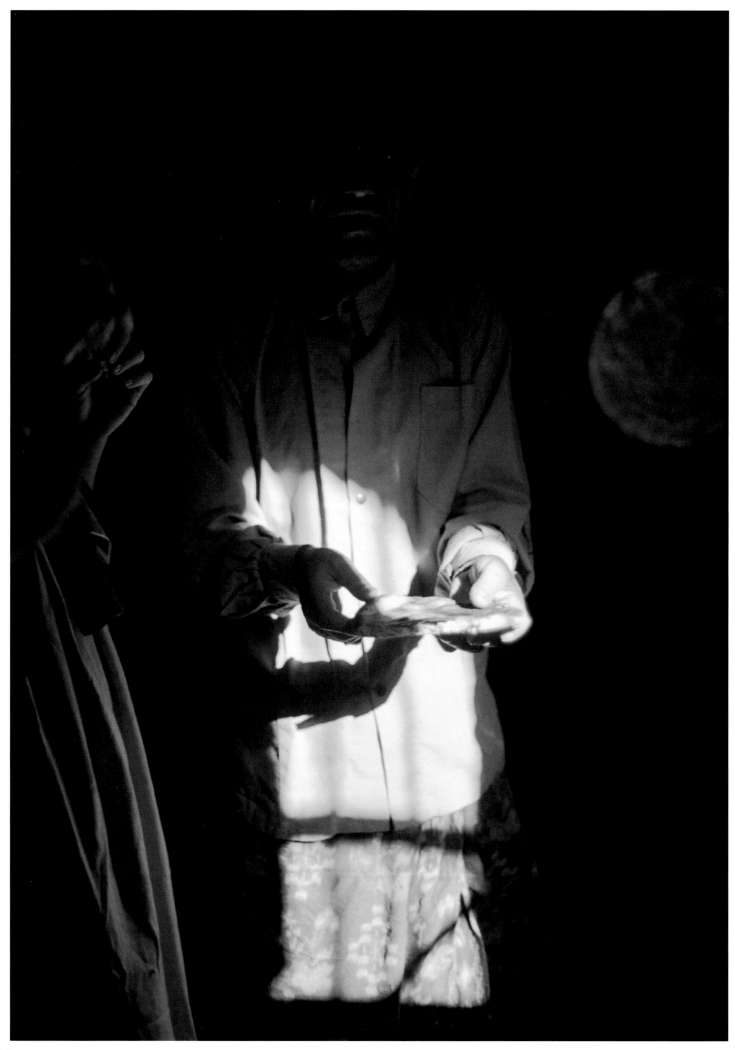

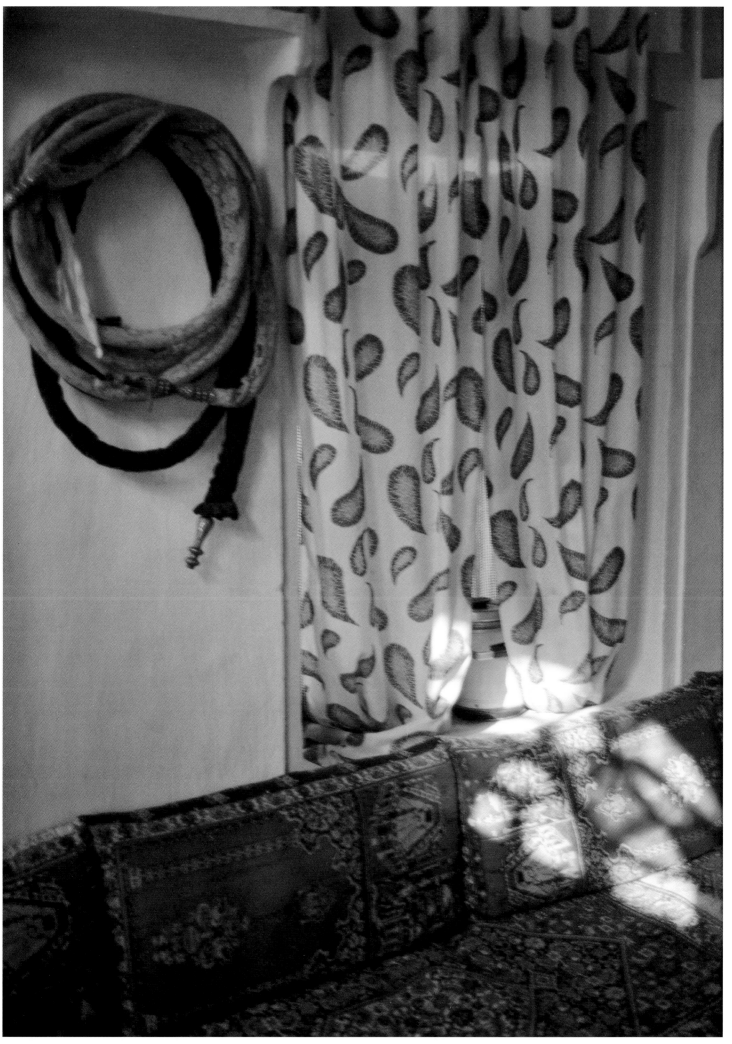

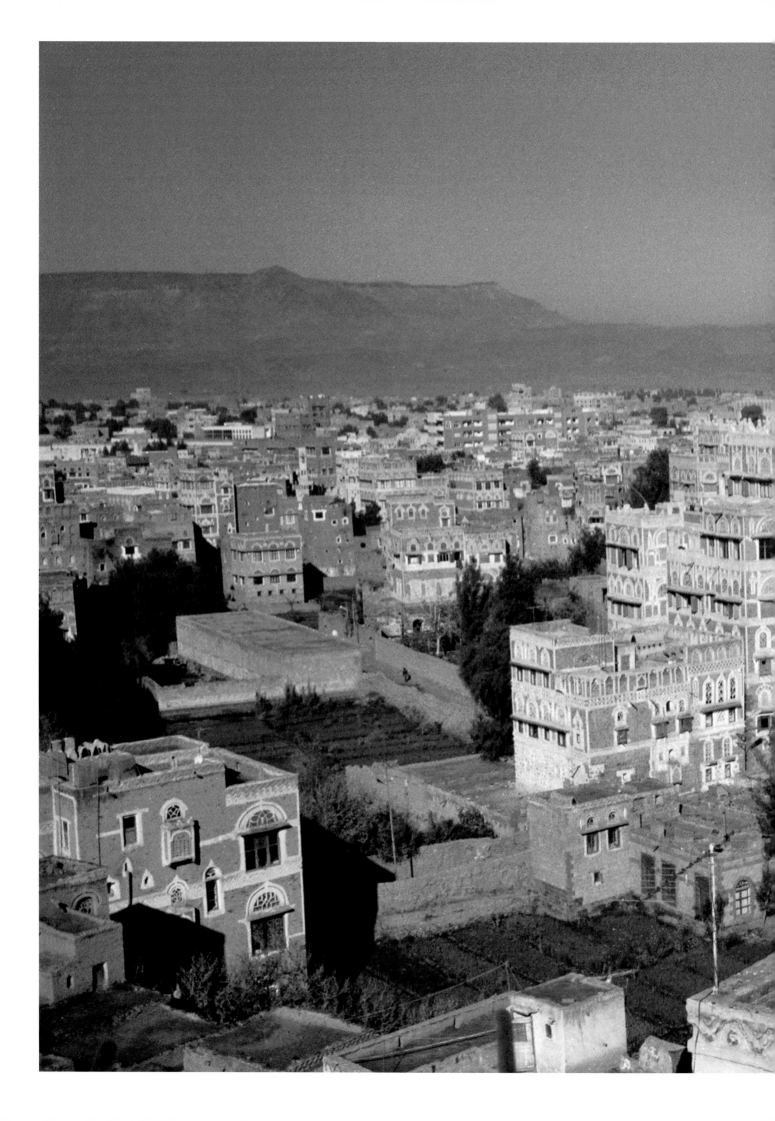

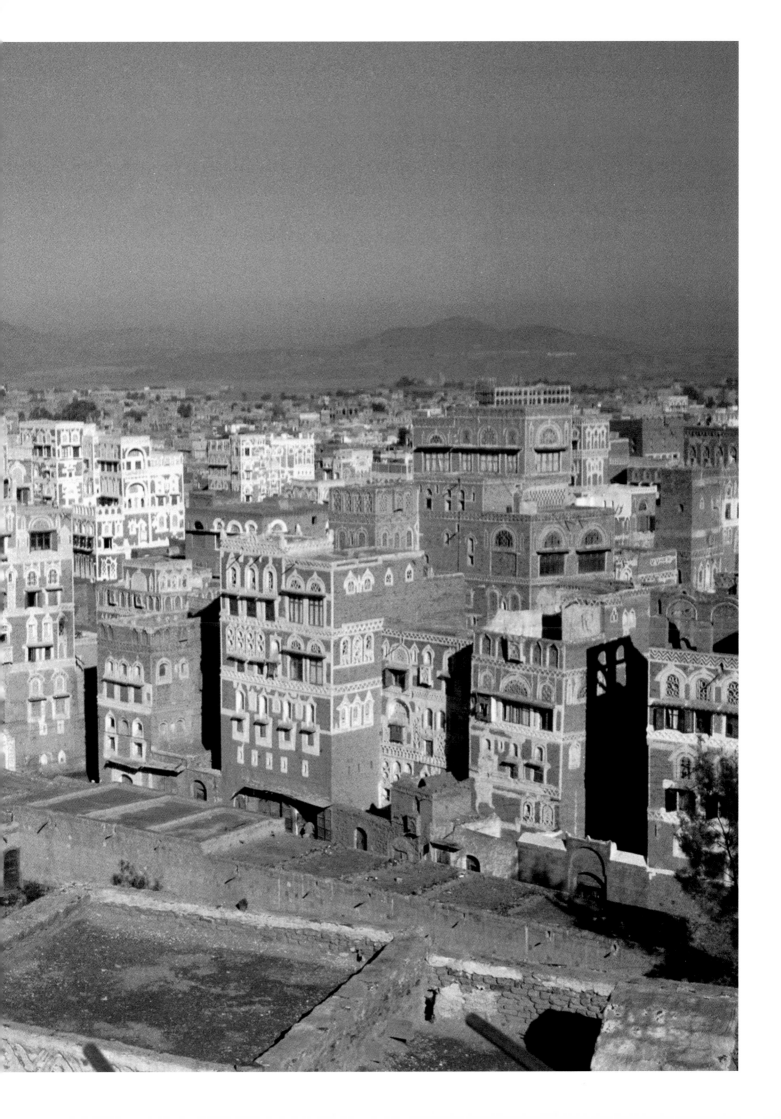

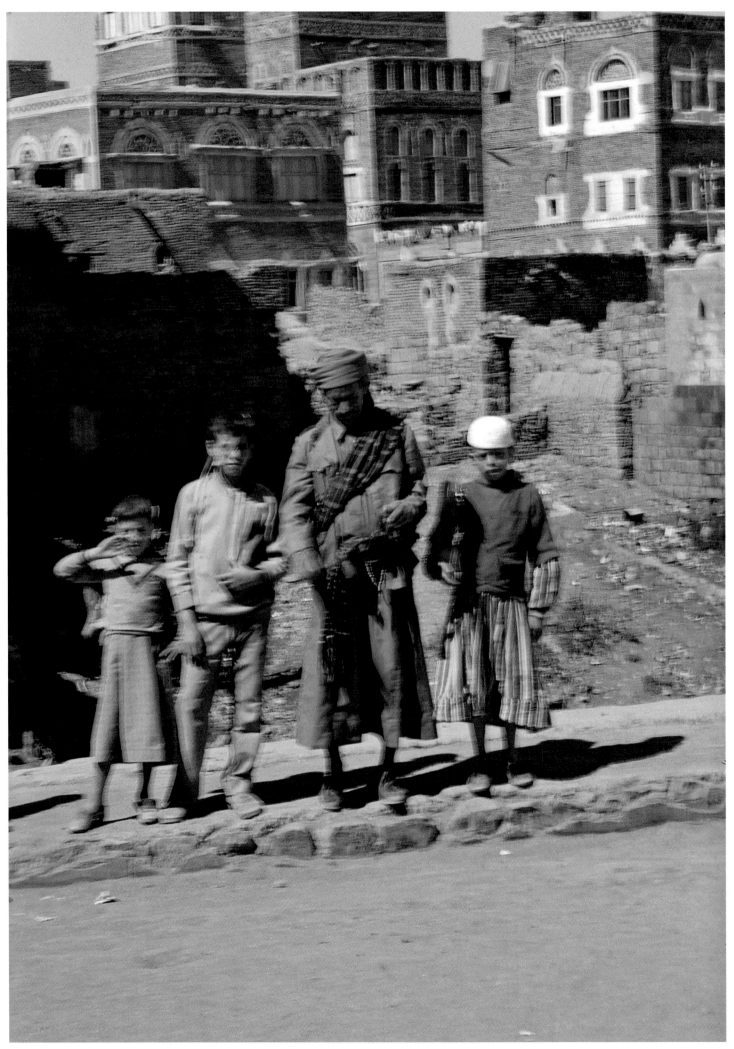

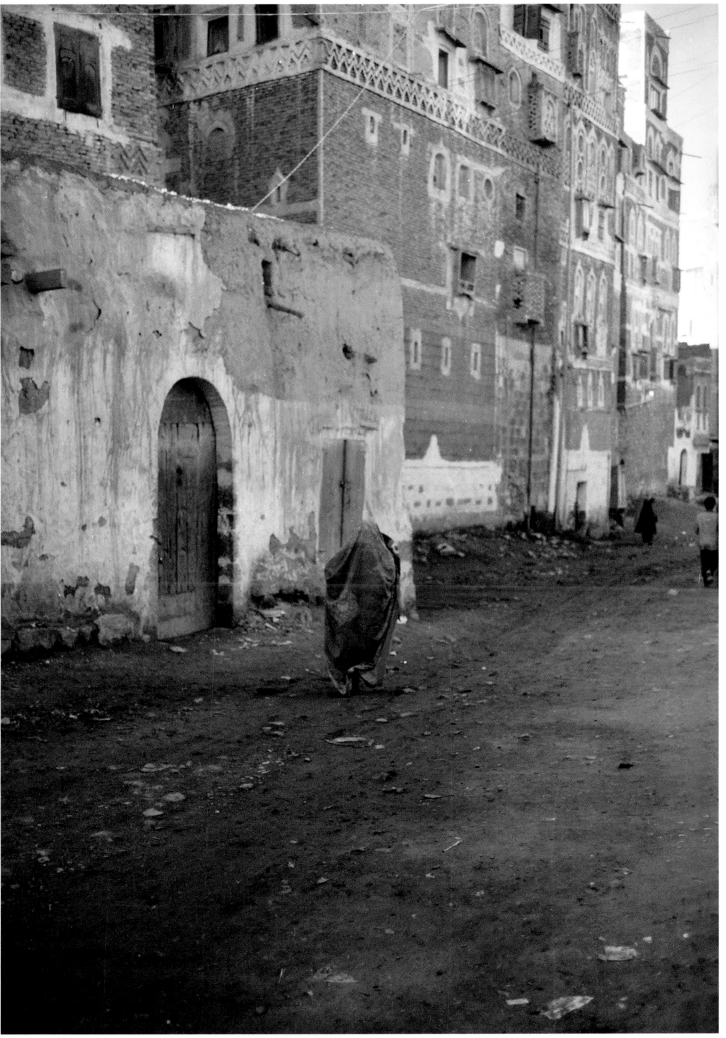

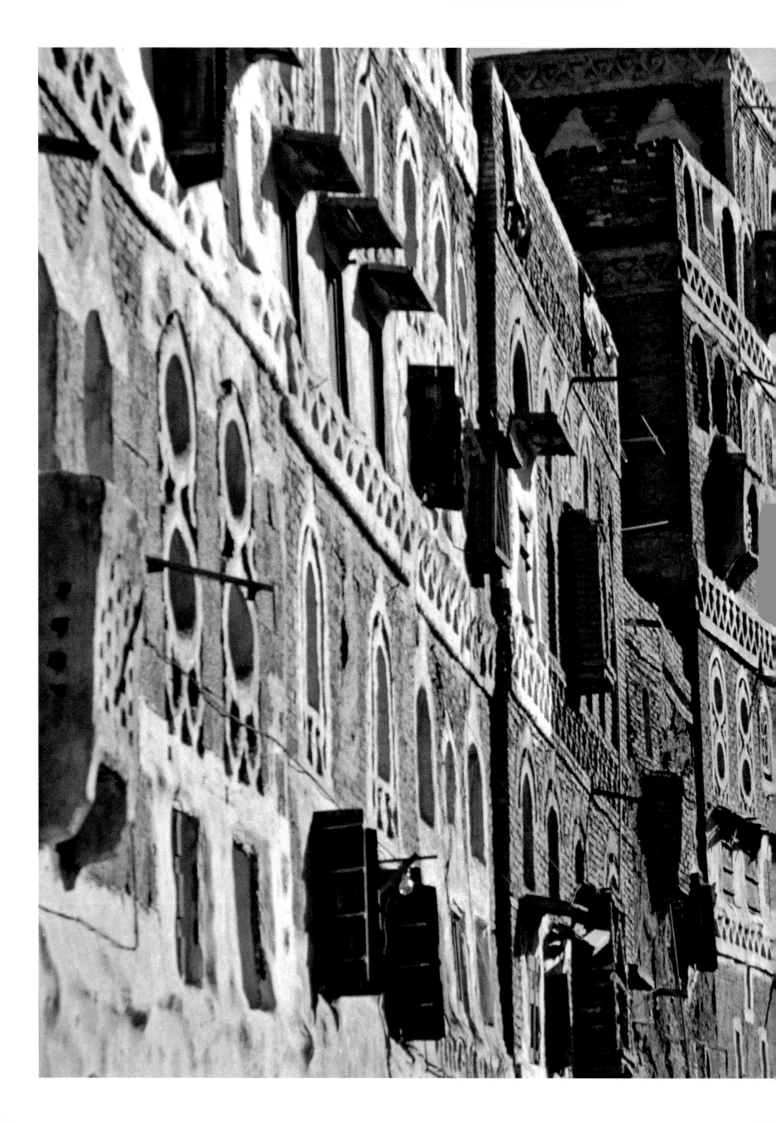

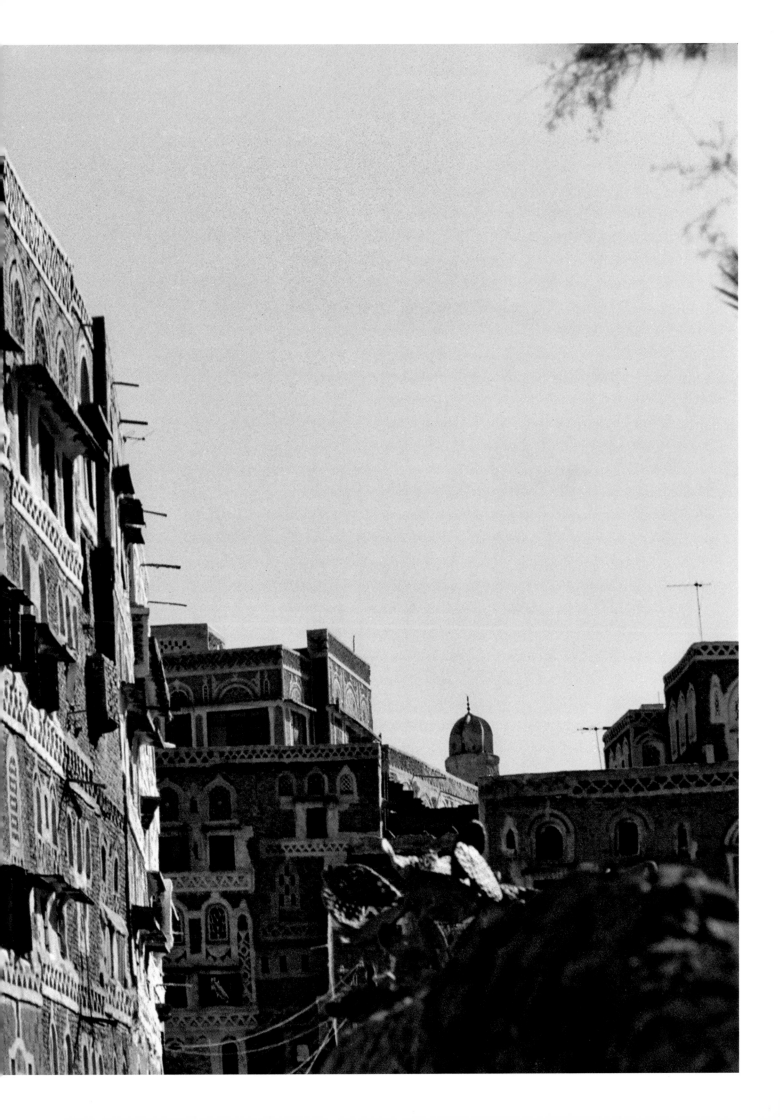

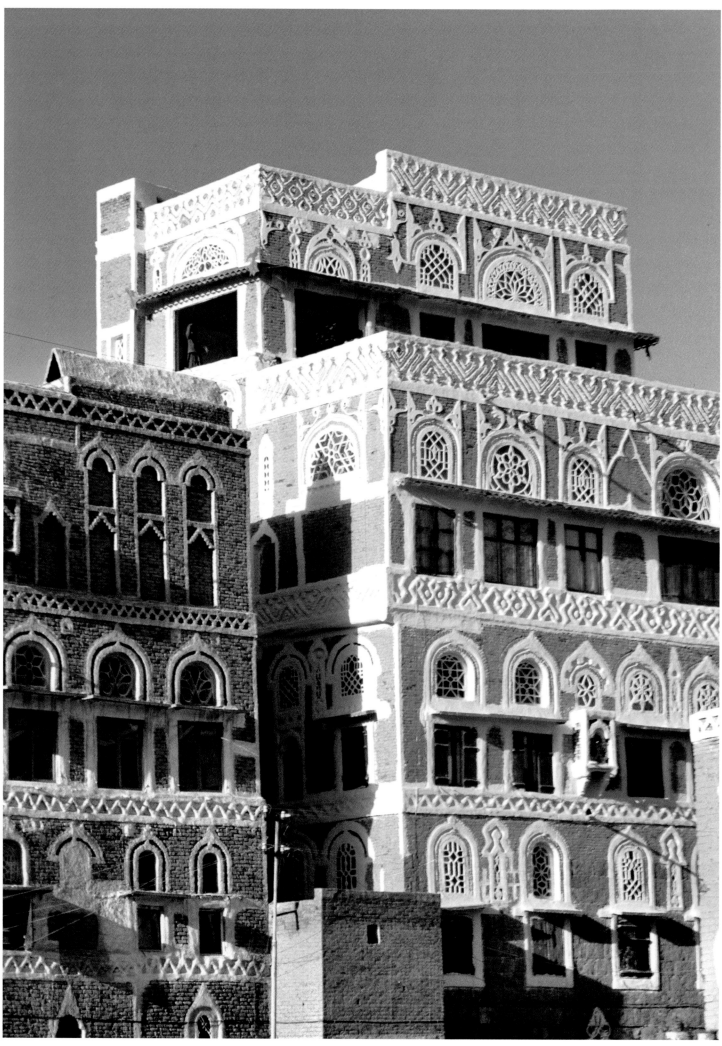

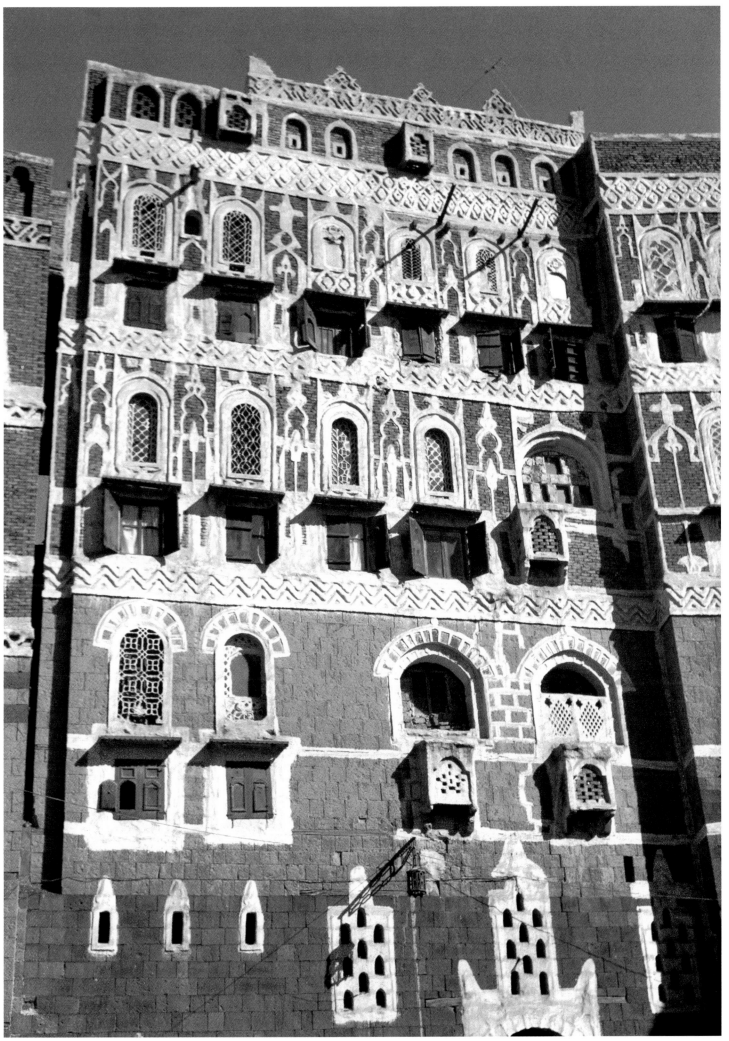

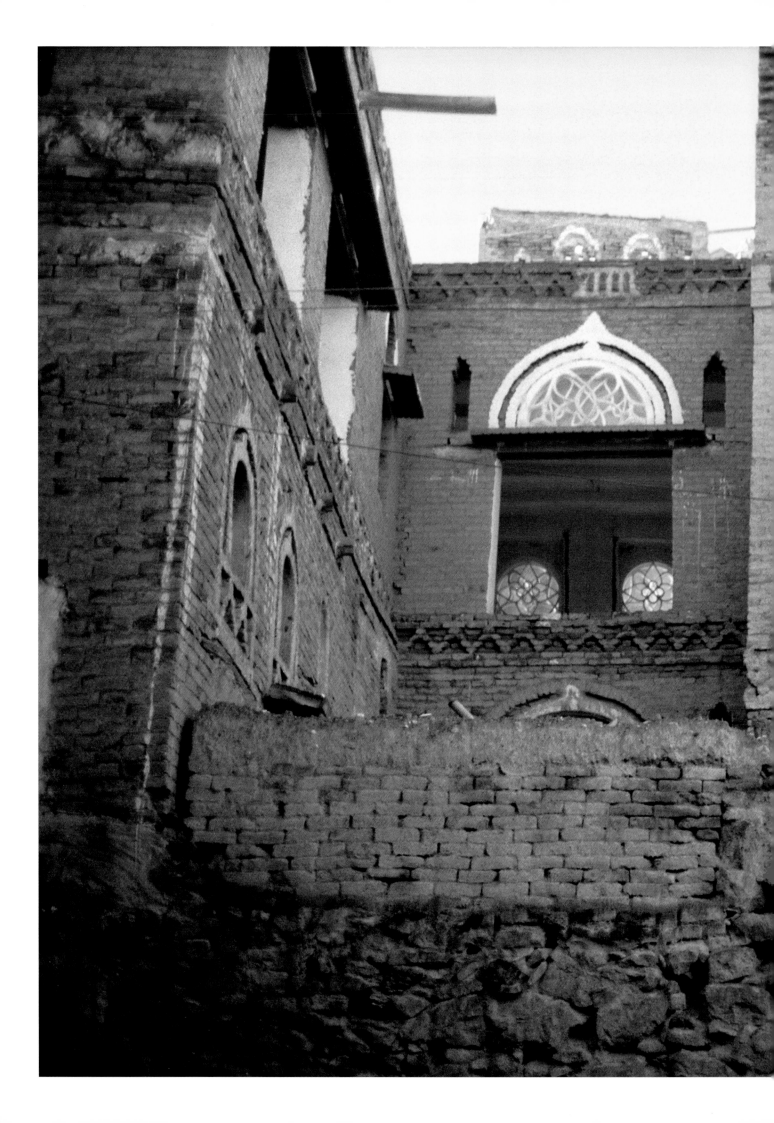

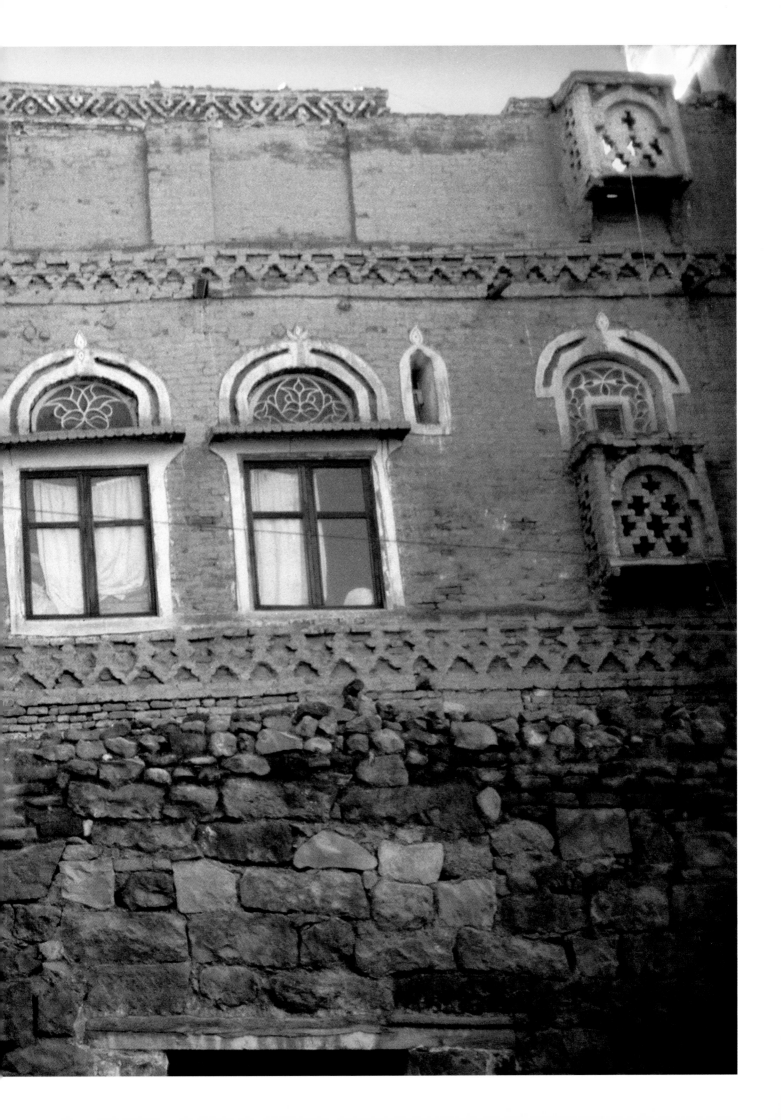

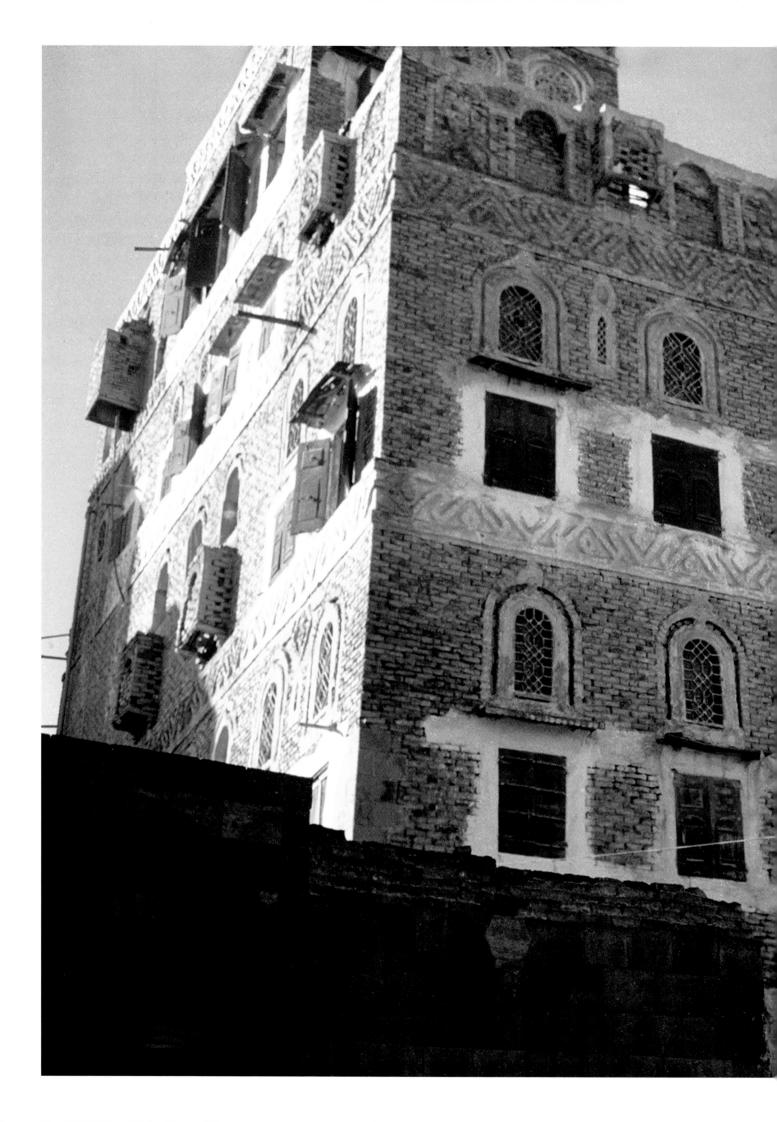

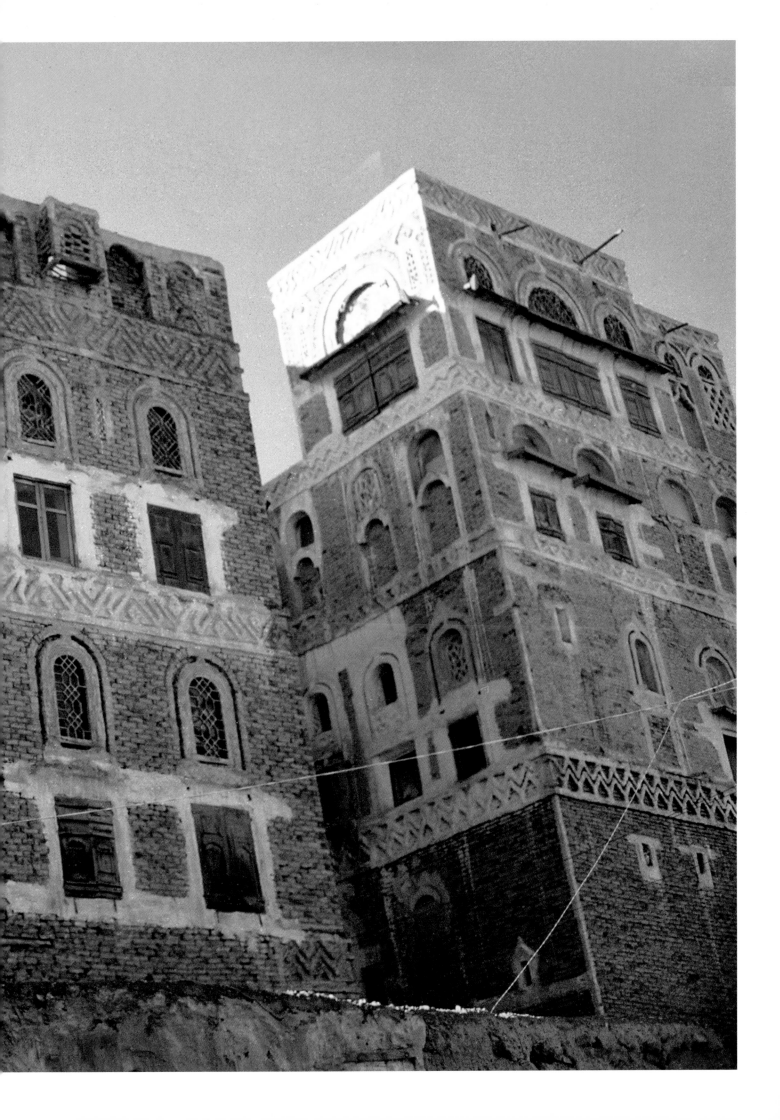

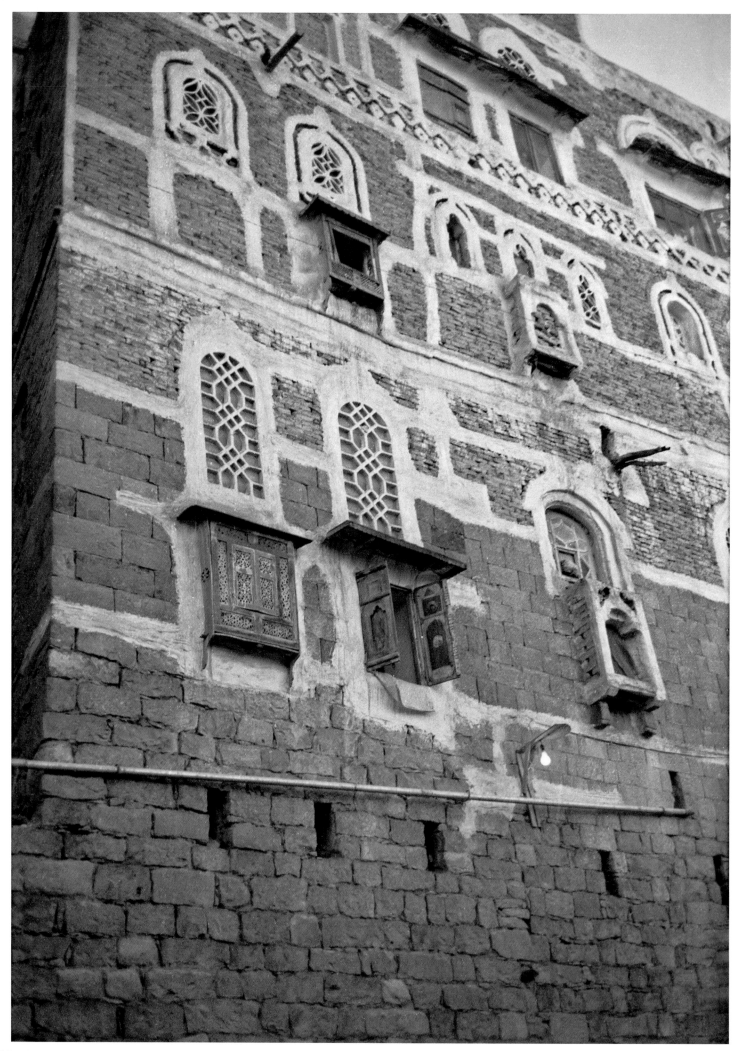

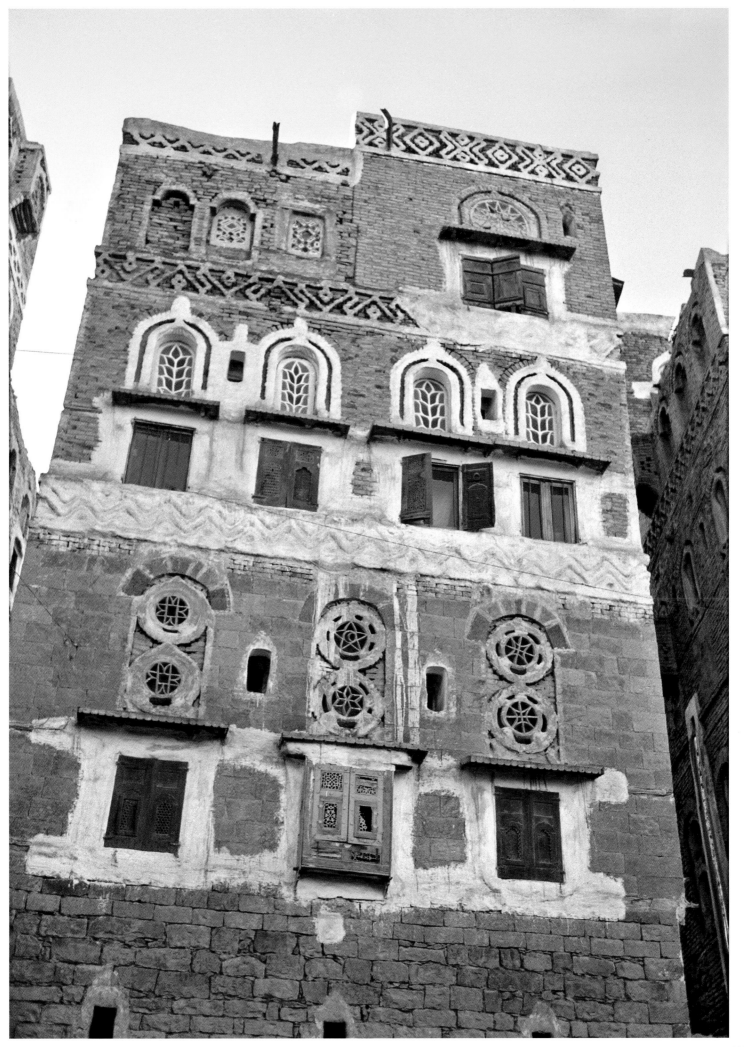

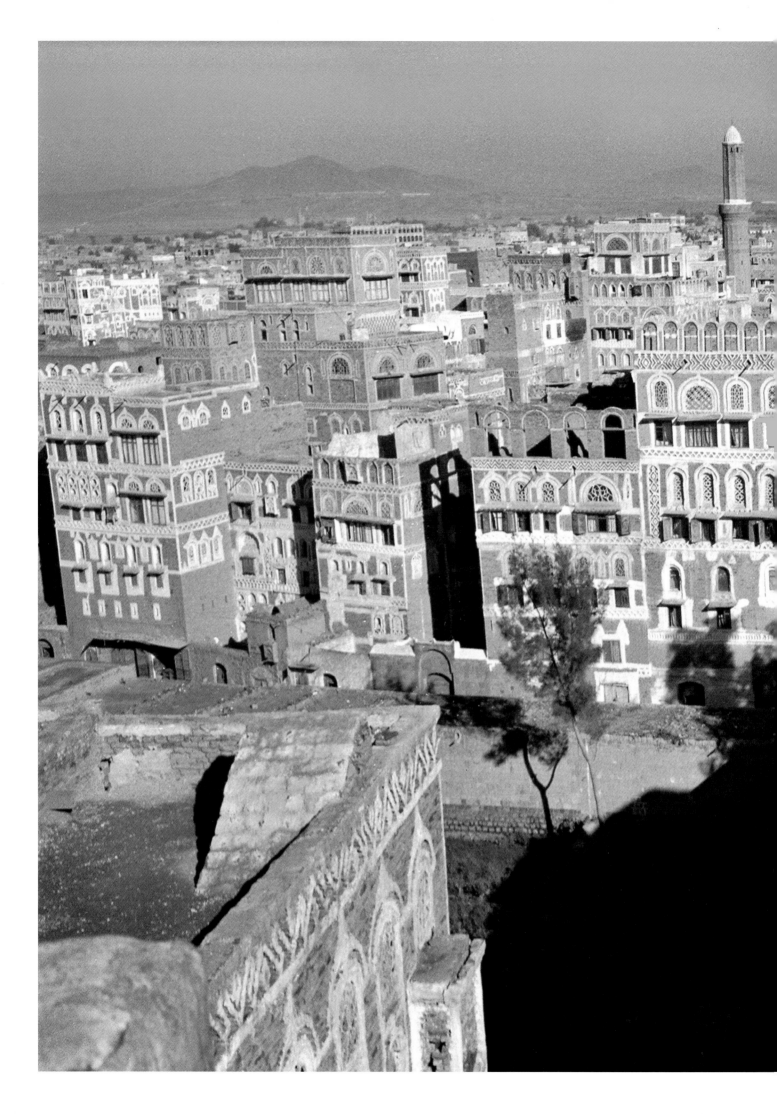

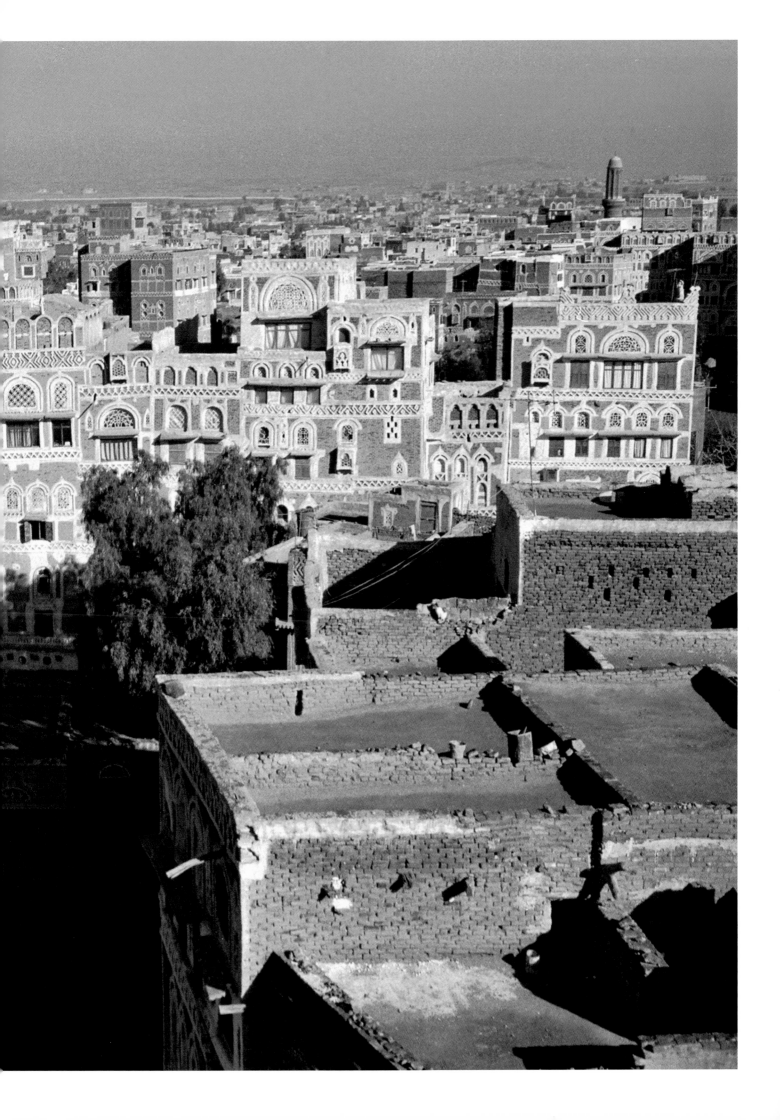

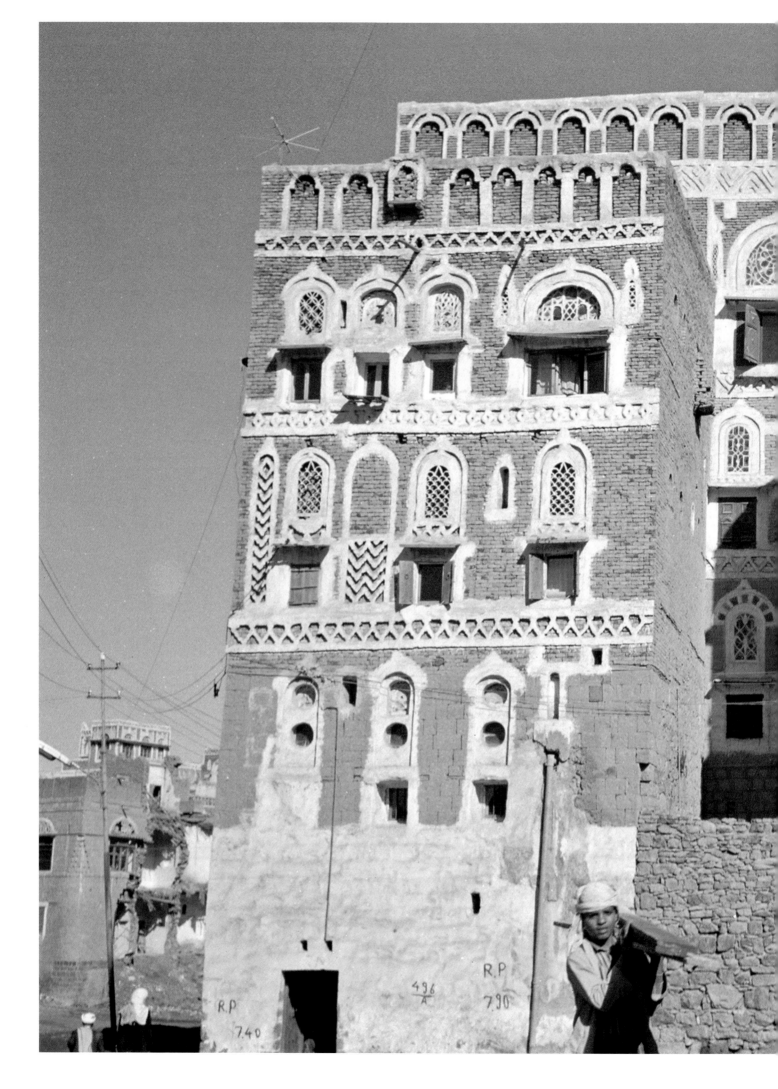

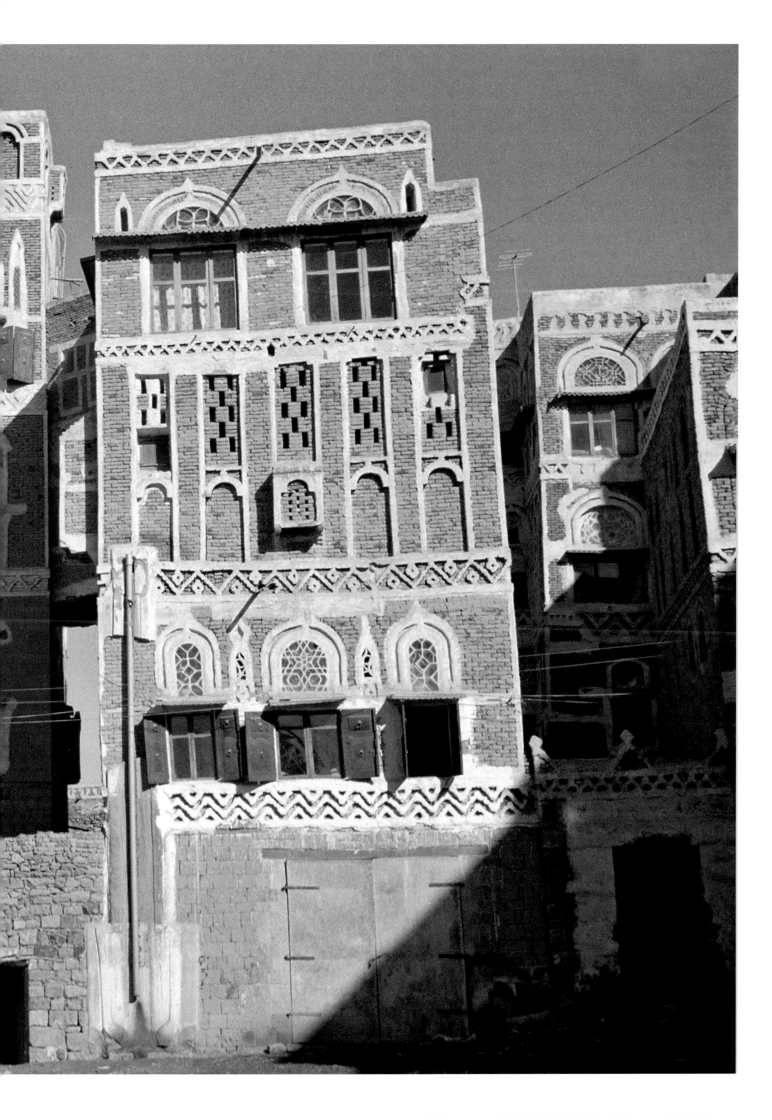

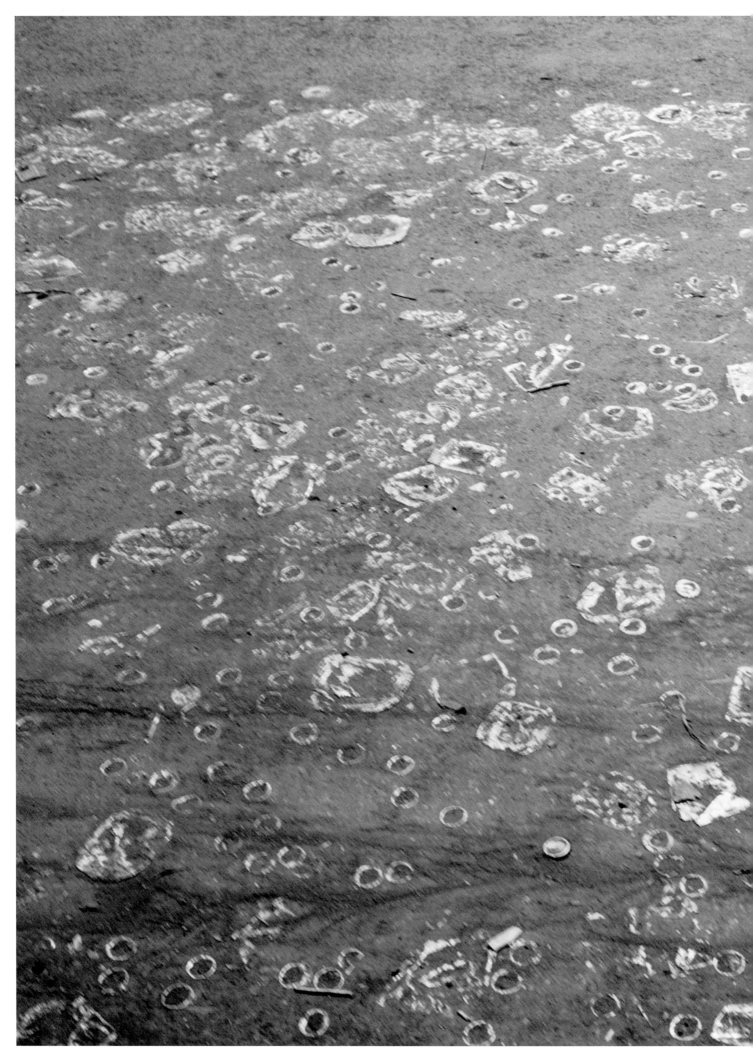

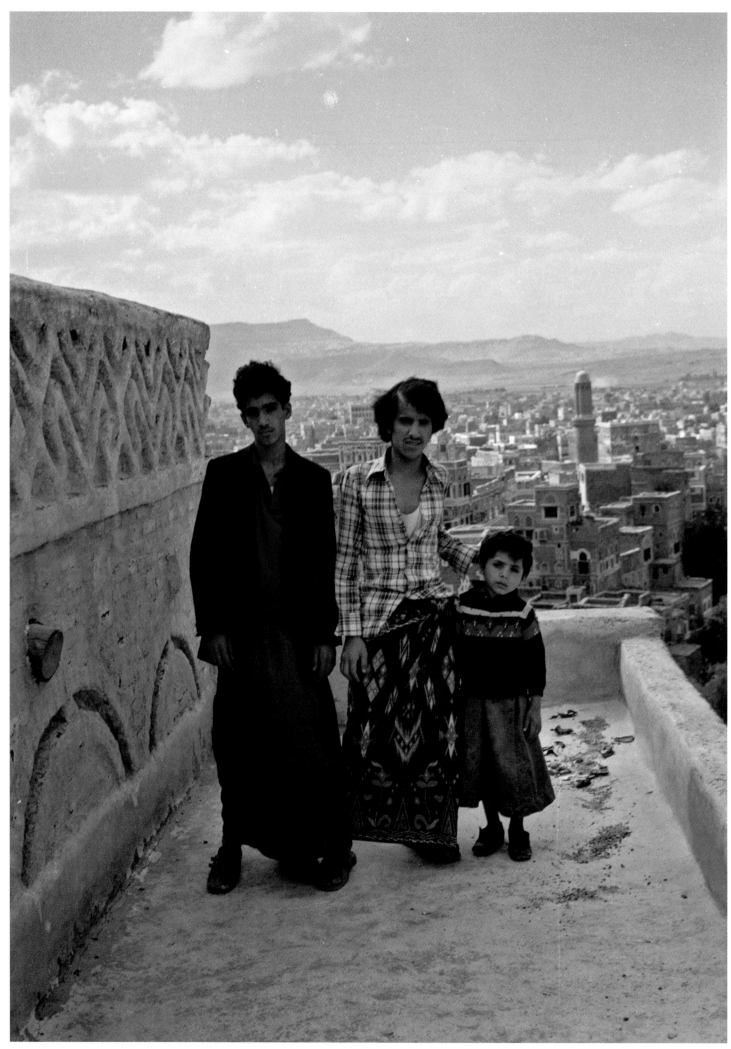

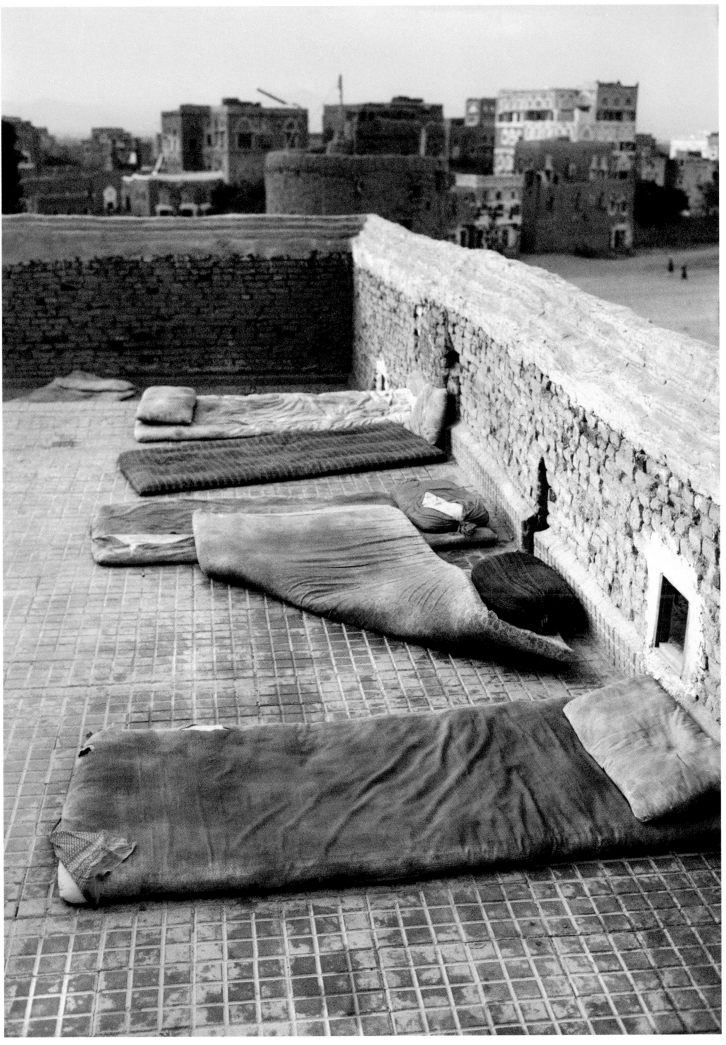

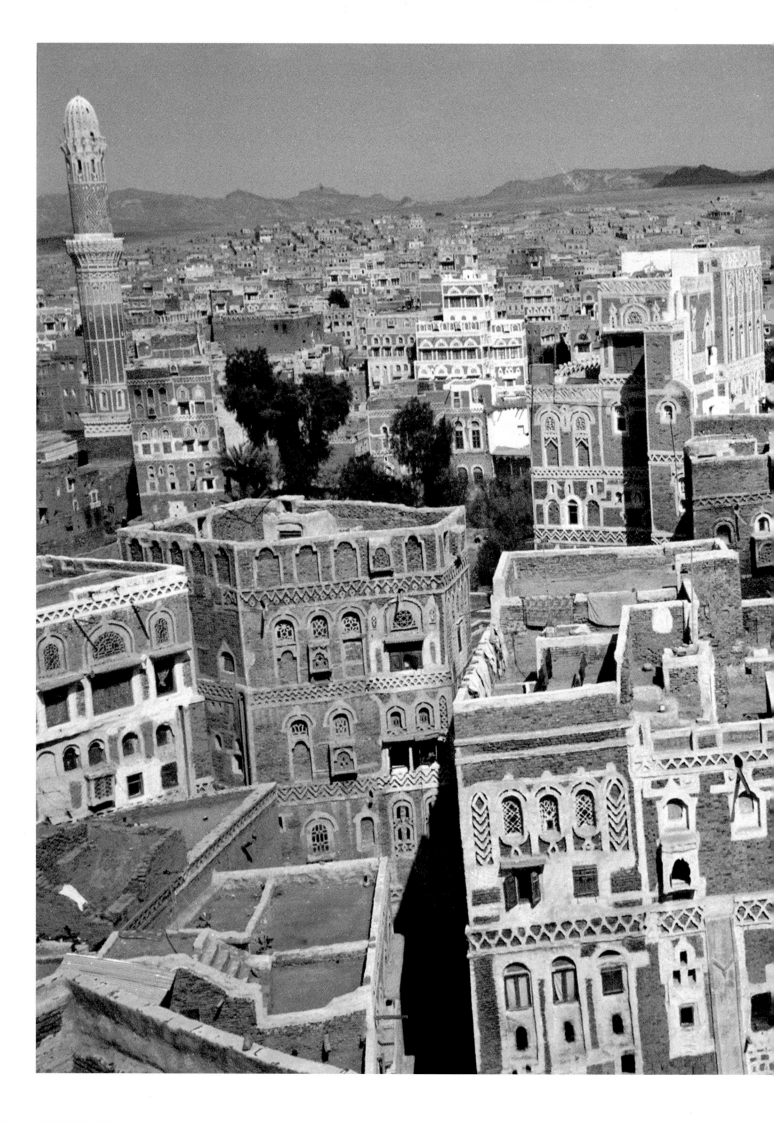

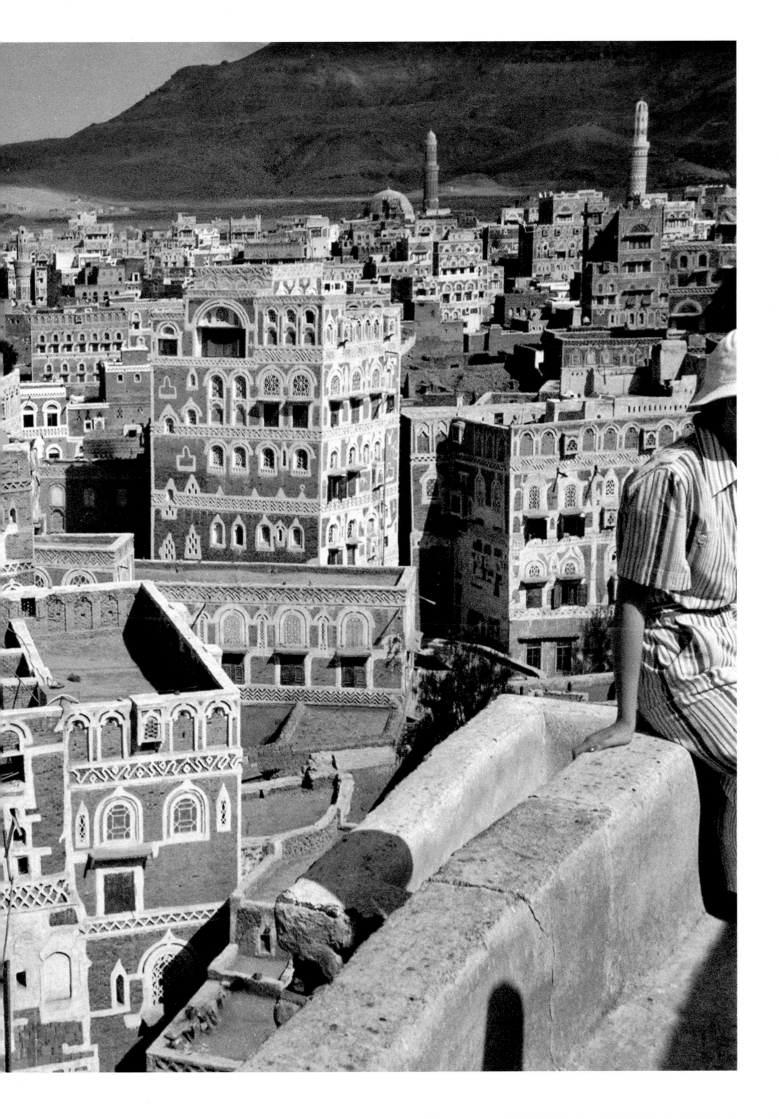

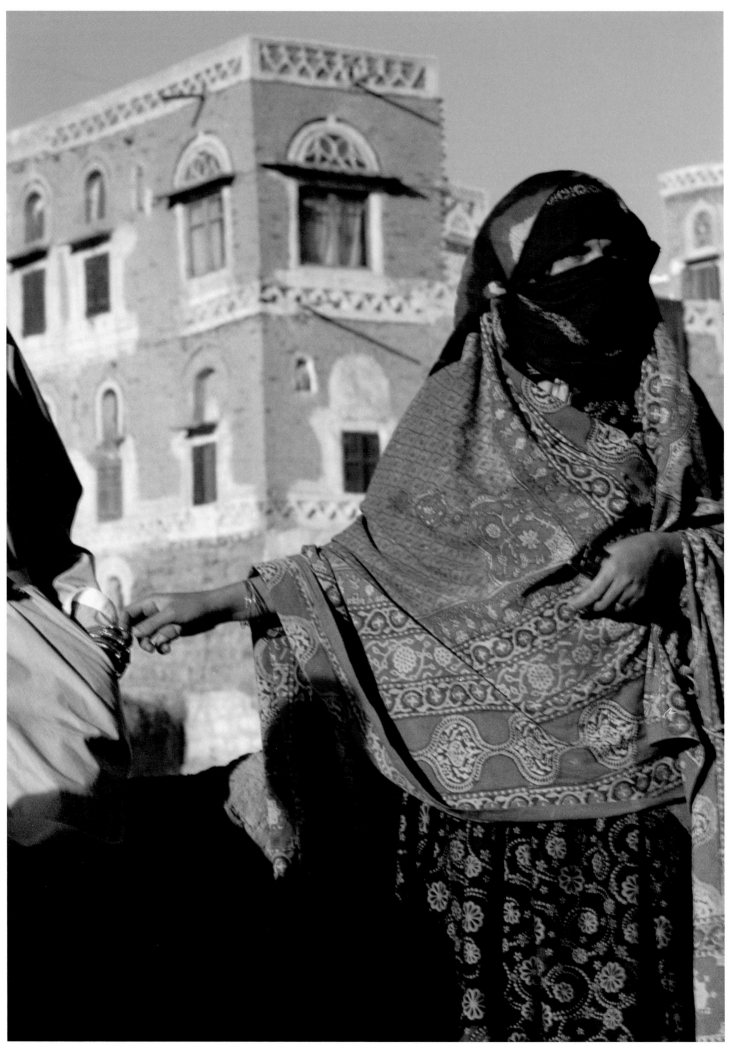

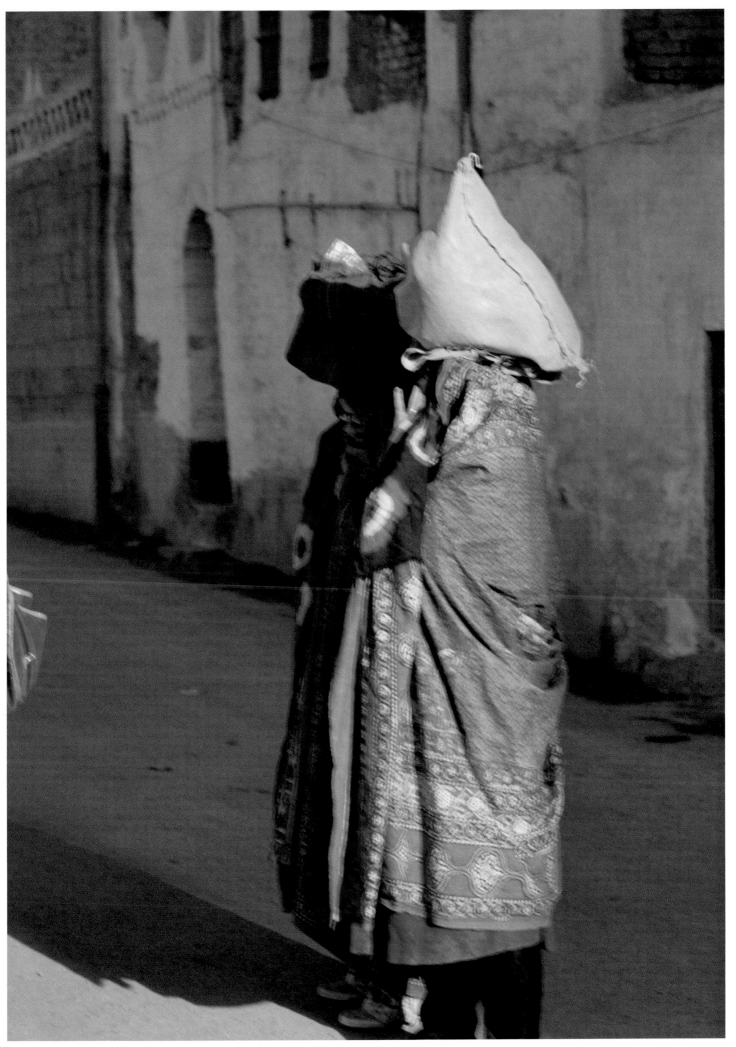

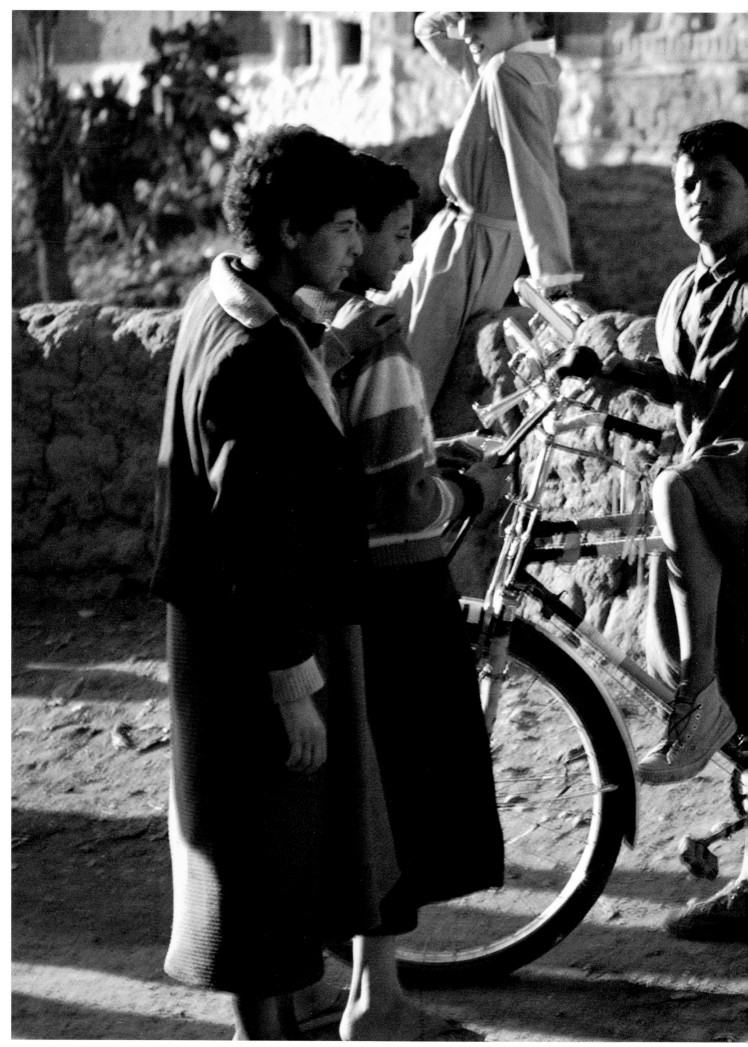

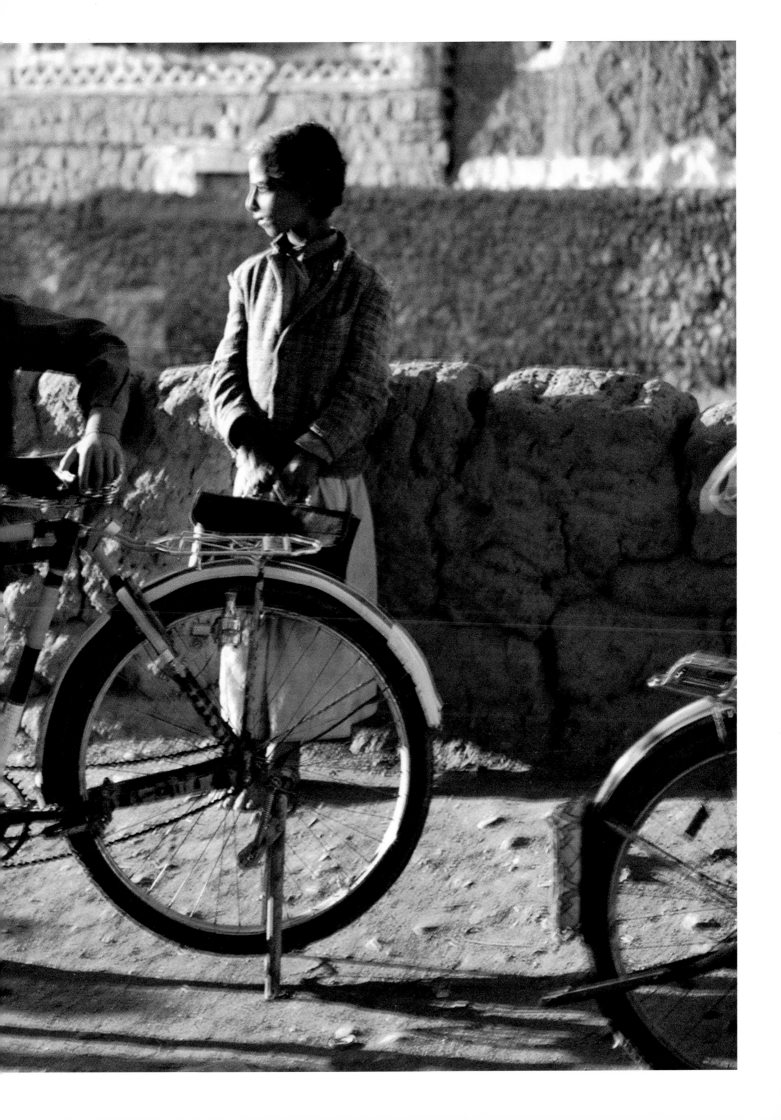

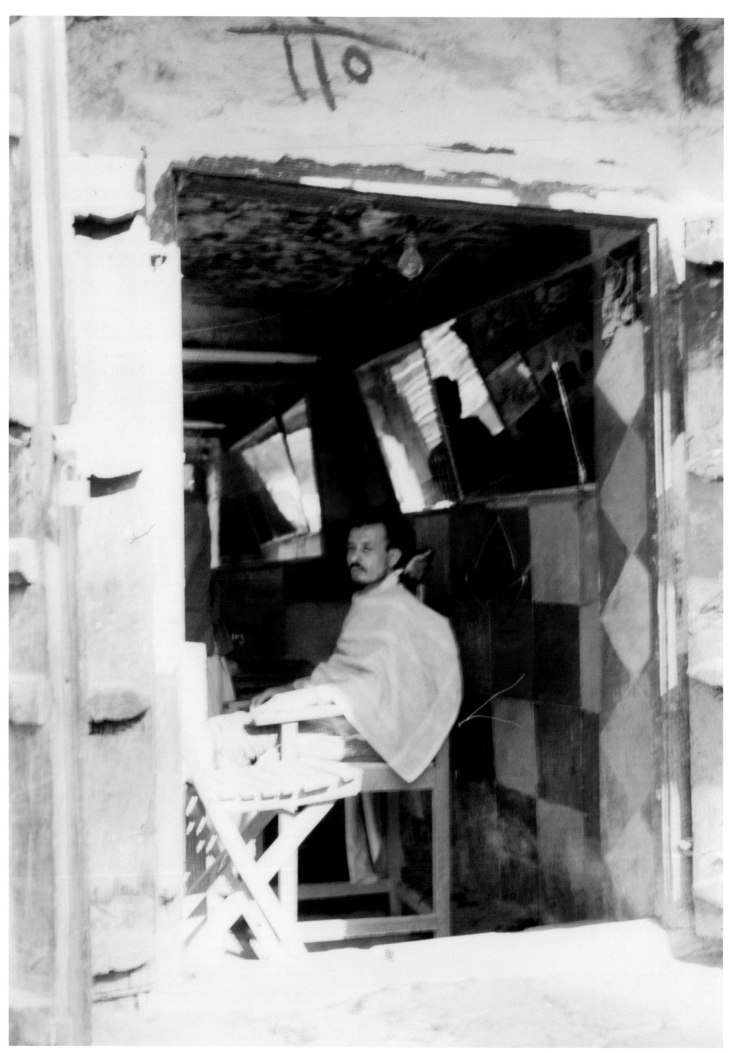

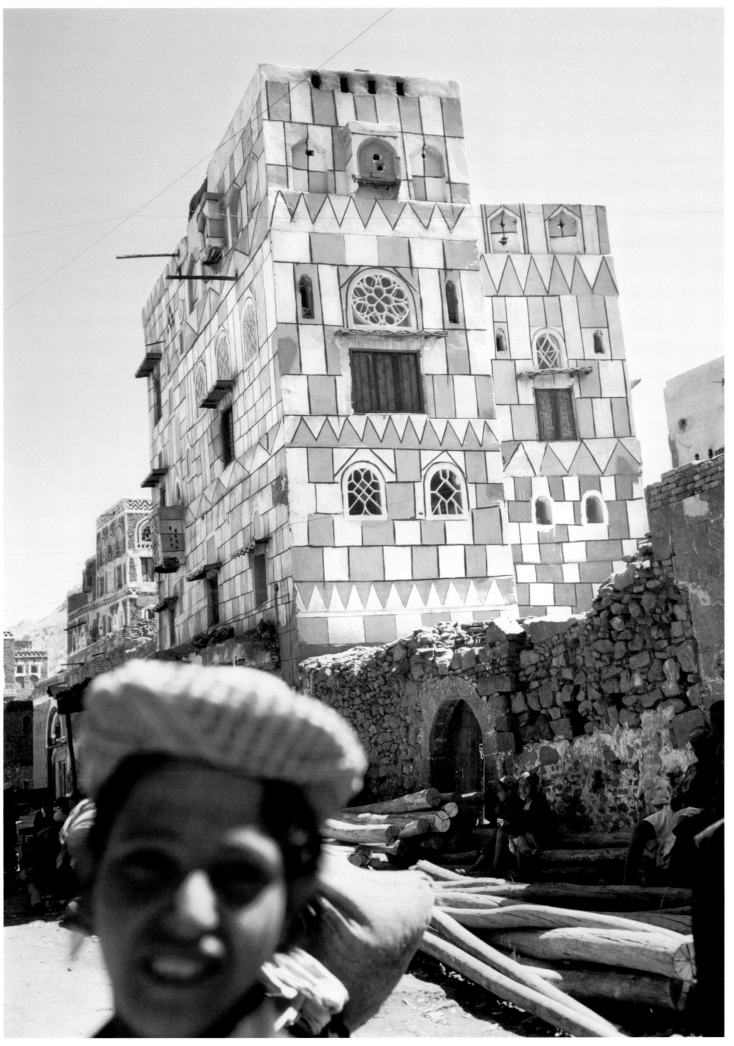

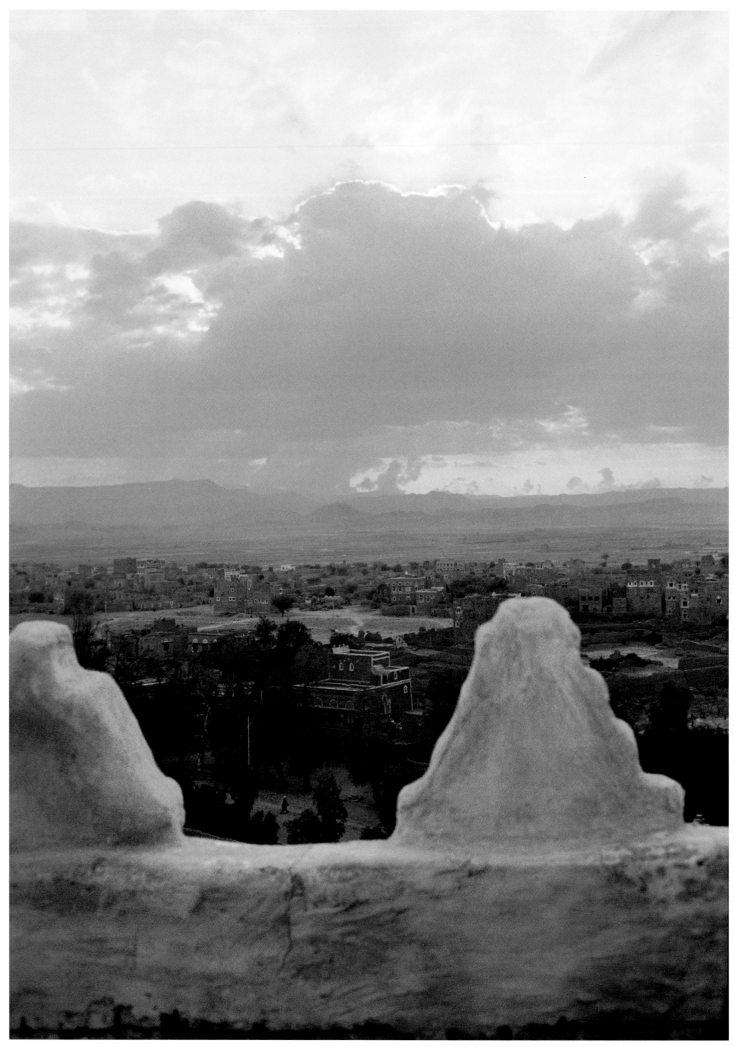

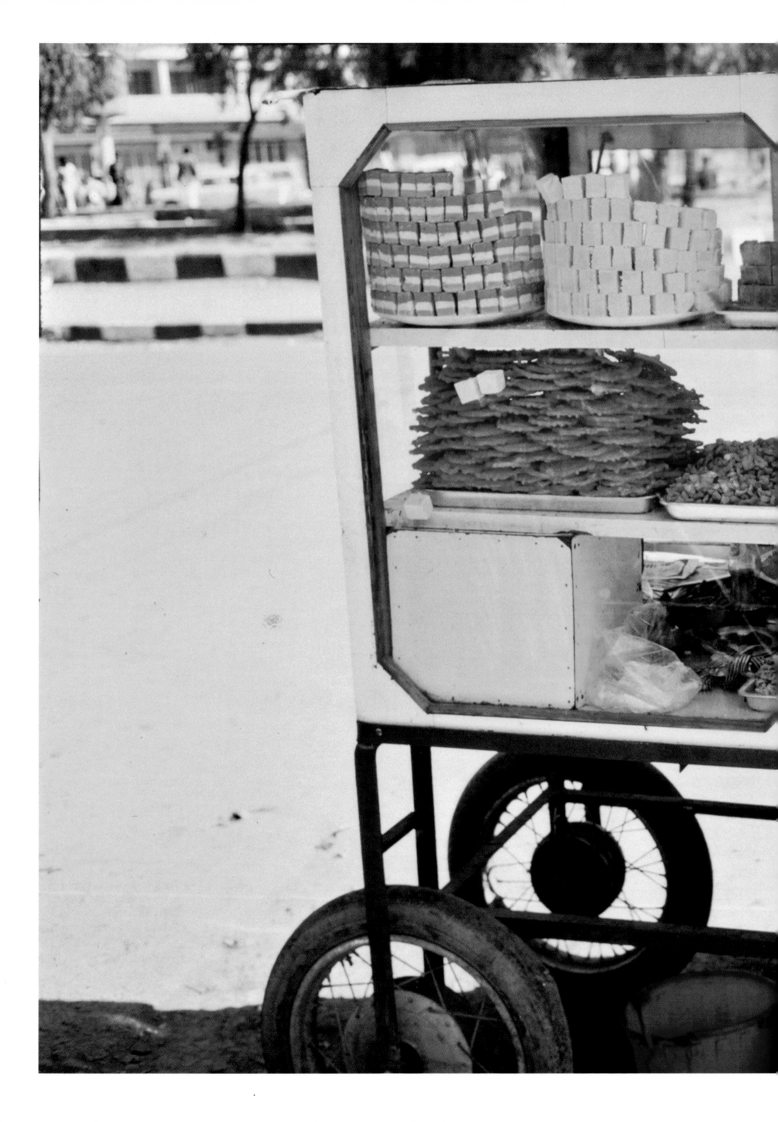

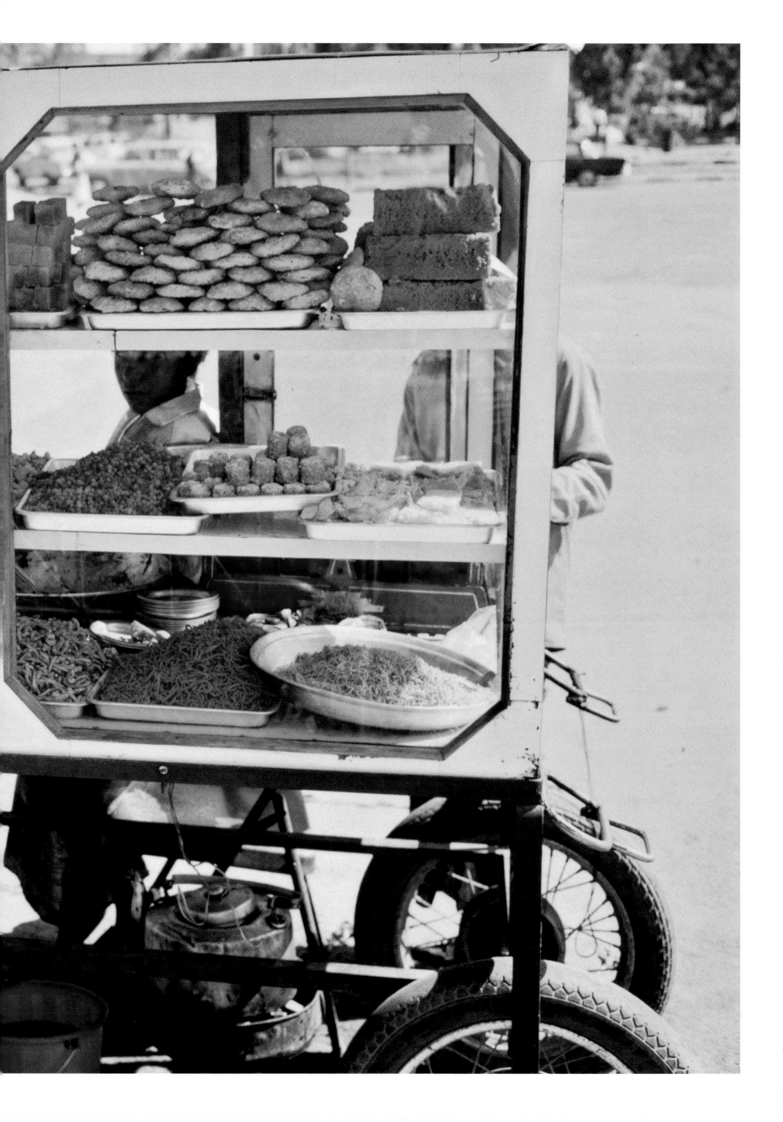

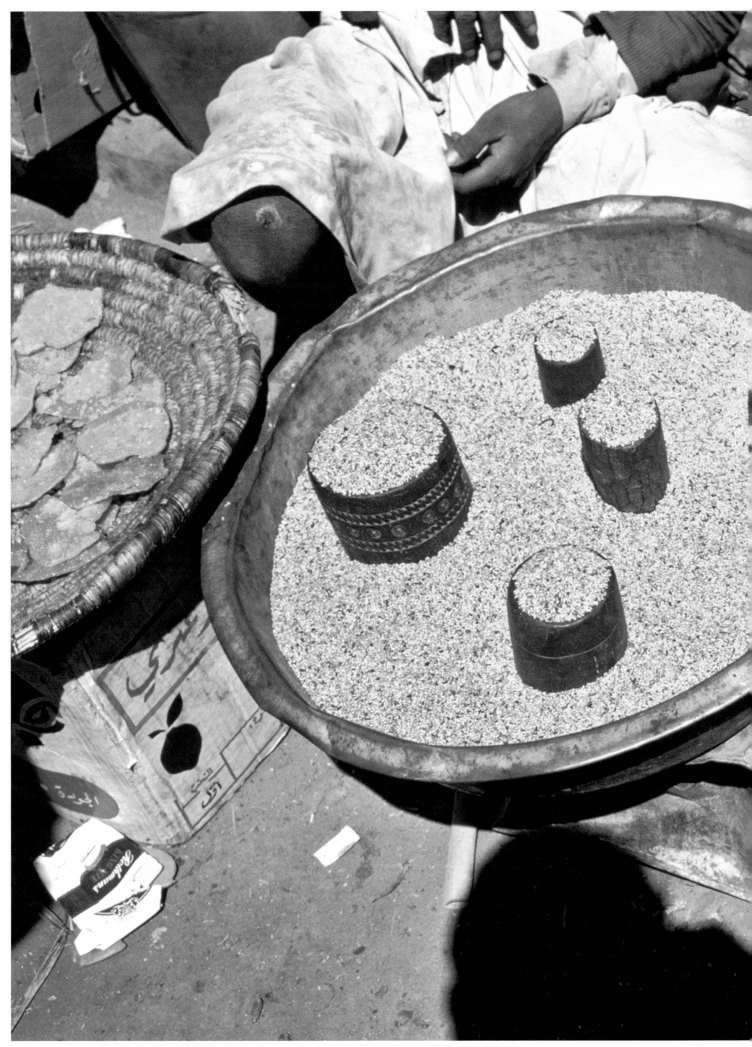

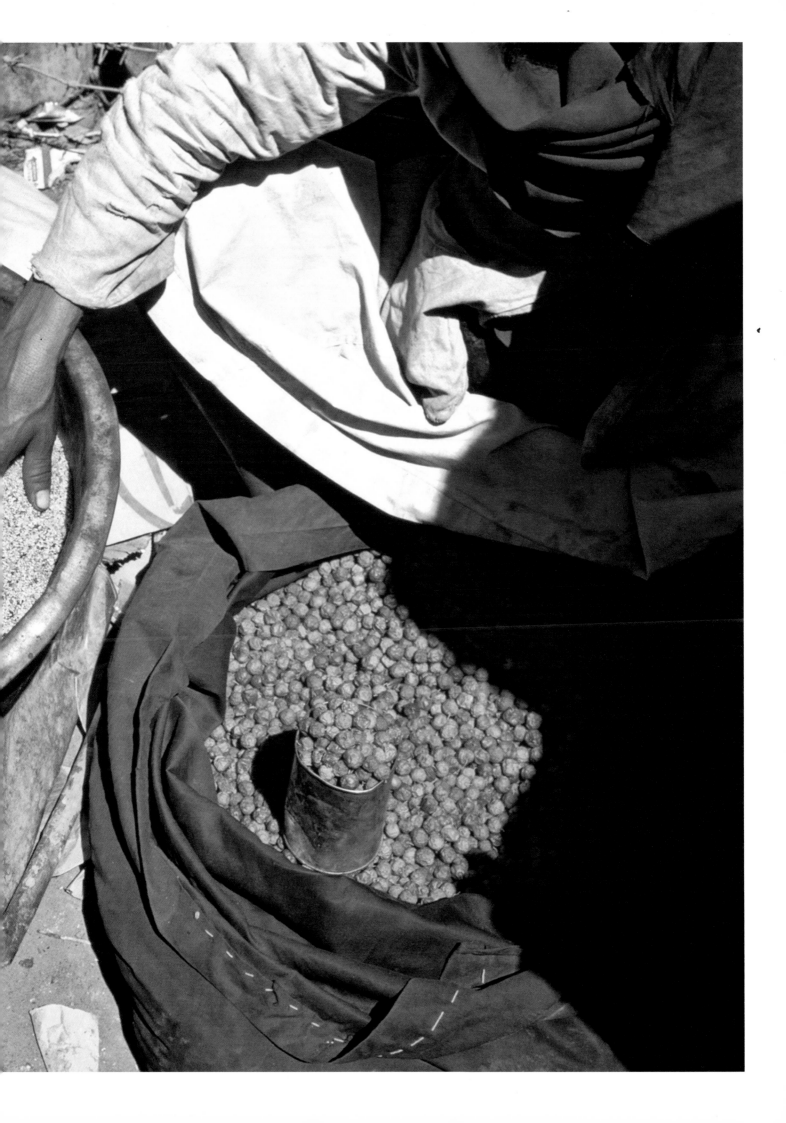

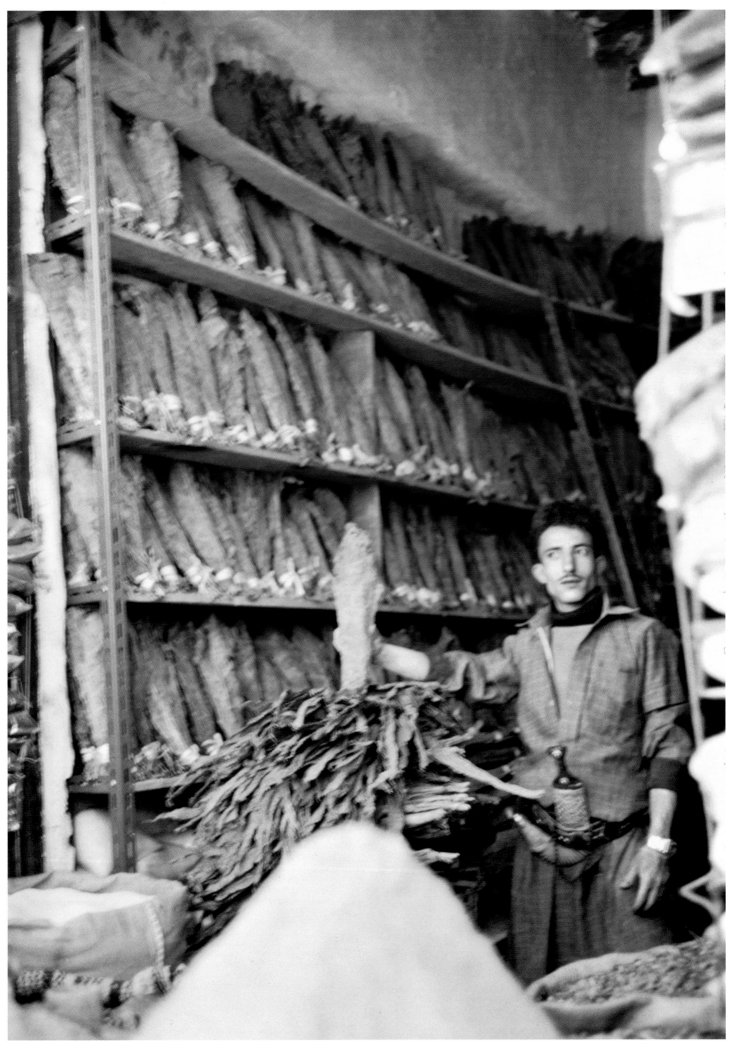

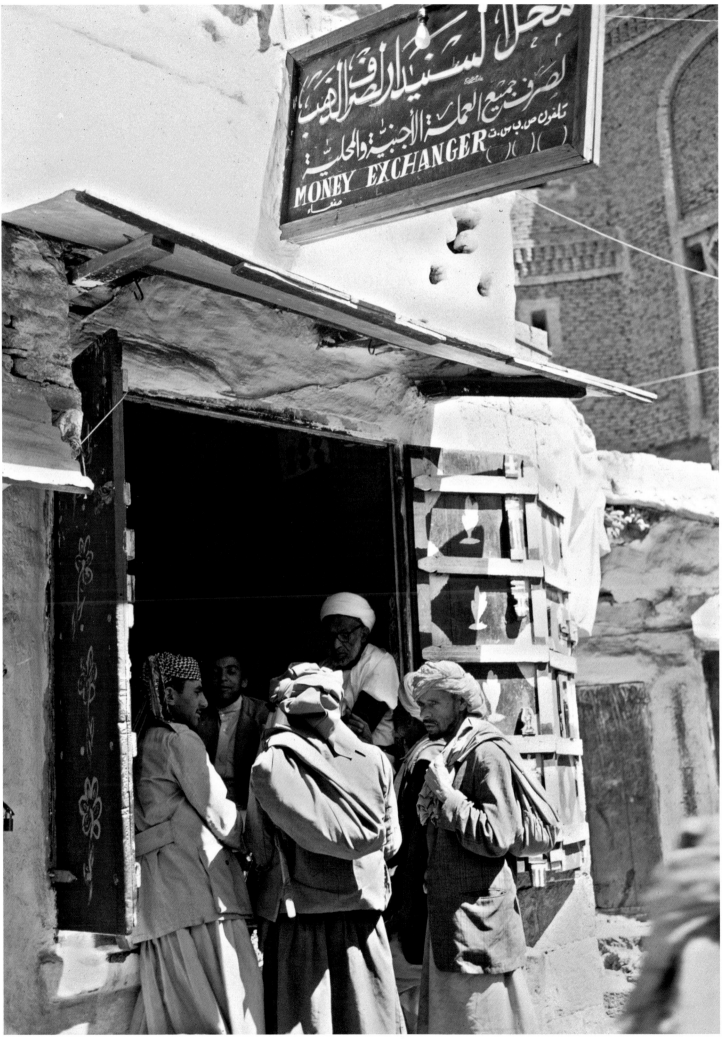

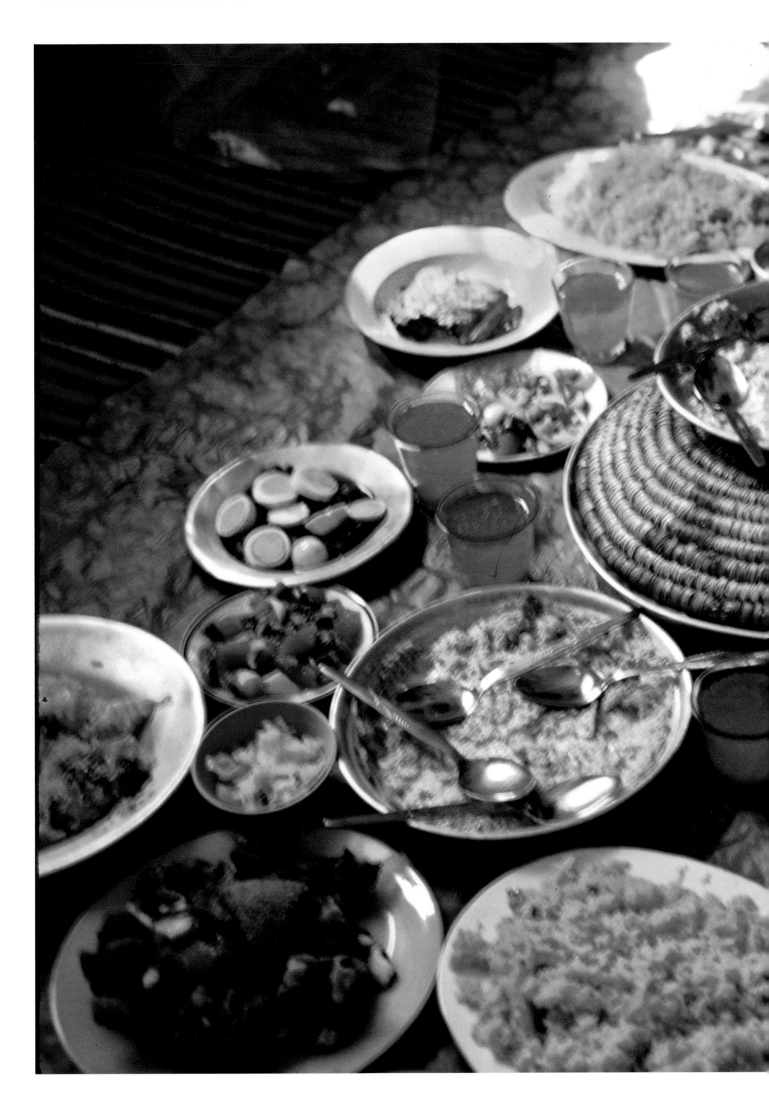

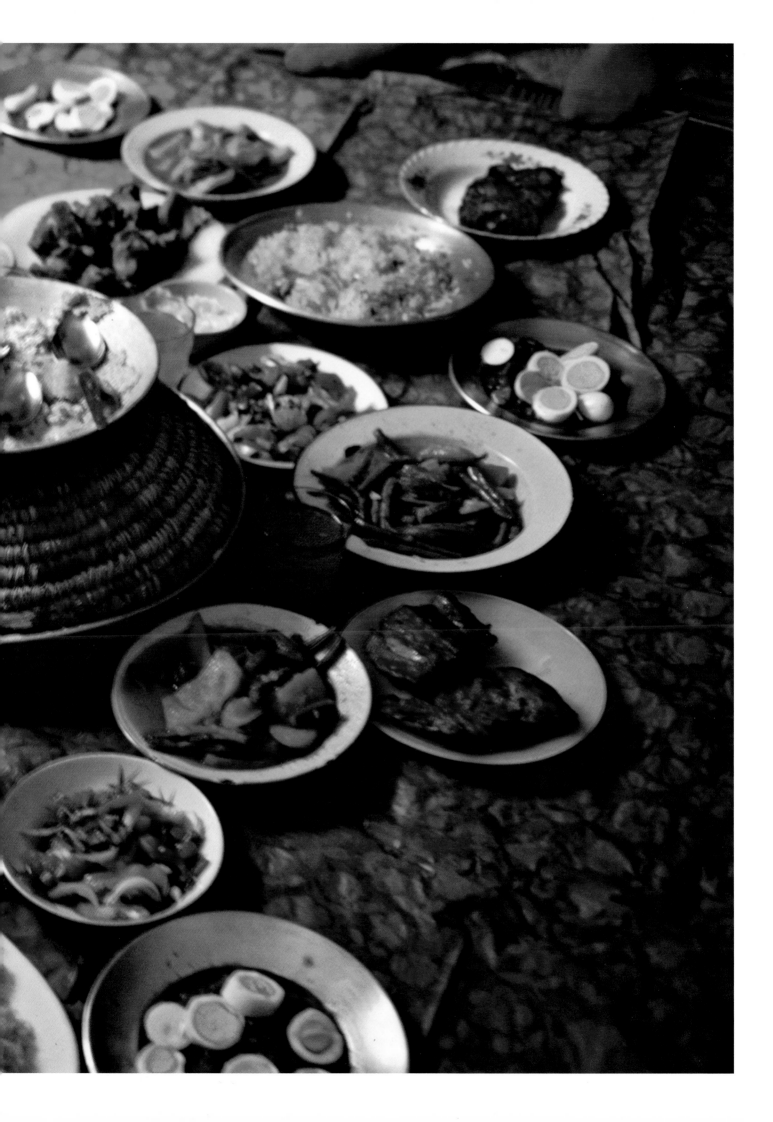

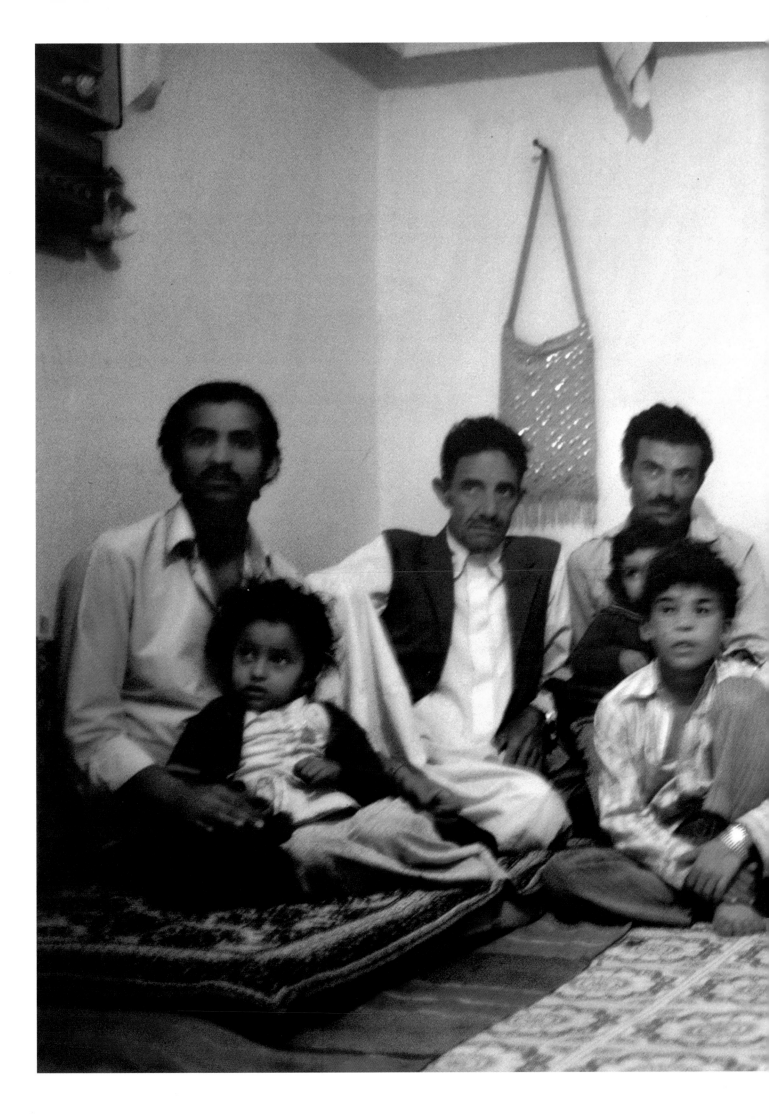

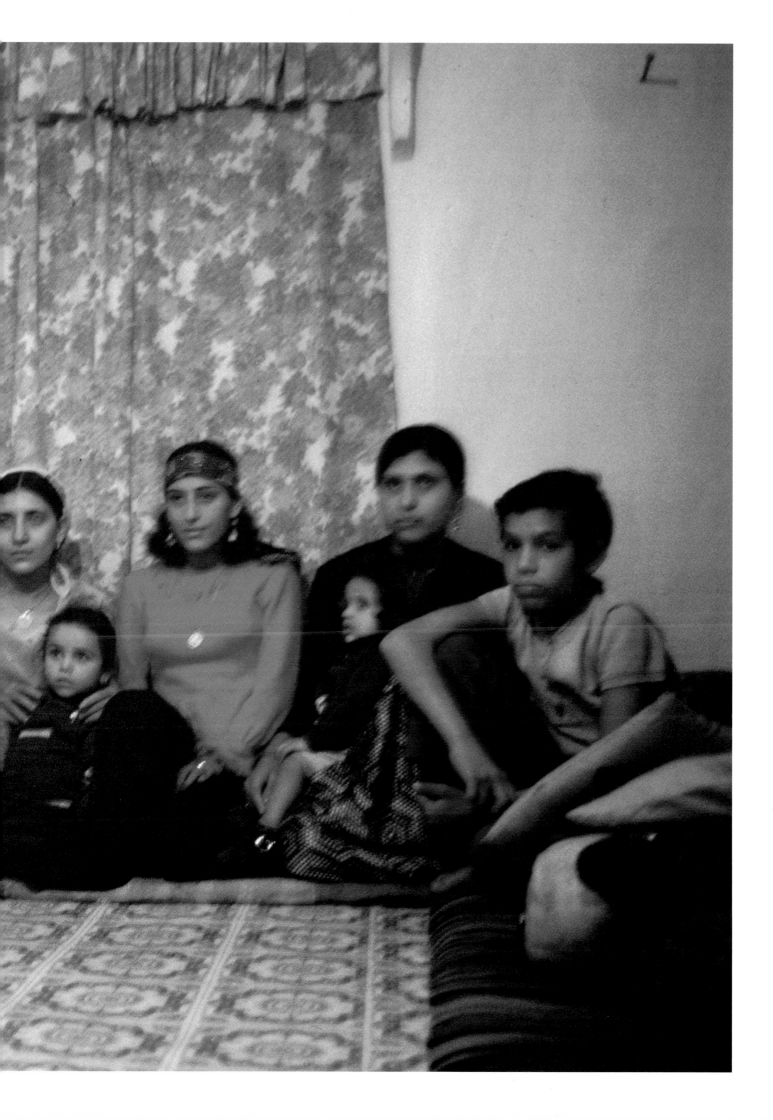

Acknowledgements

In 1976, I visited the Yemen Arab Republic — as the northern part of Yemen was then officially called — with my friend Eric Boman, who had been given an assignment to photograph a story for a French fashion magazine. As a rule, I never went on jobs with him, but this was an opportunity not to be missed: a unique chance to see a fabled land with an extraordinary ancient culture.

Closed to foreigners for many years, Yemen was forgotten to the world. In the interest of gaining tourism revenue, its government had decided to invite journalists in to give the outside world a peek at its hidden visual and cultural treasures. We were among the first foreigners to be allowed into the country in many years, and accommodations, food, and hygiene were bleak.

During our short visit, I took hundreds of photographs to document what I saw. Fighting had recently ended and we had to go through military checkpoints to travel from the capital Sanaa to the northern city of Sa'da, where the Houthis are now fighting. Forty-four years later much of it has been tragically destroyed by brutal civil wars.

Revisiting these photographs, I realized that they show a world that is now lost, and that became the seed for this book.

I want to thank Claude Brouet, the editor who made the trip possible; Silvia Pesci of Damiani; Carlos Picón, for introducing me to Navina Haidar; and especially Bernard Haykel for providing the introduction. A belated thank you to Mahmud for driving us on the trip and to his wife for the lunch on the previous pages. And to my friend Alex Galan a very special thank you.

Peter Schlesinger

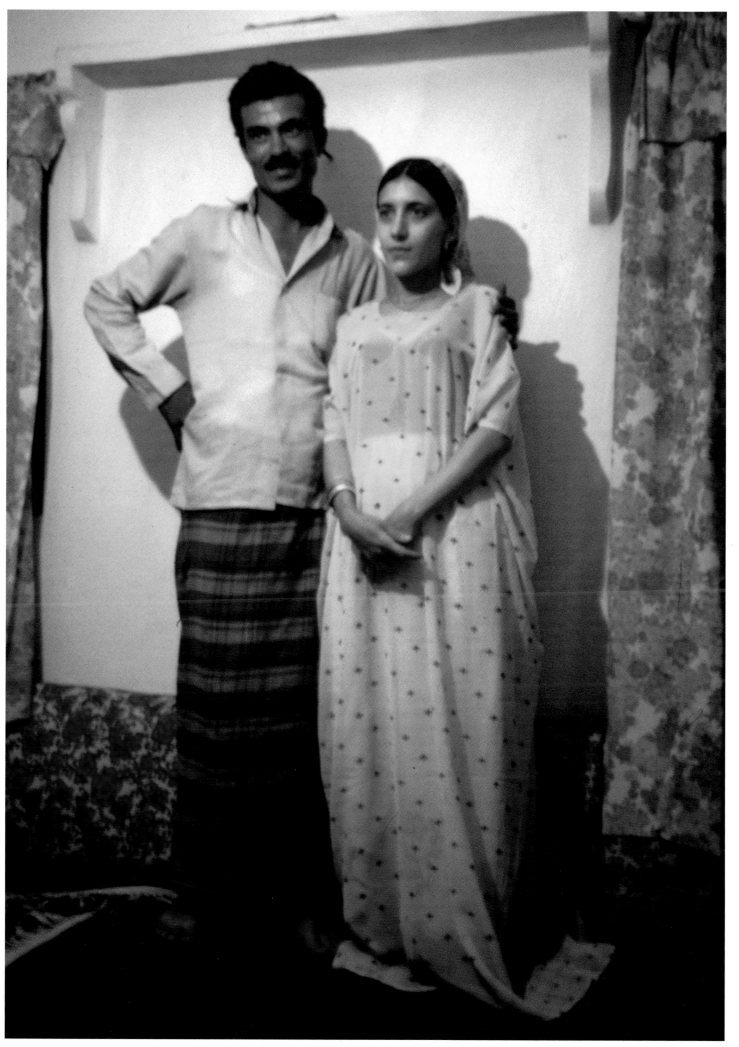

Peter Schlesinger: Eight Days in Yemen

Designed by Fabian Leonardo Bernal
Managing Editor, Alexander Galan

© 2021 Damiani
© Photographs: Peter Schlesinger
© Text: Bernard Haykel

Published by Damiani
info@damianieditore.com
www.damianieditore.com

Printed in October 2020

ISBN 978-88-6208-720-9